Interactive Design for New Media and the Web

Nicholas V. Iuppa

Focal Press
An imprint of Butterworth-Heinemann

Boston · Oxford · Johannesburg · Melbourne · New Delhi

Focal Press is an imprint of Butterworth–Heinemann.
Copyright © 2001 by Butterworth–Heinemann

 A member of the Reed Elsevier group

Library of Congress Cataloging-in-Publication Data
Iuppa, Nicholas V.
 Interactive design for new media and the Web / Nicholas Iuppa.—2nd ed.
 p. cm.
 Rev. ed. of: Designing interactive digital media. c1998.
 Includes index.
 ISBN 0-240-80414-7 (pbk.: alk. paper)
 1. Interactive multimedia. 2. World Wide Web. I. Title.
 QA76.76.I59 I97 2001
 006.7—dc21
 2001019996

British Library Cataloguing-in-Publication Data
A catalogue record for this book is available from the British Library.

The publisher offers special discounts on bulk orders of this book.
For information, please contact:
Manager of Special Sales
Butterworth–Heinemann
225 Wildwood Avenue
Woburn, MA 01801-2041
Tel: 781-904-2500
Fax: 781-904-2620

For information on all Butterworth–Heinemann publications available, contact our World Wide Web home page at: http://www.focalpress.com

10 9 8 7 6 5 4 3 2 1

Printed in the United States of America

Interactive Design for New Media and the Web

To
Dick Lindheim and Steve Goldman
. . . for helping me keep the faith.

Computers are useless. All they can give you is answers.
—Pablo Picasso

Contents

Background

Interactivity?

Interactivity! After dozens of years of hype it is still a word that excites, attracts, sells, and confounds people.

In the game industry interactivity is very tangible. It is a key feature that helps guarantee the success or failure of a product. Just how interactive is a game? "How is the *game play*?" designers ask. They are asking about the level of interactivity.

The game play had better be very interactive if the game is to sell at the level that publishers require. Take Electronic Arts' million-seller *Knockout Kings*, for example. If you want to take on Muhammad Ali or George Foreman or Oscar De La Hoya, you can encounter virtual adversaries who present their style, their skill, and their fighting philosophy right in a virtual ring. Select your character, choose your opponent, and see just how interactive an experience can be. Maybe you'll be able to punch your way to a virtual world title.

One thing is certain, unless your experience is very interactive, you'll be the one who is knocked out.

Interactive learning? In the 1950s and '60s, educators and instructional designers realized that if students *participated* in the learning experience rather than just watching passively, a measurably higher degree of learning could take place. As a result, training organizations from McDonalds to the U.S. Army began developing interactive educational media. Such instruction may have reached its zenith in the massive tank, ship, and plane simulators that were created for the U.S. military. At Fort Leavenworth, Kansas, trainees enter an enormous, hangarlike building and see creatures that look like a cross between the body of a tank and an enormous hydraulic spider. Climb up the catwalk and into the monster and you feel as if you are inside a tank. Start the system running and you find yourself chugging across a vast terrain in southern France. The outside observer sees the giant spider, lurch, jerk, and twist in wild response to your driving decisions. The overall effect is exhilarating, and the military swears that trainees who use these simulators are prepared to drive tanks with far less wear and tear on the environment and on the national budget than those who received traditional training in real tanks on real terrain.

On the Internet, interactivity is so omnipresent that it is impossible to think of a passive on-line experience. You can go on-line and meet people in a chat

room, research your favorite topic, check your stocks, watch a movie, listen to a baseball broadcast, or download some music. The truth is that there is so much interactivity built into the getting there and doing your thing that the broad nature of the experience is always interactive. Buying a book on Amazon.com means searching for titles, checking out reviews, loading your shopping cart, making sure your address and credit card numbers are right. You can't do that passively.

In Online Marketing interactivity is a hallmark as well. Take motion pictures, for example. It's never been enough to create movie Web sites that simply list the cast and crew and summarize the story. If you visited the site for *South Park—Bigger, Longer, and Uncut* last year, you found yourself invited to join tyke Kyle and his little brother in a rousing game of Kick the Baby! It was not really sadistic, but it was interactive.

So it does seem as though, at the dawn of this new millennium, interactivity has truly arrived. But that is not entirely the case. There are two reasons for this. First, for more than a dozen years the formats of interactivity have been evolving, and the quality of the interactive experience has been evolving as well. During that period interactive designers have sometimes tried their best to create quality experiences in an environment that was ill defined or technically incapable of providing all that they wanted. Their intentions were honest, but their products did not really deliver interactivity.

We should also admit that interactivity sounds good, and so some designers provided a less-than-ideal experience simply because they wanted to capitalize on the concept of interactivity without paying the price for all they could deliver. That sort of phenomenon is occurring right now with interactive elements of Digital Video Discs. There is far more than can be done with DVD interactivity than chaptering movies and including the coming attractions and presentations on "the making of" along with the title itself. But most DVD designers, who could be taking a cue (and some material) from the interactive Web sites for the same movies, don't want to spend the development time or money to add real interactivity to DVD movie titles. Put some of the Web sites on the DVDs so that people can at least page through the background information on the project. How much would that cost?

The second major reason that interactivity has not yet truly arrived is that the formats and designs for interactivity have not all been defined. We know what an interactive banking Web site is. We know what an interactive game is. We know what interactive learning is. But what is interactive television?

In the entertainment business the promise of interactivity is still unfulfilled. It is hotly debated and generally misunderstood. Hollywood writers are frightened by it, movie directors long for it, and producers doubt that it will ever exist. Studio executives and entertainment entrepreneurs, on the other hand, are interested—if only for reasons of self-defense. Just to guard against the innovations

of rival studios, they invest in technologies that suggest that they may be able to deliver interactive entertainment . . . someday.

Interactive entertainment is something of a Holy Grail: legendary, only glimpsed from afar. Some people claim to have seen it once, somewhere. "It was a truly great experience," they say. Just don't ask them to *describe* the experience.

All we are sure of is that interactive entertainment will be truly wonderful, if it ever arrives.

Of course, we have predictions from visionaries about how it will work. All the Star Trekkers out there are probably aware of what is perhaps the best example of fictional interactive entertainment: the Holodeck.

The Holodeck is the virtual playground and learning simulator that exists on most of the starships in the Star Trek series. The Holodeck is programmable and creates virtual people and places as specified by its users. The users, of course, are members of the crew of the ships. The technology that produces images within the Holodeck uses a mix of energy and force fields that allow the virtual characters and settings that emerge in the space to take on a look and feel that is very solid and very real.

Crewmembers can enter the Holodeck for extended periods and have long, complex adventures. Captain Picard and Data, for example, love to participate in Sherlock Holmes mysteries. Captain Janeway enjoys being a Victorian governess. Riker plays a trombone in a jazz band in his own virtual bar. The doctor on *Star Trek: Voyager*, a Vulcan himself, simulated the mating rituals of the Vulcans, because, in fact, he was the only Vulcan on the ship. Worf keeps his skills sharp with Klingon combat training exercises that he programmed into the Holodeck.

Holodecks require a great deal of energy to operate, but somehow their power sources are totally separate from the main energy driving the starships. So, even when there are problems with the fuel supply of the ship, the Holodecks keep chugging away.

No one knows the programming language of the Holodeck or much about its human interface. But, somehow, most crewmembers can enter their specifications and create the experience of their choosing. Of course, true to the principles of Consequence Remediation that will be discussed later in this book, choosing a scenario does not guarantee the outcome that a crewmember is hoping for. This is especially clear in those episodes in which the characters within the Holodeck become self-aware, escape their confines, and try to carry out their existence in the real world.

Another, very important portrait of interactive entertainment was created in the late 1940s by science fiction writer Ray Bradbury. I was fortunate enough (or unfortunate enough, perhaps) to stumble onto it when I was very young, and its clear vision of interactive entertainment has been with me ever since.

When I was about 6 years old, I happened to tune into a broadcast of the radio series *Dimension X*. The story presented on the radio that night was an

adaptation of "The Veldt," an episode from the science fiction book *The Illustrated Man*.*

I remember that my parents had gone out to the movies and left me alone in the house with a teenage babysitter and a great, big console radio. What could I do when the girl picked up the phone and called her best pal to talk the night away? I turned on the radio.

The radio drama presented on *Dimension X* that night had to do with a futuristic house that offered its well-to-do owners the ultimate babysitter: a "PlayRoom" whose walls were floor-to-ceiling television screens. If the parents wanted to go out for the evening (as mine had so thoughtlessly done), they simply left their children behind to be taken care of by the latest media technology (as mine had also done).

The PlayRoom in that fabulous house had the technology to create dozens of different environments for children to play in. As far as I could tell, the children controlled their play environments by sending orders with their minds, telepathically.

Of course, it wasn't long before the little brother and sister in the story found their own favorite place to be (it happened to be my favorite place as well). It was the domain of Tarzan, Jungle Jim, and Sheena, Queen of the Jungle; it was the heart of Africa, the African Veldt.

Needless to say, after the children's first night in the PlayRoom, the roaring of lions and trumpeting of elephants became common in the household. It kept the parents up every evening, and it wasn't long before they became concerned about the PlayRoom and the amount of time their children were spending there.

In the end, the parents even forbade their children to play there, locking the door and insisting that they were going to have the entire PlayRoom dismantled and sent back to the manufacturer. This, of course, is not the kind of thing that parents should do to their children, at least not in a Ray Bradbury story.

Well, I was right in tune with the kids when they broke into the PlayRoom on the very last night it was part of their home. I was thrilled as they summoned up their favorite locale and saw again the prides of lions lounging in the sun and the herds of elephants lumbering across the plain. I wasn't at all sympathetic when the hysterical parents came zooming down the stairs and into the PlayRoom to find out why their children were disobeying their directives. But I was in full support as the kids jumped out of the PlayRoom and slammed the door behind them, trapping their worried parents in the African Veldt. Remember, I, too, had been left alone to entertain myself while my parents went to the movies, and all I had to entertain me was a magical box (the radio) and the power of my own mind.

I won't spoil the story by telling you what happened to the parents as they came face to face with those elephants and lions. Instead I'll just say that the

* Ray Bradbury, *The Illustrated Man* (New York: Doubleday & Co., 1958).

story does seem to be the best introduction any kid ever had to the concepts and the possibilities of interactive entertainment.

WHAT THIS BOOK WILL DO

This book will review the principal forms of interactive media. We will look at interactive formats and formulas that have been with us since the very first lessons were taught and the very first stories were told. We will see what we can learn from them, and how they fit into the new technologies and media that are available today. We will study the latest delivery mechanisms for interactivity, from wireless technology to the World Wide Web to DVD to virtual immersive experiences, and we will see how the accelerating evolution of those technologies has begun to shape the design and substance of the interactive media themselves.

We will consider successful and unsuccessful examples of interactive applications so that we can make sure that our efforts provide the most positive experiences. Ideally our efforts at interactive design should advance the evolution of interactivity. We should not contribute to the vast body of content that has led so many skeptics to insist that interactivity is a nonsense word—that it will never provide deep, rich, universal experiences.

We will look at interactive television and see if, when, and where this most promising of all interactive media will arrive.

We will review some of the tools and practices of the trade of interactive design, including the creation of site maps and flowcharts and the writing of design documents. We will see how the latest forms of digital media can now be applied to entertainment, games, information systems, and education. And finally, one more time, we will look at where the whole business can take us . . . ideally with the same power as the PlayRoom, but with consequences far more positive and far less dire.

A Short History of Interactivity

Interactivity is not new. It is one of the oldest forms of human endeavor. Commerce has always been interactive. You have something I want. I have the cash. We make a deal. You get my money. I get what you've got. We interact every step of the way.

Learning is a similar process. You have a skill. I want to learn it. You show me how. I try to do it, too. You correct my mistakes, I get it right, and I've learned.

Throughout this book a recurring theme will be that interactive entertainment is perhaps the most difficult kind of interactivity to achieve. And yet, even in the field of entertainment, interactivity has been around since the dawn of time.

The ancient storytellers who gathered crowds around the campfire to spin prehistoric yarns did what all good storytellers have done ever since. They adjusted their stories to fit the mood of the crowd. So, on one particular set of nights, if the clan seemed more in the mood for a happy ending than a tragedy, that's what they got. The storyteller reacted to the mood of the audience and adjusted accordingly.

As people chose their favorite stories and asked to have them repeated, it became more difficult to adjust the main points of the story. So then it was the details that got adjusted. Very much as a live theater performer plays to the crowd today, performers throughout history have done everything possible to give the audience what it wanted. Storytellers were no exception. Telling stories was, and still is, a reciprocal arrangement. And when the audience and the performers are in sync, the synergy is fabulous.

The court jesters in the Middle Ages had a much more limited audience, the king and queen. The courtiers and courtesans were actually performers in that scene, and so they pretty much went along with the royal mood. In any event, court jesters did have to read their audience and adjust accordingly or (depending on the adjective associated with the title of the monarch) things could get dire.

Today, stand-up comics, the latest incarnation of court jesters, do the same thing. They see what their audience wants and select from a limited but, they hope, adequate inventory of material to provide a satisfactory entertainment experience.

Automated entertainment delivery systems, starting with papyrus and moving on down through the printing press, the movie projector, and the television set, often replaced performers and their ability to play to the immediate audience. The creator of the written work was no longer a performer—he or she was an author whose effort was permanently recorded. In spite of heroic efforts by some authors to involve the audience or give them some say in the unfolding of their stories, storytelling in the mass market was on its way to becoming a passive art. It maintained its interactive soul in the theaters and the bistros, and in the nurseries of little children whose parents chose to *tell* them stories rather than read to them. But more and more, literary works were locked in forms that fixed their content and made the audience passive observers.

The argument can always be made that the imagination of a reader gives real substance to the written word and at least represents the scene, the look of the characters, the feel of place and time. As noted, authors such as Frank Stockton in his short story "The Lady or the Tiger?" actually allowed the audience to decide for themselves how things ended. And very often authors at least allowed readers to determine what happened to the characters beyond the end of the story. But no matter how we try to rationalize it, written fiction is in fact a closed world where the story is what it is. And, as formulas for successful story structure have become more and more standardized, even the *format* of the story has become more rigid. Every good story today is expected to have a story arc, a climax, and a resolution.

Film, radio, and finally television came close to bringing about the demise of interactivity entirely. Not only could the audience not influence the progress and outcome of the story, they couldn't even let their imaginations paint a picture of the way things were. The passivity of entertainment was becoming fixed . . . not that that is entirely a bad thing. The majority of analysts and observers today claim that passive entertainment is what most people want after a hard day's work anyway. Moreover, passive forms of entertainment have given us *War and Peace*, the *Divine Comedy*, the Sistine Chapel ceiling, the *Jupiter Symphony*, and *Citizen Kane*. Who can argue with that?

Visionaries such as Ray Bradbury, on the other hand, who described children who would rather play in a virtual jungle than watch Tarzan movies all day long, weren't really in sync with their contemporaries in 1951.

In any event, while movie theaters and television sets were being built and entertainment was becoming more and more passive, a parallel track was evolving.

THE ROAD TO INTERACTIVITY

We've touched on storytelling, live comedy, theater, and other forms of entertainment in which the performers adjust what they do in response to the audience that is present. In the same way athletes at a sporting event are aware

of the crowd, and in fact the crowd can affect the outcome of the game. In more than one college basketball contest broadcast on network television, the student body in attendance has been named "player of the game" by the commentators.

Nevertheless, it is one thing to attend a game in person and share in the emotions of the crowd and the synergy with the players, and it is an entirely different thing to actually *play* the game.

Playing the game is interactive entertainment at its maximum. In some games the mechanism of the game allows everyone to be an individual player all the time. Bingo is one example of that. But in other games such as professional football, there are only a handful of players. How can people be in the middle of that experience? Well, they can't be in *that* experience, but in cases where the experience is so great that it is worth trying to duplicate, they can simulate the experience.

So, we can't all *be* the quarterback in the Super Bowl. But we call all play that role of the quarterback in a simulated Super Bowl. We can't all slug it out with Muhammad Ali, but we can play the role of Joe Frazier in a simulated boxing game.

It turns out that simulated game play has been around for a very, very long time, and it may be in fact the truest precursor of the Holodeck, the PlayRoom, and all the future interactive experiences that are to come.

Gaming, after all, did not actually begin as a sport. The ancient events of wrestling, the javelin toss, and the shot put are forms of an even more ancient activity. Think back to one of the oldest professions of all—a profession where you had to play a game to learn and you had to learn to stay alive. I'm talking about war, warriors, and *war games*. Call them maneuvers, call them mock battles, call them military exercises—it has always been safer, and more practical to practice the art of war through simulations than through actual combat.

As long as primitive peoples charged madly into battle with little preparation or practice, they were usually no match for the first disciplined troops that they came up against. As Akira Kurosawa so brilliantly illustrated in his film *The Seven Samurai*, when bandits are decimating your village, a handful of experienced soldiers can save you.

In the ancient world, leaders such as Darius the Great of Persia conquered everyone they encountered because they saw to it that their men not only exercised, but that they *practiced* fighting. The Greeks, Romans, and other successful military powers that followed improved upon the idea.

In the 20th century, however (*the century of total warfare*, as it is sometimes called) the American military began holding war games on such a scale that they were extremely expensive and extremely destructive to the environment. It happened at perhaps the first time in history when people thought more about the environment than about the military. Soon protests were raised, funds were cut, and a new solution was sought. The solution was interactive simulation.

Within the Department of Defense agencies spring up to research and develop simulation systems that would give participants the look and feel of warfare without the blood and guts or even the smog and wasted energy resources.

So the military took their war games out of the field and put them into little boxes that looked like cut-out trailers on the outside but looked and felt like the inside of jet planes and tanks and Humvees and other military vehicles on the inside.

Soldiers trained in those interactive simulators, and they learned. But like it or not, there was more than learning going on, because flying a jet plane, even in a jet plane simulator, is fun. It's some of the stuff of teenage dreams. And so, as soon as it was technically feasible, similar activities were made available to the consumer public.

I find it fascinating that among the legendary products of software giant Microsoft are MS-DOS, Microsoft Windows, Microsoft Word, Microsoft Power-Point, and of course, Microsoft Flight Simulator.

Meanwhile, the military with its gargantuan appetite for training was also looking for other sources of instruction, and it found them at the universities where behavioral scientists were suggesting that the same principles that taught rats to run through mazes could also be applied to human endeavors.

At Harvard University, B. F. Skinner and his behavioral scientists were noted for studying rats in mazes. But what they were really studying was behavior, which they defined as something that a learner did that was observable and measurable. They broke behavior down into two things, stimulus and response. Something stimulates you and you do something in reaction to it, and if your behavior can be observed it can be defined that way. Learning meant establishing new stimulus/response patterns either because your current s/r patterns were incorrect and needed to be changed, or because they did not exist at all and so they needed to be established.

The behavioral (s/r) approach to learning meant that learners couldn't just sit there passively. You can't measure behavior if the learner isn't doing anything. So the learning technology that grew out of the work of B. F. Skinner was in fact a perfect match for the emerging world of interactive technology, which enabled participants to "do something."

Interactive instruction first manifested itself in teaching machines. These were clunky mechanical systems that presented a stimulus to learners (in the form of a block of text or a picture) and then asked to respond. The principle seemed to work pretty well. So then it migrated to print in the form of programmed instruction. Programmed instruction worked the same way, but without the clunky machines. It presented a small, carefully selected amount of information to a learner and then asked that learner to write in an answer or select from a multiple-choice list. Feedback was given on the next page or on a separate feedback sheet, but, in keeping with one of the key principles of behaviorism, it was given immediately.

Programmed instruction seemed to work as well or even better than teaching machines and was adopted by the military, by industry, and by educational institutions. The behavioral approach to learning and instruction was in full swing. But it had some limitations. For example, not all information can be presented in a paragraph. Not all behaviors can be simulated by reading a paragraph and answering a few multiple-choice questions. A lot of them can be, but not all. The military was willing to build replicas of its vehicles and create systems that simulated the look and feel of driving them. Industry and education were not as willing.

So, educational technologists began looking for ways to increase the quality of the simulations that they were presenting as stimuli. Moving pictures were a way to present information, but then how would the learner respond?

Enter interactive video.

INTERACTIVE VIDEO/INTERACTIVE TELEVISION

Before the World Wide Web, CD-ROMs, or even digital video existed, there was interactive video, an exciting, if unfulfilled, technology that was the precursor to audio compact discs and digital video discs (DVDs). It was delivered on laser video discs that often carried computer control programming in the second audio channel of the disc itself.

The learner watched the video on a TV screen and then responded on his or her computer. The computer was hooked up to the laser disc player so that choices selected from the computer caused the laser disc player to search out feedback information on the disc and show it on the TV.

These two-screen systems were expensive for a lot of reasons. For one thing, every learner had to have a laser disc player and computer and a TV set. For another, not only did the video have to be produced, but so did the computer software that controlled it.

Later, systems that allowed the video images to appear on the computer used cards that showed streaming analog video in windows on the computer screen. This wasn't actually a two-screen system, but it was a multiple image system; it was just that the images were all on the same screen. This of course is standard operating procedure today, but in the 1980s it seemed revolutionary.

Interactive instructional laser disc video did not revolutionize the industrial training industry the way the laser disc manufacturers hoped. There were notable successes and notable failures. But the efforts to design truly interactive media resulted in the discovery of a number of successful design principles.

On the consumer front, laser disc designers tried to build reasonable interactivity into the laser disc systems that were being sold to consumers. However, those systems did not have the functionality that was built into the players sold

to industry, and as a result consumer interactive laser disc products seemed awkward and unexciting, and they never became very popular.

The frustrated exercise of trying to build interactivity in a technology that wasn't really very capable of it was massive and exhausting, but fortunately didn't last very long. Pioneer, the manufacturer who ended up being the main impetus behind laser discs, soon gave up trying and sold laser discs as simply a higher fidelity, elite form of linear movie delivery.

Amazingly enough, the whole frustrating exercise I have just described was soon repeated entirely, in a brand new venue: interactive television.

Interactive television (ITV) sprung up as a relatively early mutation of the media technology revolution. It got an early start because of a bizarre twist in TV marketing caused by government regulation. Cable companies, TV networks, and telephone companies were fighting to see who would become the leader in delivering TV programming to millions of TV viewers all over the country and all over the world. At the time there were strong federal laws regulating who could own what. So, telephone companies such as AT&T were not allowed to compete directly with cable delivery companies such as TCI. Deregulation would eventually change all that, but in the early 1990s, the phone companies were looking for new ways to enter the same markets as the cable companies. The cable companies were trying to stay technologically savvy so that they could keep the telephone companies out of their markets. The TV networks were involved just so that the other two would not get an unfair competitive advantage.

What was new, what was worthwhile? What could give one group of companies an advantage over their competitors? These three sets of corporate giants needed to know. They saw it as a survival issue, not only because of the competition, but also because of one historical lesson that was too recent to forget.

THE NEAR-DEATH OF THE MOVIES

The TV networks and cable companies remembered the early days of TV and what happened to the movie industry as a result of TV's arrival. Movies were the rulers of the entertainment industry in the 1920s, 1930s, and 1940s. But in the early 1950s television started to emerge and took a giant-sized bite out of movie profits. Foolishly, the leading moviemakers (with a very few exceptions) decided to treat TV as a rival. In spite of the fact that the movie industry had vast experience with the very processes that went into TV production, the movie companies decided to fight television rather than embrace it. This fight took place in the courts, in advertising and marketing, and in any other public forum that would listen. Throughout the 1950s, the movie industry lost business, lost skilled workers, and almost lost its very existence to an alternative technology that delivered what should have been its own products.

As profits shrank, new movie technologies, such as Cinemascope, 3D, and VistaVision, proved weak ammunition in the battle against the major benefit that TV offered. The benefit, of course, was convenience. People would rather have a smaller entertainment picture, a black-and-white picture, a fuzzy picture, if they could get it just by walking into the other room, flipping a switch, and rolling into their favorite easy chair.

Decades later, when the movie industry recognized the error of its ways and began to gain a greater and greater foothold in the TV business, they vowed never to make the same mistake again. They also vowed that, if any reasonable new technology ever began to emerge again, even if they didn't understand it, they would try to play some part in it. And all of this was planned just in case the new technology turned out to be the alternate delivery mechanism that TV had turned out to be in the 1950s.

Nurturing new technologies is a nice vow, but one that takes a lot of money and goes against the "survival" instincts of most species, especially corporate executives. So, very soon both network TV and the movie industry failed to recognize the opportunity of cable TV and treated it as an adversary rather than a partner, just as they had done when TV first emerged.

In the early 1990s the wars between the cable industry and the networks were drawing to a close. Cable had won, and interactive TV looked as if it might be the next big battleground. For once the rival industries decided to work together.

A HOST OF PLAYERS

Actually there were more participants in the interactive TV game than there were in the aforementioned battle between television and the movies, because so many different kinds of companies could benefit from the emergence of interactive TV (ITV).

At the time, phone companies were banned from owning cable networks in the states in which they operated. Yet with their vast delivery resources and services, phone companies would make ideal operators of cable TV services to the home. Cable companies knew this, and it scared them. They had yet to figure out that all they had to do was sell ownership of their franchises to the telephone companies and everyone could be happy. A few regulatory changes would eventually let that happen.

The TV networks, still smarting from their efforts to survive the arrival of the cable industry, also recognize that the phone company could take all the business away from the cable companies and present a newer, more powerful adversary. Phone companies in the cable business would change the face of television so completely that the very existence of the TV networks could be at risk . . . again.

Meanwhile, movie companies have been looking for better and better ways into the TV market. Fox, Paramount, and Warner Brothers finally started their own networks. They also wondered about other things they could do to improve their position.

TV manufacturers, such as Sony (which already owned a movie studio), were interested in anything that could help them sell more TVs and improve their power within the entertainment industry; ITV looked promising to them. Finally, to top it all off, a new set of players arrived: the computer companies (both software and hardware). They saw golden opportunities to use computer technology to improve interface design (making everything easier for consumers to use). They also saw a way to get into the glamorous movie business.

So, for a lot of reasons, cable companies, TV networks, phone companies, movie studios, electronics manufacturing giants, and computer hardware and software companies all said to themselves, "We don't know what this interactive TV stuff is, but we have to participate in it. We have to study it, and make sure that we don't miss the boat if it becomes a big success."

BANDWIDTH

To some degree interactive television (ITV) is two things: a new form of TV delivery, and a new art form that affects programming and its content. In both cases one of the key technical issues is bandwidth. Bandwidth, again in nontechnical terms, relates to the amount of the broadcast band any given medium uses and any given distribution mechanism provides.

Cable TV companies have mighty rivers of bandwidth. They put a big, broad coaxial cable right into your home like a great big pipe that spills the most demanding, least efficient of all media types (analog video) right into your living room. Phone lines offer very little bandwidth, but then it takes very little bandwidth to send and receive analog voice signals.

As noted, video is the most demanding of all media. To stay with our pipeline or river metaphors, it is Niagara Falls pounding out mega-gallons of signals that need mighty rivers or huge pipelines to carry it. To be useful carriers of video, telephone companies (with their rivulets of bandwidth) had to find ways to make video bandwidth smaller while going through the laborious process of expanding their delivery system from narrow pipes to giant aqueducts.

A similar problem applied to computer companies, who were faced with the fact that video processing requires vast amounts of computer memory and very fast computer processors. So, while computer companies made faster processors and machines with more and more memory, they, too, looked for more efficient ways to deal with video images.

The problems really are compounded when the limitations of phone lines run into the limitations of computing power right on the desktop of the average

consumer. It happens every day in the world of the Internet. Delivering video to your desktop over phone lines and then having it play on your computer is really still one of the most demanding things that you can try to do. Analog video had to be made smaller; it had to be compressed. As we have said, when video is compressed, it doesn't take the mighty Mississippi to get it where it is going. And it's easier for computers to process. But something else happens, too. The way to compress video is to digitize it, turn it into digital sound and picture. Amazingly enough, when you do that the digital video suddenly possesses all the qualities of a digital image. It can be manipulated or accessed randomly. It can be controlled by artificial intelligence. In other words, this whole drive to compress video also gives it the ability to be very interactive. Around 1992, the entertainment industry and all those who supported it decided that this was something they were ready and willing to explore in a very big way.

THE INTERACTIVE TV CABLE TRIALS

In the early 1990s several cable companies and entertainment content providers employed rafts of creative talent to explore the possibilities of adding interactive TV to their lineups. They wanted to find out who would use interactive TV, what it would do to their ratings, and what it would cost to produce.

Even early on in the process it became clear that programming for interactive television could only happen in areas that had more bandwidth than typical neighborhoods. So, regardless of the amount of compression that was done, the trials were held in communities that had been newly outfitted with the latest fiber optic cabling (the Mississippi River of cable). That way the companies sponsoring the trial could test every idea that they came up with without worrying about bandwidth and compression.

A variety of programs were tested, including game shows, local information guides, on-line shopping systems, TV program guides, on-line communication systems, and the most popular ITV product of them all: movies on demand.

Movies on demand are, in the words of the sages at MIT's media lab, "a no-brainer." As slow as pay-per-view cable is to evolve, going to your TV today, browsing through a list of movies, finding the one you want, calling it up at the click of a button, and then having it start at the exact time you ask for has to succeed.

So, movies on demand pretty much became a mainstay of the interactive TV trials. So did interactive program guides. Program guides are just *TV Guide*–like information grids shown on your TV screen. As the current digital cable guides prove, when they are there, people use them. And the more interactive they are, the better. That means that customers need to be able to scroll back and forth through the grid to find the channels they want and the time they

want, and even ask questions that would allow them to learn more about the program.

Interactive shopping was another mainstay of the ITV trials. Think of the Home Shopping Network without the need to pick up the phone. Think of Amazon.com on your TV set with an even simpler interface. Just a few clicks on your remote control and you bought it, baby!

Interactive news was another interesting feature tested in the cable trials. Not only could you program your TV to present the news whenever you want it, but you could edit it so that you would only get information that you are interested in. So, when the next Florida ballot count TV circus came around, you asked your ITV system to show it at the top of each day's news and you'd get it. Or ask that it be completely stricken from your TV and you'd never see it at all. What a feature!

Another benefit of interactive news, as presented in the trials, was that it let you find out your selected, latest sports scores and see highlights of the game whenever you wanted to. The same held true for weather: get just the weather information you want whenever you want it. Full-motion video news, weather, and sports information on demand on your TV screen.

And don't think that local news services and public affairs operations were to be put out of business by ITV. Every major city was to have local information on demand, including local entertainment info. Get a quick video visit to a local restaurant and see close-up shots of today's specials. See what's going on at the downtown hot spots or with the local sports franchises. Find out what movies are playing, what parks and museums are open, and see video clips of all of them. The key to these local info guides was not just that the information was there in highly produced video form; it was that it was interactive and you could search and find the details that you wanted instantly.

ITV game shows were constructed in several different ways. In two of the most common designs, games were created and played locally among members of the community, or they were created so that they were prerecorded nationally, but with all possible outcomes available. As each set of home viewers played along, their scores were recorded and shown on the screen. Moreover, the on-screen participants reacted to the home viewers' answers and scores. In competitive games the home viewers played against the on-screen contestants. "And you, home viewer, you are the winner!"

Interactive television communications services were like transferring the capabilities of on-line chats and bulletin boards to the home TV screen. Want to talk to grandma in upstate New York? Call up the ITV chat and type away. Of course, this feature changed the configuration of the TV set remote control. It had to be a keyboard, and the pursuit of the perfect remote for ITV turned into a long and difficult adventure. Certainly the design of individual TV remotes varied greatly in the ITV trials.

So those are the rather obvious applications of interactive television, and they are really no secret. It is the details of those designs that differentiate them

and make them special. Examples of these concepts have been shown to the public in trials conducted by major media companies in many cities. Most of them are making their way into homes now via digital cable or the Internet.

There is, of course, one very important additional kind of programming that could have been tried in the interactive television trials, but as far as I know was not. That is the interactive story: interactive drama or comedy. Much has been said and will continue to be said about interactive storytelling in this book. For now let's just say that the evolution of the form of the interactive story will probably be like the evolution of the form for the novel, the stage play, the feature film, and the symphony. It is the creation of a major new kind of art, and this fact may explain why ITV developers were so reluctant to experiment with it. The interactive story may very well change the world of entertainment forever. But there also is no doubt that it will be extremely time consuming and expensive to work out.

In the meantime the creation of the simpler forms of ITV were expensive enough. In fact, the creation of ITV programming turned out to be so expensive that many backers of the cable trials decided that it was not even worth continuing the tests. They especially thought this when they realized that the hardware infrastructure needed for nationwide ITV might not be in place for another 10 to 20 years. Almost all of the sponsors of the ITV tests had backed away from them by the mid-1990s. Too bad! What should have come out of those pilots were new forms of programming that pointed the way toward the Bradburyesque future and PlayRooms for all. It didn't quite happen that way.

3

The Internet

I was once told about an intense corporate survival meeting. There, the head of the company told the assembled leaders of his interactive television department why he had decided to walk away from the interactive television projects that they had been working on for three years and head off in a new direction, to develop programming for the Internet.

Attendants at the meeting said that the secret of this manager's sales skills had always been his ability to teach. He understood things so clearly and presented them so well that the sheer clarity of his presentation made people buy his ideas. So it was on this day, to a handful of dedicated people who did not want to have their interactive TV projects shut down, that he began.

His message was simple, and it had only three parts. First, the interactive TV trials that the company had been dedicated to for the past three years were being suspended because the company had decided that the required interactive television infrastructure was not in place and could not be in place for decades to come. Second, anyone working in the interactive TV development group had a job, if they wanted it, in the development of programming for a new on-line medium, the World Wide Web. His third point was the most important of all. Eventually, according to the manager, as the Web evolved and the technology improved, all the ideas, all the concepts they had been working on for interactive TV could be accommodated by the Web itself until, through a slowly evolving process, the World Wide Web would turn into interactive television.

The success of his arguments and the clarity of his reasoning convinced everyone in that room to transfer allegiance and take up the slowed-down, static, and yet popular banner of the Internet.

Six months later everyone in the group had become an experienced Web designer and had work that was published in prominent areas in cyberspace.

The boss, the world's greatest salesman, on the other hand, had long since given up the game and was off to start a new company. Apparently he wasn't able to convince himself of his vision. Too bad, because, in fact, he was absolutely right!

INTERNET CAPABILITIES

The Internet is many things. In its simplest form it is a vast network of computers linked together so that people can share information. Since so many institutions, corporations, and individuals have chosen to put high-quality information "out there" and the information is so good, the Internet has become the world's largest information source . . . the world's largest encyclopedia.

Not all of the information is "good," of course. A lot of it is skewed to the point of view of the people putting up the information. To that end the Internet is both the world's largest forum for public statement and the world's largest billboard. Hype is rampant, but, to the extent that it at least represents the point of view of the publisher of the information, it has value.

Research companies and other promulgators of classified information often charge for the data they provide. If you look up "the future of computer technology" on the Internet, for example, you will find lots of articles and essays. But, if you want the really in-depth stuff, you have to pay for it. Because so many high-quality information providers have chosen to make their reports and periodicals available through the Internet, it can honestly be called the world's largest information service.

It seems logical that more than information can be purchased on the Internet. We all know about companies such as Amazon.com and the books and other goods that they sell. The fact that they have an inventory larger than any brick and mortar store could have has allowed the Internet to become the world's largest retail outlet.

Individual people as well as retail companies have gotten into on-line sales, auctions, and trading. This makes the Internet the world's largest garage sale, maybe even the world's largest marketplace.

People of course do more than exchange goods and services for money. They also like to exchange information and pleasantries, and witty or suggestive remarks. All of which makes the Internet the world's largest medium for personal communication.

And finally, with so many people on-line doing all that researching, communicating, and buying, they might as well *play* there, too. So there is every likelihood that the Web will eventually become the world's largest entertainment medium.

INTERNET ECONOMICS

With all the business and activity going on through the Internet, an interesting question emerges: "What is the best way to make money?" For anyone who's witnessed the short history of the Internet, a better question might be: "Is it possible to make money?"

For a lot of reasons, those are difficult questions to answer. To begin with a book about technology is probably the wrong place to try.

The life cycle of the Internet and the life cycle of a published book are two very different things. The Internet is living, breathing, constantly changing. A book takes years to get into print and then sits out there unchanged forever. The net effect is that anything anyone says in hardcover print about the Internet is now, or will soon be, wrong.

To write about how to make money on the Internet, at a time when no one has figured out how to do it, knowing that by the time the book comes out everyone may very well know exactly how, is courting disaster. Nevertheless, it is a challenge, and it's not a bad way to organize information about the Internet and all that it can be. So here goes.

There are currently only so many ways to make money on the Internet:

- Selling an Internet service that people pay for
- Selling a sponsored Internet service that companies who benefit from the service pay for
- Selling ad space on a Web site that is targeted at the demographic of that site
- Generating data by your site that can be sold to companies who need that data
- Selling products with enough mark-up that they actually pay for the operation of the site

In addition to these ways of actually making money, there are some obvious ways to run a successful business without making money from the operation of the Web site itself. Essentially, that means one of two things. It could mean providing a promotional Web presence for a business that will benefit enough from the Web site to absorb its cost. Or it could mean providing a service that will be paid for by a nonprofit agency whose business is to get the information "out there" in any way possible. In short, these are ways to become successful Web development companies—but they don't make money from the Web, they make money because of the Web.

Now, here are some examples of ways to make money from the Web.

1. Encyclopedia Britannica has a Web site that people subscribe to. If they pay so much a month, they can access Britannica On-line whenever they need it. Britannica On-line is more than a matched set of books because the on-line Web site is constantly updated and has the media enhancements of video, audio, and full-color graphics. As a result, it is a perfect resource for anyone who has a constant need for information. People with that need (and people who have previously purchased encyclopedias) are potential customers. Realizing that there was also much to be gained by a site that promoted and popularized Britannica's position as the world's foremost authority on everything,

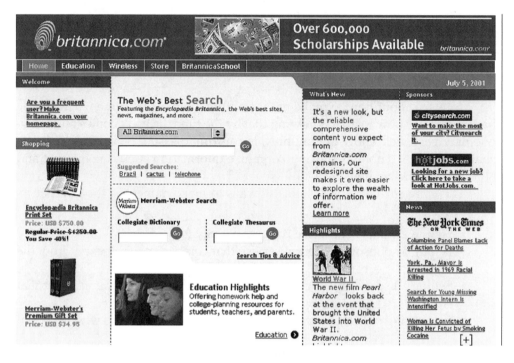

Figure 3.1 The Britannica On-line home page. Reproduced with permission from the Encyclopaedia Britannica © 1998–2000 Britannica.com Inc. All rights reserved.

Britannica expanded its news and pop-culture offerings and became a free information site as well. Figure 3.1 shows the current home page for the *free* Britannica On-line.

If you want another example of a successful subscription Web site, check out The Playboy Cyber Club. And to understand why such sites as Playboy succeed where others fail, check out the write-up in Chapter 18, The Adventure!, which is about entertainment sites.

2. Build.com (Figure 3.2) is an aggregator of services for the home. Real estate agencies, contractors, tool and appliance manufacturers, and other home-building-related companies sponsor it. Its purpose is to help you keep your home as livable as possible. Of course, the benefits to the sponsors occur when you decide to fix up or to sell that highly livable home of yours. They will keep you apprised of the property values in your area, the latest floor plans, and ideas for home improvements. They'll also fill you in on laws related to all that. It should be a synergistic relationship. You get a lot of good information, and the related companies hope that they are planted in your memory at the time you decide to sell your home or fix it up. In the end they get your business. It's a sponsored service paid for by companies who get improved business because of the Web site.

Figure 3.2 The home page from Build.com. Copyright © 1994–2001 Build.com. All rights reserved. Used with permission.

3. The best example of the successful sale of ad space on a Web site is probably the ads that appear on the various search engines. Yahoo.com helps people find the topics they are interested in. That means whenever a person uses Yahoo to conduct a search, the engine knows what they are interested in and thus knows it has a qualified prospect, a person whose very interaction with the Web indicates an interest in a certain product. When I type my favorite topic into Yahoo, I immediately see an ad for a related product. That product might be a book for sale on Amazon.com or a new car that matches my "muscle car" orientation. In any case, it's no coincidence that I have dozens of picture books of muscle cars. An ad for one appears frequently when I do a search on the World Wide Web.

4. Research companies are key practitioners of the "learn the data and make money by selling it" approach to the Internet. Harris Poll has created a Web site for teenagers that asks their opinions on just about everything. The kids have the fun of expressing their opinions on topics that interest them, and Harris gets to sell the results of the surveys.

Moreover, Harris can make even more money by asking the kids if they are interested in participating in a far more detailed, and more salable survey . . . which is made up of the stuff that corporations value most and are willing to pay the most for.

5. I've mentioned that I buy books on-line. The Internet marketers are banking on the fact that the process will become so easy and so valuable that people will spend the money needed to make it a going proposition for them. As of this writing, the stories in the local newspapers tell us that it is not. Very few companies are able to make money by selling products on the Internet. Maybe the competition is too severe. Maybe there are too many companies trying to sell the same thing. The basic premise is a good idea. The enormous inventory is a good thing. The lack of brick and mortar and the current tax breaks that are being afforded to all such businesses are all positive benefits. Why then, at this point in time, is it not working?

One answer may be that the basic economic model is flawed. That, in the end, selling products on-line just costs too much for anyone to make money. But, if you think about it, mail-order catalogs are making money. Shopping channels are making money. Why not the Internet?

Let's go back to our opening story about the meeting of the interactive television designers who became Web site designers. In thinking about that story again, perhaps the most important thing to think about is that the Web in fact is morphing right before our very eyes—and it is morphing into the kinds of things that were planned for interactive television.

However, there is a big difference between the massive audiences that use the Web and the unbelievably massive audiences that watch television. Key to that difference is the computer skills of the users of the Web vs. those of television users. Just about anyone can turn on a TV and watch it for six hours a day. Not everyone is able to log onto the Internet and use it with the same abandon.

For those Web corporations who are wondering why their business projections aren't quite measuring up to the proud targets they set for themselves, perhaps they should consider the disparity in those audience numbers and then revisit some old assumptions about things like ease of use and levels of interactivity.

This is not to say that the Web has not been a massive success, but to add that the overwhelming success that "dot-com companies" currently need to be financially successful cannot come solely from the highly computer-literate. It needs to come from people everywhere, and those people need a technology that has matured to the point where its interactive elements are second nature even to non–computer users.

To put it simply, we should all be experienced enough to realize that the Internet is a work in progress and that the technology is changing so rapidly that

it is hard to know what its final end state will be. However, we do know that that final end state won't be reached until it allows on-line sales, and in fact all forms of on-line transactions, to be more feasible because the built-in barriers to computer use that exist today are no longer there. There will have to be ultra-simple interfaces, faster access to information, a more TV-like presentation of products and services, and public confidence in the security of the credit entry system.

I spent a few years developing interactive shopping kiosks. The goal of our company was to develop a system so simple that non–computer-literate folks, who bumped into the kiosk at the local airport, would find it interesting and easy to use. And so they would be willing to charge up a few hundred dollars over the system at first contact. We knew everything we had to do, but we weren't able to do it, and as a result few people have ever heard the name of our company: ByVideo. Unfortunately for e-commerce, the problems that we faced still need to be solved.

Before ByVideo, I spent quite a few years in the interactive world of ATMs and automated banking, and I shared in the phenomenal success there. That convinced me that the interface problems of basic business transactions *can* be solved.

The same kinds of design problems also need to be solved for the infinitely more complex and fascinating realms of interactive entertainment and distance learning.

Distance Learning

According to the October 30, 2000, issue of *Red Herring* magazine, corporations spent more than $60 billion to educate their employees in 1999. Although only about $300 million of that was spent on distance learning, projections see that expenditure growing to nearly $12 billion by the year 2003. In that same period, instructor-led training will drop from its current level of 71% of all training to 42%, while distance learning will nearly match it as the leading form of corporate training.

Although a good deal of current distance learning is designed to teach computer skills, it is being used increasingly to teach interpersonal skills such as management and customer service, and that trend will continue as distance learning moves into a position of prominence.

Moreover, the trend is not confined to corporations alone. By the year 2003, 85% of all colleges are expected to offer distance learning classes. Couple that with the fact that 98% of all elementary schools are already connected to the Internet, and it becomes clear that distance learning is coming. It may come quietly, but its presence will definitely be felt.

The real question that emerges from these promising predictions, then, is just what form will distance learning take, and how effective will it be?

In the five years I spent at Apple Computer, I was able to do a great deal of work in the area of distance learning. That work still seems very relevant today. My first experience occurred during my stint as marketing manager for consumer new technology. I had to manage relationships with several important and emerging product development groups, among them a new on-line service that was to be modeled after Apple's internal networking service, which was called AppleLink. AppleLink was basically an e-mail service with bulletin boards about important Apple issues, employee want ads, and background databases about Apple products, services, and employee benefits. The commercial version of that service that was to be launched for the Apple II was code-named Commercial AppleLink. The developer was hard at work on a Macintosh version of the product about the time that Commercial AppleLink was launched.

Right about then Apple dissolved its Consumer Marketing Division. I ended up head of the Learning Technologies Group, and Commercial AppleLink

disappeared from my radar. My understanding is that it was eventually relaunched under a new name: America On-Line.

One of the key projects I had been charged with for Commercial AppleLink had to do with coming up with a model for an on-line, educational product. In other words, distance learning.

As with many Apple efforts, my job was to build a model that would show future developers how to put our technology to its best use. The prototype we created had the features that I feel all distance learning courses must have. Unfortunately, many of these features are missing from distance learning courses today.

A DISTANCE LEARNING PARADIGM

Our distance learning course was in college-level marketing. We thought that to be a very good place to start. The content was supplied by one of the most popular marketing textbooks available at the time. The essential structure of the course, then, was reading from the textbook according to one of several tracks that could be taken through the course. The tracks allowed students to skip some chapters in order to emphasize others. It was very much like the illustrations in Chapter 13 on Basic Structure.

The general structure of each lesson followed the basic instructional design that is also presented in Chapter 13 of this book. There was a demonstration followed by a set of exercises. Together, the demonstration and the exercises made up a lesson.

Our model was to have students read from the appropriate chapter of the textbook and then do the exercises on-line. Rather than referring them back to the book for remediation, we built the remediation into the exercise. So the exercise parts of the lessons were very complete in themselves. In fact, it soon became clear that one inductive way to take the lesson was to have students simply skip the reading and go directly to the exercises, which often provided enough information to teach the concepts on their own. The entire lesson was followed by a test, which had the usual "pass or start-over" consequences.

A very important point to be made here is that the demonstration did not have to be reading. It could be a lecture or a video demo. The key ingredient in the paradigm was the exercise.

The prototype came along nicely and was about half done when Apple, as noted, decided that they did not want to be in the consumer marketing business. The rest is very unfortunate history. Nevertheless, the basic design for a distance learning course that we devised at Apple still makes sense today, as you will see as you read on.

INDIANA JONES

My next experience with distance learning at Apple occurred when I found myself searching for an ideal way to provide management training to the highest-ranking officers of the company. The project that I started up with Apple's Advanced Technology Group was code-named Indiana Jones. Now, because we were dealing with the highest-level brass of the company, we decided to lower the big gun of educational resource, which in that case was on-line instruction featuring a really famous lecturer. The idea was, and still is, that there are millions of ways to present a lesson, and history had taught us that certainly one of the very best ways is through a world-class instructor.

Our proposed speaker was Tom Peters, the famous futurist, who unbeknownst to him was being designed into the center of a distance learning class that would air every morning via a very advanced multimedia computer delivery system that was to be built just for that purpose. Peters would lecture the brass of Apple Computer, take questions from them on-line, respond via live video, and then leave a video version of his lecture to be reviewed by the participants at a later date if they wanted to. In the meantime, relevant activities, including group discussions and, most notably, learning exercises similar to those that will be discussed in Chapter 15, were built into the model. The project was to be a test of distance learning concepts, but at the same time it was a real test of our media delivery capabilities as well. The year was 1989.

In any event, a reorganization came along and killed that project as well, but the model of building live lecturers into a distance learning system that still includes computer-based exercises and on-line discussion still holds today as a very good way to do distance learning.

DESKTOP SEMINARS

My final foray into distance learning at Apple came when Apple introduced QuickTime. My team and I were charged with putting together a format for teaching people what QuickTime was and how it worked. Our solution was something that I dubbed the Desktop Seminar. Desktop Seminars were essentially lessons following the models that we will be discussing throughout this book. The demonstration part of the lessons was presented as elaborate animation via CD-ROM with exercises done in HyperCard and the fledgling QuickTime technology. An important adjunct to the format was that there were to be weekly live lectures and discussions, scheduled at a regular time and delivered via the Internet. Since the Internet had barely gotten off the ground, it was a daring plan with back-up versions that offered the lectures and discussions via telephone.

On-line delivery of tests with related scoring and certification completed the picture. The Apple Desktop Seminar was introduced at MacWorld in San Francisco. Its introductory offering was a great success, and subsequent versions created a shell through which users could develop their own Desktop Seminars using tools that were part of the Desktop Seminar Toolkit. Use of the toolkit and the format we created became standard operating procedure in many training departments for years to come.

THE CLASSIC DISTANCE LEARNING MODEL

What do my three Apple examples have in common with each other, but not with much that passes for distance learning today? They presented a demonstration in the best way possible (lecture, video, etc., etc.), and then they followed that demo with very strong learning exercises that took full advantage of the strengths of interactive technology. Tests were done on-line and sent to a central scoring area for final pass/fail evaluation.

Even today you can scroll through mountains of courseware presented by universities, schools, corporations, and distance learning companies, and in most cases you will find on-line demonstrations, on-line discussions, and on-line testing. The tragedy is that far too seldom will you find on-line learning exercises. Using a computer-based system to deliver learning and then leaving out one of the things that computers do best is like going to a concert where the violin section does nothing but pluck the strings at the appropriate moment. Sure, they can do it, but violins are capable of so much more. Sure, computers can deliver textbook pages, or streaming video lectures, or audio lectures, but if they don't deliver interactive exercises based on the behavior to be learned, they aren't really doing what they do best. Fortunately, there are some commercial systems that allow the incorporation of all the features we will be talking about in this book.

CURRENT APPLICATIONS OF THE DISTANCE LEARNING MODEL

Click2Learn (Figure 4.1) is a company dedicated to encouraging the development of high-level distance learning products either through direct consultation or through the use of its primary development tool, ToolBook II. ToolBook II Assistant is a development program that enables the easy creation of distance learning products that fit the mode we will be talking about in this book, including the all-important learning exercises that we will be describing.

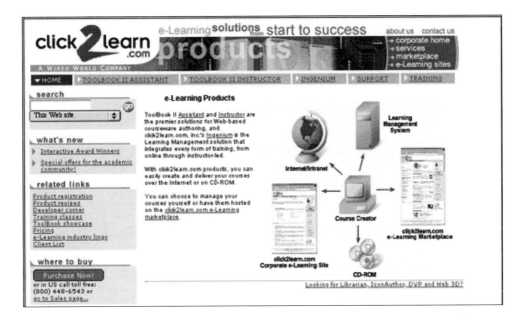

Figure 4.1 The Click2Learn Products Page that shows the benefits of Click2Learn's e-learning products, most notably ToolBook II Assistant. © 2000 click2learn.com, Inc. All rights reserved. Used with permission.

EXERCISES AS THE KEY TO DISTANCE LEARNING

Well-constructed, fully tested learning exercises are the key to effective distance learning. Make no mistake about that. The ability of the computer to simulate systems, situations, and activities gives learners a realistic world in which to practice, and realistic practice is the element that allows learners to apply the skills and to learn them. But there is more.

When the exercise is big enough, good enough, and complete enough, it becomes more than learning. It becomes an entire experience unto itself. A major, well-constructed distance learning exercise actually becomes an adventure. And adventures are the stuff of entertainment. There are more than a few respected futurists who predict that the convergence of entertainment and education is where the future of distance learning truly lies. (Not to mention the future of all the profits expected to accompany it.) That is why it is only natural that we should follow this introduction to distance learning with a discussion of interactive entertainment, which at least in its highest current form is the interactive game.

Interactive Games

In their 1999 annual report, Electronic Arts describes the electronic entertainment business, that is, the interactive game business, as a $15 billion market. That market is made up of three kinds of interactive game products: CD-ROM games that are played primarily on personal computers, console games that are played on devices such as the Sony PlayStation and the Sega DreamQuest, and Internet games.

Of the three kinds of game formats, console games account for two-thirds of all products, with the PlayStation, as of this writing, accounting for 70% of that market. The PlayStation 2, which is expected to continue Sony's market dominance, is equipped to offer DVD video, Internet capability, and access to video, audio, and other cable services. In other words, it is positioning itself to become the hub of home entertainment.

All that having been said, it is still important to remember that the PlayStation is, beyond all else, a game machine, and the expansive world of interactive entertainment that it will eventually open up begins as a game world.

So what are the primary characteristics of interactive games, and do they portend the future world of interactive entertainment?

Well, let's look at the interactive games that have evolved to this point and see where they are heading.

CHARACTERISTICS OF THE GREATEST CD-ROM GAMES

There is no doubt that *Myst* (Figure 5.1), the fantasy game that first came out in 1993 and remains a bestseller today, is still one of the definitive works in the genre. For one thing it defies culture and gender; it is popular with everyone. Moreover, it really doesn't require a special set of skills to play. Patience and attention to detail are more important than the ability to react quickly to sensori-motor stimuli.

Myst is more an abstract experience than anything else. It uses magnificent graphics, animation, and small amounts of well-placed video. Perhaps, most important of all, *Myst* takes full advantage of the sound capabilities of CD-ROM

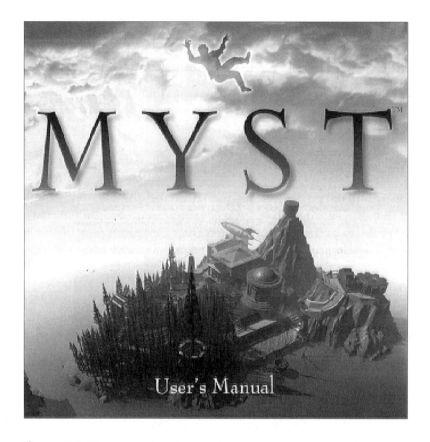

Figure 5.1 The game *Myst*. © 1993 Cyan Inc. Image from *Myst®*, Cyan Inc.

to create a feeling that is often as frightening as any of its more horrific counterparts.

The sound, the color, the music, and the extremely high-quality art all combine to give the user the intense feeling that they are entirely, entirely alone. As you play the game, that sense of "aloneness" sometimes seems reassuring. (You're so alone you begin to feel that nothing can harm you.) But at other times your aloneness makes you feel frightened or even desperate.

There is already a feeling among some game designers that this kind of cross-cultural success may not ever happen again, at least not in the same way. Certainly it didn't for *Riven*, the much-anticipated successor to *Myst*.

But surely there are hints in the success of *Myst* that can point the way toward other future multimedia masterpieces. One of the most amazing secrets of *Myst* is that its roots tap into a quality that the most successful interactive video games all share. They are all addictive.

Think about it! If you have played *Myst*, you know how many hours you had to put in just to get inside the spaceship. You asked your friends for advice, got hints, and you still needed hours. Why did you keep playing? It is the addictive quality that the designers of *Myst*, and of all good games, have tapped that keeps you awake into the night until you find that it's morning and you haven't gotten any sleep at all.

What is addictive about games, and how can that quality be translated to the other worlds of interactive media? A few key characteristics of addictive games are:

- *The environment.* After all, this is where the game takes place and hence what it is all about. Giving you a location in which to play lies at the heart of games. This was the major function of Bradbury's PlayRoom: to create an environment, so you can see how central it is. There are those who say that using game simulators to create massive private, home environments in which to spend an evening is one sure future use of home interactive games. As graphics become more realistic and 3D movement through that space becomes more natural, just moving around becomes very enjoyable . . . for a while.

- *Playability.* This is determined by the feeling of control the player has, the ability to move a character through space, and the concentration required to do so. Think of Lara Croft (in *Tomb Raider*), the excellent style of her movements, and their less than excellent link to the cursor keys and the space bar. Much of the hype relating to PlayStation 2 focuses on its improved playability response.

- *Quantity and quality of the interactions.* What are you doing? How often do you do it? What is the essence of the interaction? Does the variety of the interactions make the world seem boundless? Are the interactions immersive? Game designers tell me that this, more than anything else, is what you get hooked on. So, to go back to the *Knockout Kings* game that we described at the start of this book, interactions are the kinds of punches you throw, how you throw them, and the effect they have on your opponent. Their quality is determined by your ability to master them and see that they have an effect. Interactions also include your defensive maneuvers and their ability to save you from getting beaten. In the case of *Knockout Kings*, the moves are based on the tactics of real professional boxers, and there are dozens of them . . . quality and quantity.

- *Interface design.* How you get things done within the interactive space—the less complex the better, but it has to be as complete and as good as the best interface designs out there because the mass of players will compare your interface to all the others and expect the same functionality they are used to in the genre and even more. Do it better, faster, and

more efficiently. It has to be intelligently automated. The quality of the user interface (UI) is judged by its ease of use against the breadth and depth of the activities it controls. If a player has to think about the UI beyond the first play session, it breaks the immersion and is a poor tool for interaction. Also, it should be language-independent, offering the ability to navigate without words or text instructions. An interface that can do that offers worldwide accessibility.

- *Levels of play.* Is there a place you can go to after you succeed at the first level—a world, an episode, another chapter? Are there things you can do after you master this locale and this set of requirements? Once players have learned a set of skills, they want to apply them in new situations. Elevating a game to other levels has long been a secret of good game design. Hidden levels are key, as are bonus points for exploration, short-cuts, and doing more than you're asked to do.

- *Replayability.* Is there a branching storyline with a variety of strategies to complete the game? If you were to play it again from start to finish, how different would it be? Does it reward you uniquely for a different style of play? Will your friend share the experience exactly or with much difference? If it gives you something to socialize about and compare notes, that's a good thing. What happens when you go back to an old locale in your game? Do you find it affected by your progress in the rest of the game? Have people and places changed? Have they grown older, moved around? Replayability gives a game a great sense of realism.

- *Character growth and development.* This is the most important thing in games today. Do you feel progress evolving your character over the course of the game? Are there a variety of ways and strategies to develop your character during gameplay (e.g., gain items, increase in skill and experience, become more powerful visually)?

So, if it is possible to learn general lessons about interactive design from games such as *Myst* and apply them to other kinds of interactive applications, they probably grow out of that short list of characteristics we have just described. Designers of interactive digital entertainment should make sure that their stories contain a rich environment and meaningful interactions over which the players have a feeling of control. They also need to create and present an interface that is simple, complete, and functional. Finally, they need to build interactive designs that offer progressive levels so players can experience a sense of growth and progress.

There might not be much argument about our ability to learn interactive design lessons for games such as *Myst*, but in fact, there are also lessons to be learned in the nonstop action world of teenage boys and their "shoot-'em-up" adventures. What are they? To find out, let's take a look at one of the most successful action strategy games.

COMMAND & CONQUER

"World domination in a box!" The *Command & Conquer* series of realtime strategy games may be very fast-paced and its objectives may seem a little primitive, but they are easy enough to understand: "build bases, muster forces, lactate your enemy." (See Figure 5.2.)

Command & Conquer is a real-time, 3D battle game. The game is all about control of the earth's most valuable mineral, tiberium. "In a world where covert surveillance reigns supreme and savage combat is the norm, players have to take sides in an all-out race for global control." Or so says the *Command & Conquer* Web site.

Which side do players choose? It just depends on how nasty they want to be. They can side with the humanistic GDI or the cruel Brotherhood of Nod. But in the end, no matter whom they side with, they'll have to be "aggressive without mercy, because their enemies certainly will be!"

Everyone I talk with about action games tells me this is one of the very best. What is it about *Command & Conquer* that they feel sets it apart? Certainly the quality of the 3D graphics is critical, but so, too, is the use of audio and

Figure 5.2 *Command & Conquer.* Copyright © 1996 Westwood Studios, Inc. All rights reserved. Command & Conquer is a registered trademark, and Westwood Studios is a trademark of Westwood Studios, Inc.

animation; and, of course, there is the basic functionality: the realistic environment, playability, interaction, interface design, and levels of play.

Is there a general lesson in such games for interactive designers? One article in *Entertainment Weekly* magazine thought not. The writer suggested that action games such as *Command & Conquer* appeal to an increasingly highly skilled set of game players whose attention span is so brief and whose focus is so mercurial that trying to generalize from their interests to that of the mass population is a waste of time.

I don't think so. First of all, the same rules that we listed that worked so well in *Myst* still work for interactive television and action games. Moreover, action games, more than any other kind of game, are about pacing, and pacing, as any good movie buff will tell you, is critical to all of the lively arts.

If there is anything wrong with *Myst*, it is its lack of pacing. It is almost a static, lost world, and so its pacing is naturally the pace of the users who are feeling their way around. I'm not saying that all games should operate with the breakneck speed of *Command & Conquer*, but the pace of a game, like the pace of a narrative, is at the core of what they are. Let's also be clear about this: the pace of the game is determined by several things, such as the music that is playing in the background, or the responsiveness and mobility of the player. But more than anything else, the pace is determined by the beats between the interactions . . . the number of interactions per second. Watching some frantic game player wildly pound a button on a PlayStation gives you the sense that realistic control is irrelevant. For the masses, at least, the control of individual interactions will have to be much more deliberate and realistic.

MULTIPLAYER GAMES

Massively multiplayer games are solely the domain of the Internet. Nowhere else can you engage your skills with dozens, hundreds, even thousands of other players in the same game space.

In the current crop of PC CD-ROM and console games, the computer is called upon to create opponents for you, the personalities and the situations that you, as a player must come up against. The computer's ability to create personalities for you to play against is done through artificial intelligence (AI).

In some on-line games, users send messages to fictitious characters and the computer generates responses based on word recognition and other factors. The problem is, as games get more and more complex and the skills of the players increase, the ability of AI to provide realistic characters and meaningful responses falls further and further short of the task. Alone, AI has not been able to generate the kinds of opponents that feel entirely real and worthy. AI has not been able to come up with the answers that respond to every nuance of every question. And those of us who are completely addicted to games know it.

The solution, of course, is multiplayer games, where the opponent is not the machine, but other living, breathing players who can outmaneuver you and out-think you.

If you have played both AI games and multiplayer games, you know that there is just no comparison. A multiplayer game just feels more natural. Or to put it another way, people do things that computers would just never think of doing. Feelings enter into the way the game is played.

The next generation of games will be multiplayer games, whose graphics and audio may reside on CD-ROM or DVD or on your hard drive, but whose interactions take place on the Internet, where thousands of participants add personality, creative thought, and even the necessary percentage of chaos to the mix. In fact, that next generation of interactive games is already here.

MASSIVELY MULTIPLAYER ONLINE GAMES

Perhaps the first great on-line game success, *Ultima Online* has more than 120,000 players, each paying $10 a month to play. Of course, the game is constantly being updated and has fairly hefty maintenance requirements. Nevertheless, those are the kinds of numbers that seem quite successful.

Another entry in the massively multiplayer game field, Sony's *EverQuest*, is already far more successful than *Ultima Online*. One big difference is EQ's 3D graphics. *EverQuest* (Figure 5.3) follows the format for the current generation of multiplayer games. It begins with a persistent-state world that people can explore. Of course, before players can start to roam, they need an identity. So they choose their species, their look, their skills, their costume, their weapons, and they set off on their adventure.

Adventure means danger, and in exploring the worlds of *EverQuest* (there are many continents) players can encounter assorted beasts, ogres, and enemies whose mission is more often to kill them than to help them. So the adventure is one of survival as well as exploration. The good news is that, as the exploration goes on and players become more and more successful, they build skills and acquire wealth, weapons, and magic. This is exactly what I mean when I mention "character growth and development." The fact that it is "persistent," or will always remain until you stop paying your $10 a month, makes it 100 times more addictive than other types of games.

Do the character development aspect and the content of *EverQuest* sound like *Dungeons and Dragons*? Well, it is like that classic game, especially because there are those other players and AI characters out there roaming the realms, and they have their own agendas. They may let you join their band, or gang up on you. Conversations with real people add a lot of new twists. This game almost never allows players to kill each other unless they are signed up on a server that is player vs. player. So EQ is almost entirely a cooperative game experience. Its teams of humans "hack and slash" the AI characters.

Figure 5.3 Screen shot from *EverQuest*.

Soon you will be able to do battle, form alliances, build empires, all the cool stuff that games are made of, while planning and scheming with your allies and plotting against your opponents. Your character becomes more and more you. The opponents you are facing become more and more them. And "them" are real because it is real people, people you can chat with, people you can strategize with and against, people you can outwit or who can outwit you.

The future of the most advanced games is sure to go in this direction. It combines the best of graphic elements with the interpersonal powers of the Internet. People can retain the anonymity that is so much fun, they can play roles, and they can have all the action they want.

It is the process of immersing real people in fantasy interactions that will lead to the next generation of games and experiences beyond games: high-level simulations involving real people, experiences that immerse people in whole other worlds. Wasn't that what Ray Bradbury's PlayRoom was all about?

The virtual immersive experience may be a long way off technologically, but we are already building the elements that will make it happen. We are evolving all the little strands that will someday allow us to weave our own PlayRoom (Ray Bradbury), Holodeck (*Star Trek*), or Matrix (William Gibson).

Interactive Experiences

If computers and the Internet will eventually contribute to any major architectural trend, it will be the reduction of bricks and mortar in the world. There may soon be fewer banks because people can bank on-line. Stores can be smaller or may not have to exist in as many locations because on-line shopping is reducing the need for bookstores, clothing stores, and even grocery stores.

One marketing effort that is running counter to this trend is the expansion of the interactive experience. Sure you can play *Ultima OnLine* and have adventures in a world of sword and sorcery through your computer. But a whole other way to do it is to go to an interactive location that uses the latest technology to place you in a whole other world that you can move around in physically.

Makes you think of Disneyland, right? Yes, it does.

A whole new generation of attractions that are brick and mortar is emerging, at least to the extent that these attractions have actual physical locations. The difference is that they are not housed inside enormous amusement parks like Disneyland. They exist on their own, on street corners in San Francisco, or more likely in tourist meccas such as Fisherman's Wharf.

One example of this kind of attraction is Paramount's Star Trek Experience that is currently featured at the Las Vegas Hilton hotel (Figure 6.1).

Customers go through a long preshow adventure that sets the mood, sets the stage, and accommodates the long lines that are still forming for the attraction. Once inside the ride, participants take their seats and are lurched into virtual space by the enormous hydraulic pods that gyrate the ship's cabin. An enormous screen makes them feel that they are boldly rocketing where no one has rocketed before.

It is then that they learn that the whole ride has been abducted from the 20th century. Starfleet intelligence reports that the dreaded Klingons have learned that one person on the ride is an early ancestor of Capt. Jean-Luc Picard. If the Klingons can wipe out that ancestor, Captain Picard—their nemesis—will never be born.

Needless to say, the entire audience is in mortal danger. However, the Federation has interrupted the Klingons' attempt to seize the audience and has beamed them onto the starship *Enterprise*. If the crew of the starship can safely return everyone to the early 21st century, everything will be fine. However,

Figure 6.1 Artist's conception of the Star Trek Experience at the Hilton in Las Vegas. TM & ©2001 Paramount Pictures. All rights reserved.

at that very moment, a fleet of Klingon vessels is in hot pursuit and doing everything in their power to destroy the starship and its passengers. From that point on, all kinds of intergalactic hell breaks loose, and the audience is launched into one of the wildest rides in the history of movies, television, or virtual reality.

You've seen rides like this at Disneyland, at the World's Fair, and at one or two of the great museums and science centers of the world. Again, what's unique about the Star Trek Experience, other than the quality of the experience and the fine detail of its story, is that it is not *in* an amusement park, a world's fair, or a science center. It is a stand-alone attraction at a hotel.

Many prognosticators are pointing to the day when such attractions will exist as part of theater complexes and shopping malls all across the country. They will be especially common in themed locations that bring together shops, restaurants, theaters, and experiences into a single tourist destination. Fortunately, for me anyway, the premier example of such an attraction already exists in my local megalopolis of San Francisco.

SONY'S METREON

This "Sony Metreon" is located on one very large city block right in downtown San Francisco. It is right on the edge of the Moscone Convention Center. The Metreon is four floors mostly dedicated to the high-tech experience. The first

floor is largely shops and restaurants featuring Starbucks, Jillians, Longlife Noodle Co., and other cafes. There, stores feature a gigantic PlayStation emporium and a shop called Sony Style, which features displays of every kind of Sony media product from the largest TVs to the smallest Walkmans.

Go up a floor and there are more stores. A Microsoft Shop with unlimited software selections. But now add in *The Way Things Work*, a very funny 3D movie about the evolution of machines. It is based on the efforts of architect/illustrator David Macaulay, an assortment of cave people, and one exasperated woolly mammoth. It is presented by Mercury automobiles. Across the escalators, the Airtight Garage is a giant video gaming center set in the world of legendary French comic book artist Jean Moebius Giraud.

On the third floor there is a suite of the newest, most comfortable movie theaters, including a Sony IMAX theater (an eight-story view of the world) showing a rotating series of IMAX features.

One story up and you would expect to find the crown jewel of the Metreon, and that is just what you *do* find. *Where the Wild Things Are* is your virtual experience. "A larger than life play space re-created from the illustrations of Maurice Sendak's renowned children's book." To quote the Metreon brochure, "In this dream-come-true rumpus room, you can make flowers spin and birds drop, swoosh down a tree slide, control a seventeen foot tall Wild Thing Puppet, run around in a crazy hall of mirrors and more." Where the Wild Things Are (Figures 6.2 and 6.3) is an enormous area that provides all the fun that giant sets of building blocks and pulleys and levers will allow. It also cries out for all that new media technologies will be able to deliver, including holographic images, surround-sound music, interactive computer displays, and virtual characters.

What's great is that the Metreon exists *now* as a massive prototype of the virtual experience of the future. It shows us exactly what can be done and what should be done to maximize this great idea. The next generation of virtual experiences will use more technology and fewer mechanics. They'll deliver more because they can use virtuality, which costs less. A high-tech layer on top of the Metreon would give this already wonderful experience an even richer cast. It would also show how smaller, Metreon-like centers can be created all over the world.

Even now advances in presentation technology have reduced the cost of creating such experiences. The $20 million price tag that is currently only applied to typical Disneyland- and World's-Fair-class rides is coming down. And it is allowing the expansion of this venue of entertainment.

The evolution that you will probably see is virtual experiences being added to venues that currently only feature movie theaters, shops, and restaurants. They will also move into museums and science centers and bring newer, more elaborate attractions to locations that could not previously afford them.

Although there is a vast payoff in the social aspects of these experiences, which make them great as date and family entertainment locations, it is clear that eventually they will be able to move into the individual home, where

Figure 6.2 Where the Wild Things Are at Metreon—A Sony Entertainment Center in San Francisco. Photograph © Virginia Iuppa, 2001.

Figure 6.3 The author prepares to whack a Wild Thing, at Where the Wild Things Are at Metreon—A Sony Entertainment Center in San Francisco. Photograph © Virginia Iuppa, 2001.

your home theater will eventually become much, much more. It will become the PlayRoom, the Holodeck, and the new art and entertainment forms of the future.

Now that we've taken a quick look at all the different uses of interactive media, it's time for a slower, step-by-step review of all the elements of all the technologies that make media interactive. Our purpose (again) is to train designers to create interactive experiences. There will be a lot of attention paid to the Internet where so much is happening today. We will also look at those forms of training, entertainment, and sales where interactions and transactions occur as a matter of course. But we should also consider the process that goes into conceiving, designing, and selling interactive products. Let's begin!

Creating Interactive Products

The Process

For the purposes of this part of the book, we are going to assume that your goal is to create an interactive product that you are going to sell.

We have briefly overviewed the categories of interactive products that exist. They are gaming and entertainment, information, commerce, and distance learning. The products can be delivered on the Internet, via CD-ROM, or on DVD, and eventually they will be delivered by entirely new presentation systems such as handheld devices, interactive television, and location base experiences.

Surprisingly enough, the method for creating the product and starting the business to launch the product are remarkably similar for most interactive businesses. So this chapter will serve as a brief overview for all you would-be entrepreneurs, as well as an organizer for those of you who are new to these processes and may not realize all that is involved.

The process of creating and launching an interactive product generally follows these steps:

1. Concept development
2. Funds acquisition
3. Product design
4. Interface design
5. Design documentation
6. Prototyping
7. Product production
8. Product launch
9. Product maintenance
10. Product updating

This is absolutely *not* a primer on funds acquisition. If you are a creative development type, the best answer to that need is find someone who knows how. Or to buy a different book. However, since part of the funds acquisition step is being able to present the product concept to potential investors, clients, or sponsors in the strongest possible way, we do need to address the development of sales presentation documents. These are differentiated from design documents and functional specifications that are used to gain bids from vendors who will

work on part of your product. Those documents will need to be much more detailed, and their focus is different. Sales presentation documents sell with feature/benefit statements. Specifications go into details that will turn off potential investors, but are absolutely essential for accurate bidding and for the process of creating the product.

CONCEPT DEVELOPMENT

This is probably the one step in the process that needs very little definition, or maybe can't be very well defined.

Where do you get the great idea that will become your interactive product? I won't comment on that. You've read what I have said in the previous section about interactive product categories and their possibilities. Somewhere between doing your daily job, moments of Zen meditation, going to church, cutting the grass, shoveling the snow, watching TV, shopping, or just general conversation, you get an idea. And the more you think about your idea, the more you realize how great it is and that it could work.

That's not enough!

You have to go at least one step further. You have to flesh out the idea enough so that people will understand it, see its potential. Only then can they invest in it, buy the idea, or somehow provide you with the money or at least the room to create it.

So brainstorm your concept. Have the fun (and it is fun) of thinking it through, talking it over with close and trusted friends or colleagues. Work out the details. Organize it logically. Have someone play devil's advocate. See where the bugs and the fallacies are in the idea and work through them. Is it still a great idea? It may very well be. We are going to assume that it is.

What you will have done over a period of days or months is to develop a concept.

The first *document* that is usually created in the evolution of an interactive product is called the concept statement. Once you've had your brainstorming sessions and two or three or seven people have talked through their view of the idea, making notes on napkins, and drawing rough flowcharts on white boards, someone will have to articulate the idea. The document that comes out of that effort is the concept statement.

Occasionally, the concept statement may not really exist on paper; it may exist only in the producer or designer's head and be presented in sort of a live dramatic storytelling. This is very much how it happens in Hollywood these days, at least for those producers who have reached a high enough level to be able to get directly in front of the right people.

Because a riveting storyteller is still one of the best presentation tools in the world, having the concept exist only as a well-rehearsed but still unwritten idea is a reasonable way to go. It is very dramatic. It also lessens the chances of having

the idea stolen. Of course, no matter how good the presenter and how much interest he or she generates in the idea, eventually someone is going to insist that the idea be written down. So sooner or later you will be faced with the task of creating a written concept statement anyway.

Here's my advice on that. Make it short, but make sure that it is complete. One paragraph may not be enough; six pages is way too much. Think about the essence of the product and what is interesting, unique, and exciting about it, and write that into your first sentence. Think about the interactions—what role the user plays—and include this element in the statement. Consider the benefits to the company (if you are presenting it to your company) or to outside investors. Then keep going until you've said everything that it takes to get the concept across. Don't make the mistake of thinking that a page and a half of cryptic notes that are clear to you will be complete enough to sell your idea. Consider whether or not you are supplying 60 percent of the vision out of your own head. Maybe, without that part of the vision, the picture is incomplete.

Headlines work well to break out the main points and provide an overview for the casual reader. Once you have a draft, rewrite and rewrite until the concept is crystal clear. Shorten in the process, too; don't ramble. Whenever you have two sentences that basically say similar things, take one of them out, or at least combine them. When the concept statement is down to a few pages, you're there.

It's possible that you may be able to run out and get funding right away with a concept statement alone. Probably not, but it is possible. Most venture capital firms, business partners, or even corporate sponsors insist on much, much more. Specifically they want a business plan, and that's bad news. A business plan is one heck of a lot of work. But then if you are asking for a lot of money, you should expect to have to do a lot of work.

THE BUSINESS PLAN

You can read magazine articles, take courses, and even get degrees in business plan development. It is a laborious process that can take six months to a year.

Here are some general topics that have to be included in a business plan.

- *Vision statement.* What is your very best description of the concept, stated in ways that show how really great it is? What benefits will it offer your investors or your company? Sort of a condensed concept statement with a little broader scope to make sure everyone gets all the possibilities.
- *Development history (if any).* What is the history of the development of the concept and related products in your company or companies you have worked for or companies that develop similar products?

- *The market for the concept.* Here is where the hard work comes in, because to know the market for the concept you have to do research. Who are the customers? What products are out there now? What are the economics of the current marketplace? What differentiates your product concept from what exists now? How will it be able to make money in the face of the competition? What is the market opportunity for you? Unfortunately, the answers to these questions exist in market research reports, many of which cost money to be able to read. If your company has access to them, read them. The good news is that even if they don't or you can't, you at least have a chance to learn how great a research tool the Internet can be. Promotional Web sites for the very products you will be competing against offer good information. Professional societies, even if you don't join them, publish reports that will have valuable content. News sources will present the latest information on product trends. So the market research phase of the report, although still difficult to create, will at least be doable.
- *The organization required.* What is the organization you will need to make your product a reality? What are the combined salaries of the people who will work on it, plus all the equipment and office space needed to house them? Maybe if you are lucky, it will be you, your spouse, and your best friend working out of your family room. Maybe you'll all work for mere sustenance for a year. Inside a corporation the personnel and finance people have the kind of numbers you will need and can put them together for you once your boss says that he or she is willing to review your business plan. How long will it take to pull the team together? When can it have a product ready?
- *The economic model.* Based on the market research you have done, what is the economic model for your product—the projected cost and revenue? How and why will income grow over the upcoming years?

Sounds formidable, right? Better find a friend with an MBA. If you have to do it yourself, there is one very good shortcut that I can recommend. It may exist right on your computer now.

Microsoft® PowerPoint®, the presentation tool, contains templates for organizing content. And it provides an excellent template for a business plan. To get to the template, go to the auto content wizard in PowerPoint and select "business plan" from the list of possible presentation types. Answer the questions on the slides; Microsoft's template has 12 categories, and of course you can dedicate more than one slide to each topic. Then, presto, you have a business plan.

Well, not quite presto of course, because, as I have said, the business plan template requires information that takes research and planning. Several of the key slides from the Microsoft template are duplicated in Figures 7.1 and 7.2.

Mission Statement

▼ A clear statement of your company's long-term mission. Try to use words that will help direct the growth of your company, but be as concise as possible.

7/5/01

Figure 7.1 The Mission Statement template from Microsoft PowerPoint. Screen shots reprinted by permission from Microsoft Corporation. Copyright ©1987–1998 Microsoft Corporation. All rights reserved.

Market Summary

▼ Market Past, Present, & Future
 – Review those changes in market share, leadership, players, market shifts, costs, pricing, or competition that provide the opportunity for your company's success.

7/5/01

Figure 7.2 The Market Summary template from Microsoft PowerPoint. Screen shots reprinted by permission from Microsoft Corporation. Copyright © 1987–1998 Micorsoft Corporation. All rights reserved.

Business plans are pretty much required for launching an interactive company. If you propose setting up a new venture within the company you currently work for, you will still need a business plan.

If, on the other hand, you are proposing an interactive product for an outside client and you are really not talking about starting a new venture, then you may not have to go that far. What you will then need is a sales presentation, which of course requires its own documentation.

THE SALES PRESENTATION DOCUMENT

The sales presentation document contains the concept statement (now boiled down to key points), plus all the information that your client will want to know about the project. That is, what will it do for me, which customers or clients of mine will it reach, how much will it cost, when will it be done?

Here's an outline of a typical sales presentation document:

Title page, with graphic
Objectives of the program
Benefits to the sponsor
Demographics of the target audience
Concept statement
Description of the interactivity
Definition of the look and feel
Background on key development players
Timeline and budget considerations

The ideal length for a sales presentation document is no more than 10 large-type, bulleted pages. That form is great for the prospective buyer of the concept and for the seller as well. Having been on the receiving end of sales presentations, I know that 40- to 60-page sales presentations in 9-point, single-spaced type are usually rejected based on the form of the presentation alone. An even better approach than a printed sales presentation is a computer-projected presentation using an application such as Microsoft PowerPoint.

As it comes time to give the sales presentation to the prospective client, rehearse so that you are ready to do the job well. Then call ahead and make sure that the client's office or the facility where the meeting will be held is capable of showing your presentation. Just to be safe, print out the presentation, too. You can fall back on the printed copy if the equipment isn't there or won't work for some reason. You can also use the printed presentation as a handout.

The sales presentation has to be fully formed and worked out. If it isn't, you won't get past the first meeting. Figures 7.3 and 7.4 show two frames from a PowerPoint sales presentation that attempts to sell a mythical Web site designed to support an equally mythical television series. Presentations similar

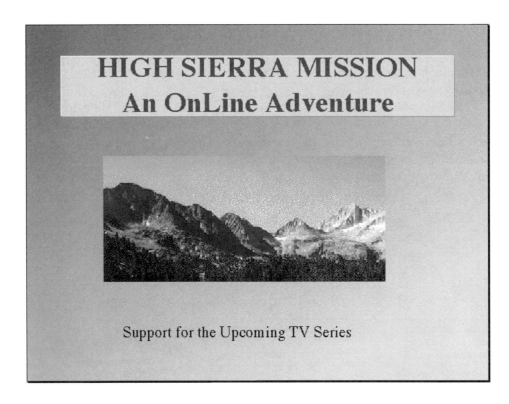

Figure 7.3 Title Page of PowerPoint Presentation.

Objectives

- Give users a chance to share in the adventure by becoming part of the team chosen for the High Sierra Mission
- Build interest in specific upcoming episodes of the TV show
- Promote the HSM franchise
- Create a place where HMS fans can congregate, talk and learn.

to this one have been very successful in my pursuit of new business in the companies I have worked for.

At this point, we have overviewed the process of creating an interactive product, and we've taken a moment to look at the creative demands of documents that can help secure the funding for the product. In short, we have covered, if ever so briefly, steps 1 and 2 in the process. Now let's look more closely at the steps that follow, starting with the design of the product itself.

Interactive Design

There are detailed design principles for major kinds of interactive products presented in the chapters ahead. But, whether your interactive product is an information system, a learning system, e-commerce, or interactive entertainment, the design of the product begins when you ask yourself two simple questions: (1) Who are the users? (2) What is their role?

These are the questions that novices in the business of interactive design either forget to ask, or ask too late in the design process for it to do any good. When that happens, their creations become linear works with minimalist interactivity.

"Minimalist interactivity" is my name for a few extremely fundamental acts that form part of any interactive experience, but should never be considered the interactive experience as a whole. The mistake is to think that adding minimalist acts to a linear program makes it truly interactive.

My list of the most notorious minimalist interactivities includes page turning, lookups, side games, and talkabouts. Let's review them one at a time and then come back and review those fundamental questions in light of specific interactive designs.

PAGE TURNING AND NAVIGATION

It is remarkable that some designers consider the fundamental navigation of a linear or even branching story the heart of its interactivity. The fact that users can progress through a story in a linear fashion, skip ahead, or review what they had previously read is so fundamental to any interactive system that it can hardly be considered the heart of the experience, any more than turning pages in a novel or jumping from article to article in an encyclopedia can be considered the essence of enjoying a work of fiction or doing research.

Good, clean, clear navigation is critical to the success of any interactive experience, but it is so basic that its excellence has to be a foregone conclusion. Good navigation is still an issue to be dealt with; it is still difficult to achieve. However, after all these years of experience in interactive design, people who call themselves interactive designers must be able to put together a simple,

workable, and intuitive navigation system and interface for their designs. Designers of interfaces whose users ask the terrible question "What do I do now?" when they suddenly find themselves at a dead end should surely consider another line of work.

If you find that you have fallen into that category and you don't want to change careers, it's time to do some developmental testing and some interface refinement. Then, if the developmental testing reveals users who utter the unthinkable phrase "What do I do now?"—well, congratulations at least on doing the testing, but please, check out my review of interface design in the next chapter.

LOOKUPS

Here's another part of interactivity that is clearly not the whole experience. Searching for information is certainly interactivity of sorts, but it is probably not the interactivity of choice. It is a very fundamental and very important part of any interactive system. It's what makes interactive encyclopedias easier to use than hardbound encyclopedias. In an interactive story it is the beginning of the adventure, but it is not the adventure itself. So the lookup part of interactivity is only the beginning of what interactive digital media can be.

In the classic tale "The Veldt," the children in the story went to the African plain and visited the animals that were there. They were surprised and even frightened by them. Looking up a list of locations, learning more about the animals was good preparation for the adventure. Choosing to go to the veldt from among the other locations that were available, deciding which animals would be present when they arrived: these were interesting lookup and selection activities, but they are not the interactive adventure. Being on the African plain and interacting with the environment—that's what made the adventure real. In the case of Ray Bradbury's tale, of course, the environment was far too real.

Another example of a lookup that has begun to emerge in supposedly interactive DVDs generally falls under the category "Other Features." The Other Features usually consist of selected elements about the movie on the DVD. So, in a really good DVD you can get a section on the Making of the Movie, perhaps commentaries by the director or the stars, one or more of the trailers (coming attractions), even a set of production stills. Those are minimalist activities outside the realm of real interactivity.

They are valuable, they are good, they are worth including in the DVD; but to tell the public that such a DVD is full of interactive features is just misleading and a disservice to all that interactivity can be. An even better, but still minimalist version of the supposedly interactive DVD would at least include a side game as well.

SIDE GAMES

Anything with a little interactivity tacked on is not really interactive at all. More-over, programs with a little interactivity tacked on often act as bad representatives of the interactive design art and as such, reduce the chances of acceptance and success for all efforts at interactive media.

It has often been said that interactivity is not something that consumers understand or care about. The reason for that may very well be that there are so many bad examples of interactive programming, so many examples of linear programs with a little interactivity tacked on.

So, what do you tack on to interactive media besides general navigation and lookups? Well, the most obvious thing to add is a little game that you play on the side. I've just been ranting that interactive games could at least be tacked onto the minimalist interactive features that are currently added to DVDs.

Take the "Kick the Baby" game that was on the *South Park* movie Web site and make it available on DVD. Then you have at least created another feature to give your movie viewers who are caught in the afterglow of an interesting movie experience. However, though side games would be a reasonable addition to the current limited list of interactive features that can be found on today's DVDs, they are still minimalist activities.

Stick a little multiple-choice quiz at the end of what is supposed to be an interactive lesson and you've done the same thing. All you have really given your students is navigation to one lesson out of many followed by a little tacked-on side game.

Side games are even more deadly when somehow, misguidedly, they are thrust into the middle of what are supposed to be interactive stories. Imagine a puzzle that is thrown in the middle of an interactive adventure. For example, you are trekking across the universe and suddenly you are confronted with a puzzle that you have to complete to steer your space ship. It is so complex and distracting that it destroys the continuity of the story, and because there is no way around it, the puzzle becomes a dead end that frustrates the users, gets them thrown out of the adventure, and eventually leads them to abandon the adventure completely.

A better, but still imperfect, interactive side game is the activity that *accompanies* a linear story. It does not interrupt the story because it is not really part of it. Instead, you go through the linear story and then play the game after the story is complete. At least it doesn't interrupt the story, but then it doesn't add any real involvement for the participant, either.

Chuck Jones produced a brilliant, but rather linear, version of *Peter and the Wolf* on CD-ROM. To add interactivity to the experience, someone added a nice little game where the players helped Peter escape the wolf by jumping across a river from one floating log to another (sort of Frogger and the Wolf). It was a

cute, interesting game, but it was not integrated into the story. It was, in fact, a perfect example of a side game.

TALKABOUTS

"Talkabouts" are actually a wonderful activity, and they take advantage of one of the most popular aspects of on-line services, one that will eventually become part of interactive television, I'm sure. I'm referring to chats and bulletin boards.

Talking about an interactive story or adventure is great fun. It may be the second-best thing about being *in* an interactive story. But it is not the story or adventure itself. Unless the group discusses things so that they can take action that will affect the outcome of the story, they are only observers of the scene.

In an interactive lesson, talking about solving a problem or identifying the right way to do something is still not the same as solving the problem or actually doing the thing. There is a lot of value in talkabouts. They certainly are involving, but until they provide more than an aside to the adventure or learning experience (as in the on-line role-playing game described in Chapter 5), they are not the highest form of interactivity. People who include them in their designs must realize that they are not delivering the true interactive experience.

THE BIG QUESTIONS

So, where does that leave us? We have reviewed four fundamental interactive elements that many people believe to be the essence of good interactive programs. But we said that those techniques are only secondary activities, and anyone who builds an interactive adventure or a learning system around them is creating a very incomplete experience.

What is the answer to designing a truly great interactive experience? For me, whether you are designing a CD-ROM, a Web site, or an interactive TV program, the key to success is to ask yourself, "Who are the users and what is their role?"

In an interactive story you have to ask yourself, which characters do the users play? How do they become part of the story? How do their actions and decisions affect the progress of the story?

In a learning system you have to ask yourself, who are the learners and what are they doing that will make for an effective learning experience? In an interactive game you have to ask yourself, who are the players? What is their role in the game? How do they play that role? If they are golfers in a golf game, they had better be playing golf. If I'm a lover in a soap opera, I'd better be able

to love somebody or have someone loving or rejecting or at least acknowledging me.

When you ask, "Who are the users and what is their role?" you automatically take your interactive creation to a much higher level, one in which the users are the focal point of the experience and their actions become the most important elements in the experience. Even in stories with strong linear elements and characters who are strong and self-determined, the game players and their actions must be paramount.

USERS AND THEIR ROLES

So now let's consider the possible answer to our two questions: who are the users and what is their role? To simplify the answer, we can break down the role of the user into three major categories. The categories are participation, direction, and transaction. These three major categories can also be broken down into subcategories. For example, if users are going to participate in the action of an interactive experience, there are usually two or three different ways to do it. But, before we get too deep into the substrata, let's start with a look at the top levels, beginning with the most interesting kind of interactivity: participation.

We'll define participation by saying that it means that the user becomes *part* of the interactive experience. In the easiest example, an interactive game, the user participates by being *in* the game. The number one way for the user to be *in* the game, of course, is to be the hero of the game. That seems simple enough, right? If you are the hero in a game then you are the main character. But it is not that simple. For example, who is the hero of Pac Man, that little round guy who goes around eating pills and being killed by ghosts? Well, the truth is that the Pac Man is the hero, but the user is not the Pac Man. The user is manipulating the Pac Man. In Pac Man or any other game where you have a character that you create and whom you manipulate and follow around, *you are not the hero.* The character is the hero.

Think of the movie *Being John Malkovich* in which the hero climbs inside the head of John Malkovich, sees through his eyes, and speaks with his voice. He or she is limited entirely by the Malkovich field of view, hearing only with the hearing abilities of JM, moving only with the coordination of JM.

If we are going to work toward interactive experiences where people actually feel that *they* are in the environment, then we have to begin by defining that realm in which people participate by *being* the hero as unique and ideal. We then have to say that any other kind of participation is different from that.

That means that the user controlling the Pac Man or the character he created for himself in *EverQuest* is not the hero and is not even really a participant. That user is a director who directs the action of another character. So there we have defined another role for the user . . . the director.

Conversely how would a person *participate* in a game and not be the hero? Easy—the same way that people participate in life and aren't the hero. They play other roles. One of the most common of those roles is that of an advisor. So when you help the chief of police track down the villain, when you help solve the crime, when you tell the colonist on the lost planet how to avoid being eaten by the incredible blue glob, you are *participating* as a secondary character. You are an advisor, but you are not the hero. Of course you may be lucky enough to avoid getting eaten by the blue glob anyway. But, then again, maybe you will be eaten and that is the critical test. If you cross the line into participation, then you exist in the world of the character: you *are* the character, and anything that can happen to the character can also happen to you, including, and especially, death.

Sure, there are a million ways to show death to outside observers, and they are well presented in a million different interactive games. But none of them have to try and convey the *feeling* or experience of death, which would be one of the challenges that would have to be dealt with when designing a participant hero game. In the participant hero game, you don't just watch your character being eaten by the blue glob; you experience what it is like to have the blue glob eat you.

This is not to say that being a participant hero is any more exciting than being the person directing the actions of the hero or the various characters in *EverQuest* or any other character in an action-directed game. Right now action-directed games are much more exciting than participant-hero games. But the designers of action-directed games will never have to worry about how to create the experience of death for their players.

Again, the reason this distinction is important for simulation games is that as those games are more and more capable of putting users into virtual worlds, the role they play and the point of view they have in those worlds affects the quality of the experience. (Not to mention the design and production cost of the experience.) But even in outside simulation games, the role of the user and how they are acting continues to be a set of critical questions. To see how, let's continue this analysis.

In a game the user can participate by being the hero or some other character within the experience: an advisor, a helper, even an observer. The user can also be the director who manipulates the character, but who does not see through his or her eyes and whose movements are not really limited by his or her abilities or senses.

The exact same issues that apply to games apply to learning. The learners can be the heroes who see through their own eyes and manipulate things themselves to perform the tasks. They can be other kinds of participants who observe or give advice. Or they can be directors who control some kind of surrogate or stand-in to do the job.

Does any of this matter in interactive media other than instruction, entertainment, or game play? The simple answer is yes. Remember, there is a third major kind of interaction, which we called *transaction*.

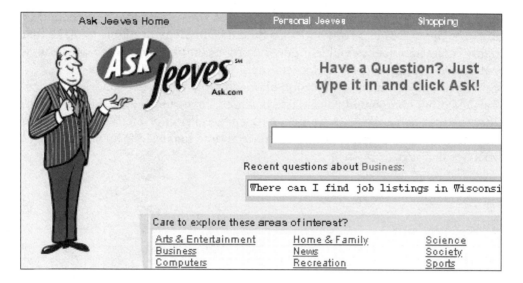

Figure 8.1 Current format for the Web site "Ask Jeeves." © 1996–2001 Ask Jeeves, Inc. ASK JEEVES, ASK.COM, and the JEEVES DESIGN are service marks of Ask Jeeves, Inc. Used with permission.

Transactors, as we will call them, interact to do business. The easiest form of business to understand is a sale. It's easy to understand whom the participants are, and what they are doing, on an Amazon.com Web site. They are customers, and they are here to buy something. Even designers of on-line or CD-ROM encyclopedias can easily jump to the conclusion that the interactive participants at their information service are customers who are there to perform transactions and get information.

We can identify subcategories of transactors as buyers, information seekers, and communicators. It all should be obvious, and it is . . . until we remember that transactors are only one of the three kinds of interactive users. There are participants who can be subdivided into heroes, observers, and other players, and there are directors.

Then we ask ourselves, do we want our interactive customers to be transactors, or do we want to make them heroes? Do we want our information seekers to be transactors, or do we want to make them directors who send some character off to get the information for them?

These are the creative possibilities that emerge when we think about the participants and how they are interacting. It may be fine to have a very utilitarian information site that just gives answers to questions that the user types in. Or the info site could be Ask Jeeves, which creates a character to take direction from the customer. And at this point we have to ask ourselves how long is Jeeves going to be no more than a name and a small cartoon image in the corner of the screen (see Figure 8.1). When is he going to step into the foreground, develop a

little personality, and take a more active role in the service that is named after him? The answer can't be any sooner than the technology available to make that highly interactive Jeeves viable on everybody's computer. As noted previously, that time is coming rapidly, but it isn't here yet.

Once you've made the decision about the role of the user and its implications for other components of the site (such as Jeeves himself), it's time to consider the way your Web site, game, experience, service, or instructional system presents itself to the user. In other words, it's time to consider interface design. Let's do that next.

9

Human Interface Design

One of the most important considerations in interactive designing is the way your system works with people—or, more appropriately, the way people work with it. The point at which a person and an interactive system come together is the human interface. There is little disagreement that the basic principles of the quality user-friendly interface had one of their earliest and clearest manifestations in the design of the Macintosh computer.

With that in mind, it seems that a good place to start the study of interface design is to look at the principles that were written down and followed in the creation of the Apple Macintosh human interface and, by imitation, many of the most successful subsequent computer-interface systems.

THE APPLE HUMAN INTERFACE GUIDELINES

These principles are published in *The Apple Human Interface Guidelines*, a book that is available to the general public. Here is a summary of the principles it presents:

- Simple design is good design.
- People deserve and appreciate attractive surroundings. A mess is acceptable only if the user makes the mess.
- Good design must communicate, not just dazzle.
- Objects should look like what they do so that the user can recognize them and point to them.
- Consistency should be valued over idiosyncratic cleverness.
- The transfer of skills is one of the most important benefits of a consistent interface.
- The environment should appear to remain stable, understandable, and familiar.
- There should be little or no difference between what the user sees and what the user gets.
- The user, not the computer, should control the action.
- The interface should stimulate the feeling that the user is in charge of the system, and it should be fun to use.

- The user should be kept informed of what's going on via messages (presented in dialog boxes).
- The user should be allowed to do anything reasonable and be forgiven if a mistake is made.
- Generally the interface should use metaphors.
- These metaphors should be supported with audio and visual effects.
- Animation, when used sparingly, is one of the best ways to draw a user's attention to a place on the screen.
- There should always be a way out.

Consistency of Interface

The way Apple wrote these human interface guidelines seems to indicate that, although consistency is a valuable commodity, effective interface design does not require strict adherence to tight constraints. Rules governing consistency probably don't carry down to the level of the exact shape or placement of individual icons or buttons or the shape and wording of menus. In fact, Apple puts this principle into practice in its own design environment, where lack of consistency is the byword. HyperCard, for example, offers 12 different kinds of "standard arrows" in its icon menu, as well as four different kinds of question marks that can be used to indicate "Help."

The fact that a question mark always indicates "help" is well in keeping with the human interface guidelines. The shape of the question mark or the shape of the button the question mark is in, or even the fact that designers have a choice between a question mark and the word "HELP," indicates that creative freedom can and should be exercised.

In spite of all this, it is important to remember that icons (such as the question mark) should never mean one thing in one place and something else in another. So, if the question mark means "help" in one part of your program, it should never be used to indicate a "list of questions" in another.

FUNCTIONS OF THE INTERFACE

So, we've reviewed the general design guidelines for the interface, with suggestions on how to help ensure that it is attractive, effective, and consistent. But remember: the interface is there for a purpose, and above all else, the interface is there to help users achieve that purpose. Let's review the general functions or purposes of the interface one by one.

Navigation

The interface does many things, one of the most important of which is to help the user get around the interactive space (Web site, interactive lesson, game,

shopping area, etc.). Moving from the current location to others requires some important and consistent activities. First, the interface has to allow users to get to the place they want to go and then get back. The three most important ways to do this are to jump, to step, and to search.

Jump means you go from where you are to exactly where you want to go in one quick step, no matter how far away it is. So if I am in a Web site that sells cars and I am interested in buying a yellow 1957 Chevrolet convertible, I may be able to click on something that takes me right there. Depending on how critical the '57 Chevy is to the design of the site, it might be a button or even a picture of the Chevy itself that is featured prominently on the home page and that links me to the location. The critical factor in determining whether or not to jump directly to something has to do with how important it is to the overall functionality of the site, or how many alternatives there are.

If there are only six cars on the site, I can list all the cars on the home screen and allow users to jump right to them. If there are thousands of cars on the site, but the '57 Chevy is one I am most concerned with selling, I can put that picture right up front and allow people to click on the picture itself and jump right to the '57 Chevy page.

In addition to being able to jump right to the yellow Chevrolet, I may also be able to step through all the cars on the site and get to it that way. Step navigation is usually done by using arrow buttons or buttons labeled with the word "next" or "previous." Since this is a classic car site, I might go from one car to the next to the next to the next.

I could have a list of cars and click on the list to jump, or click on arrows to step. But if the number of cars on the site were really great, say several hundred, those methods of navigation would be cumbersome. So I would need a better way to move between items. What I could do is search.

Search means I type in the name of the item I want and the system finds it for me. There are drawbacks to searching. They have to do with people's inability to spell and their ability to enter information in consistent ways. To overcome the inconsistencies of input, searching is almost always performed by a highly sophisticated "off-the-shelf" computer product, called a search engine. The search engine sees what the user has typed in and uses its own internal logic to match it to the correct available page.

Again, depending on the depth of the information that is available, search engines are more or less mandatory on Web sites, interactive reference media, shopping media, and even interactive instruction or stories that have research components built into them.

The placement of the search function, the links, and the stepping buttons are matters that relate to the overall look and intent of the site that is being built. In shopping sites or information sites, getting to the product or information right away is critical, so the search function is usually at the very top of the page.

Links are placed at appropriate places in the body of the page depending on how critical they are to the overall goals of the site. They can exist as words (which are called hypertext) or graphics that are considered embedded links.

THE NAVIGATION BAR

It has become common practice to place stepping controls in a single consistent strip that can be found along the top, side, or bottom of each page or screen. In Web design this strip is called the navigation or nav bar or sometimes the menu bar.

The nav bar usually consists of links that are represented as either words or icons. The number of links on the bar can vary depending on which functions, in addition to stepping controls, are needed.

Stepping controls are usually enhanced by buttons that allow users to jump out of any part of a particular segment and go directly to the end or beginning of that segment or the beginning of the next.

An even more critical element in the nav bar is the home key, which allows users to go directly back to the first or home screen so that they can start over again whenever they want to.

On the Internet, Netscape and other Web navigators provide next and previous controls on their own control strip (as part of the interface), so it has become common practice in Web design to rely on those controls. However, those nav bars are not permanent. Users can close them down if they want to increase the amount of room on the screen. In fact, program designers can make them go away whenever their site is accessed, again to gain more room on the screen. So it is not a good idea to rely on the navigation controls provided by the Web navigator. Designers of the site should make them present on the pages of the site.

Global Control

Nav bars or control strips provide additional navigation functions that can take users completely out of the sequence they are in. They usually allow users to access the different categories of a site. So again, in my classic car example, the nav bar might have buttons that access areas related to Chevies, Dodges, and Fords in general along with the stepping buttons.

Nav bars can also give users the ability to access more general or global controls. A help button can call up a menu that leads to a variety of instructional segments. Another global control should allow users to "quit" the program. In sites where search is not as important a function, the nav bar can be the place where users are able to access the search function when it is not permanently present on the screen.

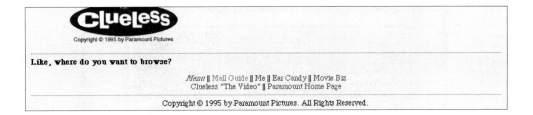

Figure 9.1 Nav bar from the *Clueless* movie Web site. TM and Copyright © by Paramount Pictures. All rights reserved.

The most useful control strip configuration might contain a combination of global and navigational controls that are arranged so that the order of the controls has some logical relationship with the position of the segments in the program. Figure 9.1 illustrates such a control strip from the *Clueless* movie promotion site. Note that the names of the different areas of the site are included, as well as global controls to the main menu and out of the site to the home area, in this case the Paramount Home Page.

Tools

In addition to global and navigational controls, many Web sites and other interactive programs use nav bars to provide certain sets of tools. One such tool is the bookmark, the most familiar application of which is setting a place in the Internet that you can return to immediately. Bookmarks are indicated by icons on some interactive nav bars and by the word "Bookmark" in others. Sometimes they exist in both forms on two different menu bars in the same program. That's fine. Redundancy helps ensure that if users don't get it one way, they'll get it another.

Additional tools that appear in nav bars include site maps so that you can know where you are within the overall site at all times. There are also photo tools that can grab a picture of the screen that you are working on, and messaging tools that allow you to send communications to the designers of the system.

When I worked at Apple, we determined that tools such as these should always be considered whenever we planned the creation of a multimedia learning program, and their use matched the objectives of the project. Figure 9.2 shows a set of interactive multimedia tools from one of Apple's major multimedia learning programs.

Special Function Controls

Depending on the goals of the interactive program, controls may need to be added to the interface in order to provide the kind of unique functionality that the program needs.

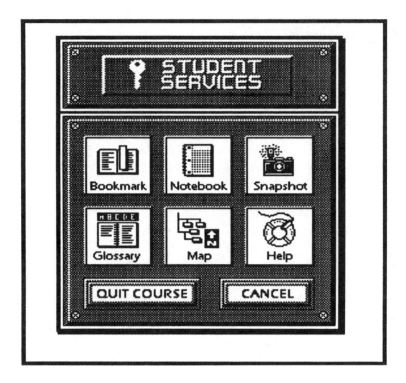

Figure 9.2 A set of multimedia tools from an Apple training program.

Aircraft simulation games often feature an interface that looks like the cockpit controls of a jet plane. Some travel sites allow you to access simulated trips through the countryside. Highly interactive versions of those sites allow users to fly over different locales with aircraft-like controls.

We showed some images for a hypothetical TV promotion site called High Sierra Mission.

Full development of such a promotional Web site may require a simulation game that features a mountain rescue mission that turns into a full-on race to save the residents of a small village from a disastrous flood. The design for this adventure reflects a series of decisions that the users (who are also the only ones who can save the village) have to make.

In working through the design, the hero's decisions require that the interface take on a certain kind of functionality. At first there may only be simple controls that allow for navigation through mountainous terrain and simple "yes–no" choices about how to handle the rescue. Then, as the design evolves, multiple choices may be necessary. As the designers of the interactive experience continue to develop the details of the story, it may become clear that various new kinds of decisions are cropping up in the story that were not in the initial concept.

There may be conditional "if–then" choices that have to be introduced. There could even be a language issue and a translation capability that arises when the mission team encounters the injured parties at the bottom of a 1,000-foot cliff. All that functionality has to be added to the interface, possibly in places that exist permanently on the nav bar. So now our nav bar has navigation controls, global controls, access to tools, and special-function tools that are unique to the purpose of the interactive program.

Look and Feel

The look of a multimedia program and the production values it takes to get that look are important. As stated in the guidelines, "Users deserve and prefer an 'attractive look' to their experience." As a general rule, the look should be designed to match the objectives of the program. This implies that the program is designed to appeal to a specific audience, and that audience should be understood and addressed. Because audiences vary, the programs you create will require a variety of different looks, but the match of design to audience and program goals should be a principal goal of human interface design.

At Paramount, we created a look for the Web site that promoted the film *Indian in the Cupboard*. It was a little boy's room, and it gave the sense that this was a safe haven that a little boy could come to when he needed to be alone, a special place. It is pictured in Figure 9.3.

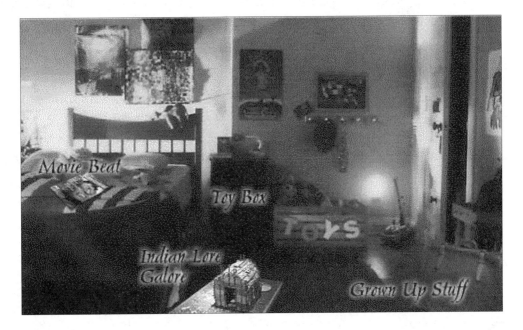

Figure 9.3 Amri's room from the *Indian in the Cupboard* Web site. TM and Copyright © by Paramount Pictures.

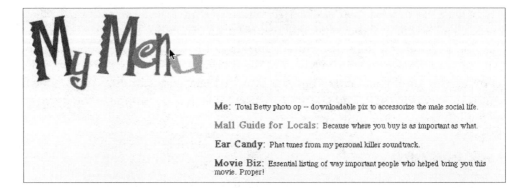

Figure 9.4 Banner of menu for *Clueless* Web site. TM and Copyright © by Paramount Pictures. All rights reserved.

A very different look was created for the movie *Clueless* with its focus on teenage girls, high-end Beverly Hills fashion, and gaudy taste. The top of the menu page for that Web site is pictured in Figure 9.4. The color, design, and even the vocabulary are clear.

So the typeface, vocabulary, style of navigation controls, and background images that support the program all have to be in harmony if the desired mood is going to be achieved. Beyond getting the look right and achieving an appropriate feeling, an even broader goal can be achieved.

THE EXPERIENCE

Human interface and the total look of the interactive product contribute to creating a complete experience for the user. Additional elements that can add to the sense of a total experience are:

- Program structure
- Program flow
- Transitions

For example, a Web site designed to represent an action–adventure film can capture the experience of a movie if the sense of tension that is present in the film is transferred to the images, the language, and the sound effects of the site itself. The activities on the site should share the same theme. The names of the areas and the buttons that go to those areas should share the feeling. Even the pacing of the use of the site (program flow) should be exciting. Pages might present a few short phrases of information before the users must go on to the next so that they have a sense of a staccato movement that matches the pace of

the movie itself. In the same way the transition between pages might feature effects that maintain the mood and pace of the film.

Now you are saying, "How can that be done with a 28.9-baud modem?" And the answer is, "It's a creative challenge." Look at the limitations of the technology you are forced to work with and then try and find ways around them.

Unique interactive experience can't happen if designers are locked into rigid structures and held back by conservative approaches to the limitations of technology. For this reason, it is the "spirit" of the Apple Human Interface Guidelines that makes sense. One major goal should be that those guidelines do not limit the capability of developers to use newer and more complete applications of interactive multimedia technology. Everyone needs to develop, or at least seek to develop, programs that take full advantage of these technologies. This means creating designs that push the envelope for the use of media. Interactive designs should only be scaled back when the harsh realities of the medium's limitation can no longer be denied. Am I saying that you should always design the newest technology into your interactive applications? I'm saying design them the way you feel they should be, and then back off to simpler solutions when the limitations become clear. Keep trying to push that envelope.

THE STABLE INTERFACE

The balancing act between evolving design and a universally consistent interface goes on. As we discover the best tools, icons, buttons, and menus to convey given ideas, we should make them available to everyone so that people everywhere can share the common experience and transfer that knowledge across various Web sites, programs, and systems. Finding ways to meld consistent standards and creative designs is a major challenge, but this chapter should have suggested methods for achieving just that.

The trick for all of us is to make our creations so transparent that users do not need to learn them at all. They must be intuitive. With the democratization of the Web and the popularity of CD-ROMs and DVDs, usage of interactive media has become all-pervasive. Today most people can pick up the use of a new human interface quickly. The trick is to allow them to maintain that capability while maintaining the right to allow the interface itself to add personality, character, and a unique experience as well.

Flowcharts and Site Maps

Flowcharting is an integral part of the interactive design process. It is done to communicate sequence, decision points, branching, and the flow of information in interactive multimedia. In traditional linear media there is no need to document the various paths a viewer can take through the program because there is only one path. In the Internet, CD-ROMs, and other interactive digital media, flowcharts not only show all possible paths a viewer may take, but also indicate the various activities that will take place along the way, such as video motion sequences, subroutines, games, tests, or transactions. The simplest on-line flowcharts are often called site maps.

Quite a few programs have been created to allow developers to create flowcharts electronically. One of my favorites is Inspiration from Inspiration Software. It's a simple click-and-drag program with pull-down menus that allow you to create flowcharts with a variety of standard flowchart notations as well as unique symbols and icons.

Figure 10.1 shows a simple site map created with Inspiration. I couldn't resist the temptation to substitute some of Inspiration's more interesting icons. We'll soon learn that what I've made is definitely a "level-one" flowchart. For a more traditional look at the standard kinds of flowchart symbols, check out the several pages of Figure 10.2. Note that access to the variety of icon images for Inspiration is achieved through pull-down menus under the symbols on the little toolbar shown in Figure 10.1.

LEVELS OF FLOWCHARTS

Flowcharts are used for a number of different purposes. They are used to communicate general program flow to executives, clients, and writers; to indicate the organization of all parts of the program to production staff; and to indicate the mechanics of the program to software engineers. As the needs of one group are quite different from those of another, there are three levels of flowcharts, each designed for a specific purpose:

1. *Level 1 flowcharts.* To communicate general program flow to clients and decision-makers prior to scripting stage.

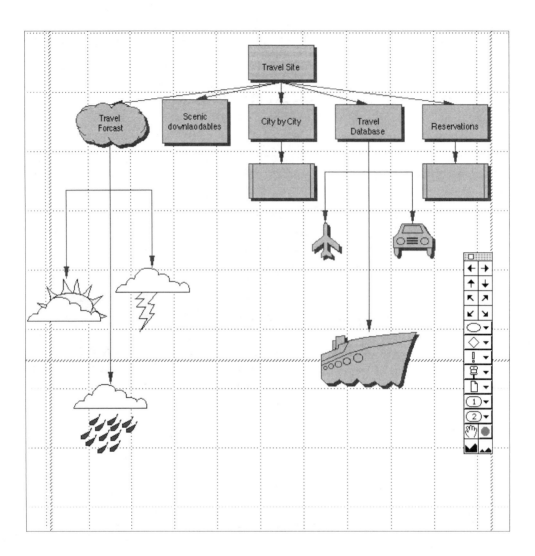

Figure 10.1 Level 1 flowchart created with Inspiration.

2. *Level 2 flowcharts.* To indicate complete organization of all parts of the program to production staff and writers.
3. *Level 3 flowcharts.* To indicate the mechanics of the program to computer programmers.

Level 1 flowcharts document the paths available to the user or viewer and are based on the information developed in the concept statement. Level 1 flowcharts are frequently used to "sell" the interactive program to clients. For this reason, they are sometimes even embellished with illustrations and mounted on

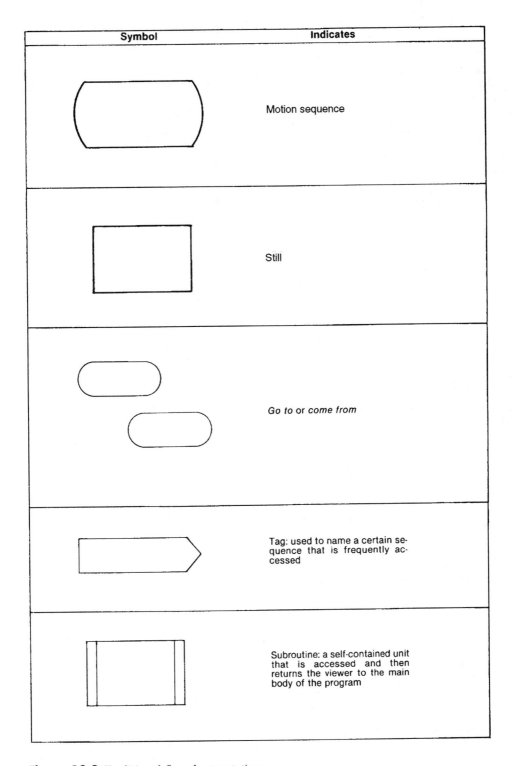

Symbol	Indicates
	Motion sequence
	Still
	Go to or *come from*
	Tag: used to name a certain sequence that is frequently accessed
	Subroutine: a self-contained unit that is accessed and then returns the viewer to the main body of the program

Figure 10.2 Traditional flowchart notation.

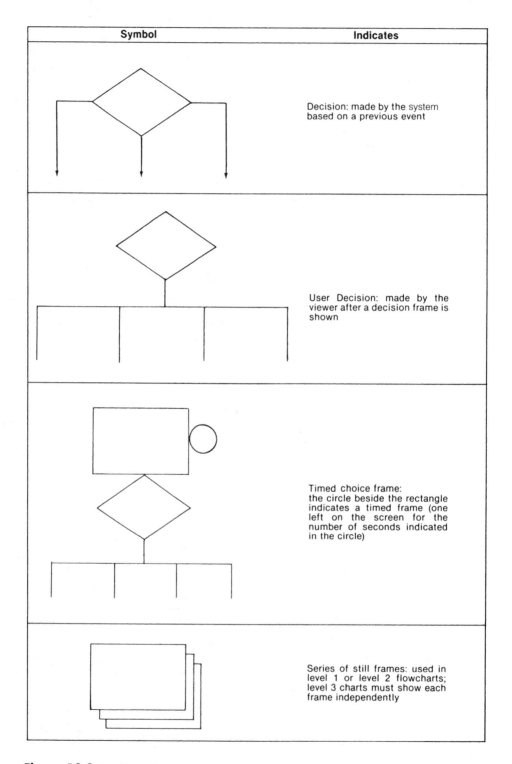

Symbol	Indicates
	Decision: made by the system based on a previous event
	User Decision: made by the viewer after a decision frame is shown
	Timed choice frame: the circle beside the rectangle indicates a timed frame (one left on the screen for the number of seconds indicated in the circle)
	Series of still frames: used in level 1 or level 2 flowcharts; level 3 charts must show each frame independently

Figure 10.2 (continued)

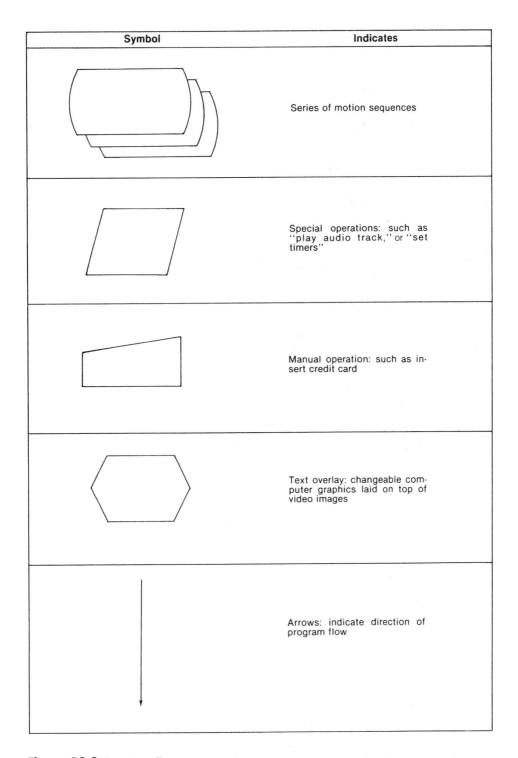

Symbol	Indicates
	Series of motion sequences
	Special operations: such as "play audio track," or "set timers"
	Manual operation: such as insert credit card
	Text overlay: changeable computer graphics laid on top of video images
	Arrows: indicate direction of program flow

Figure 10.2 (continued)

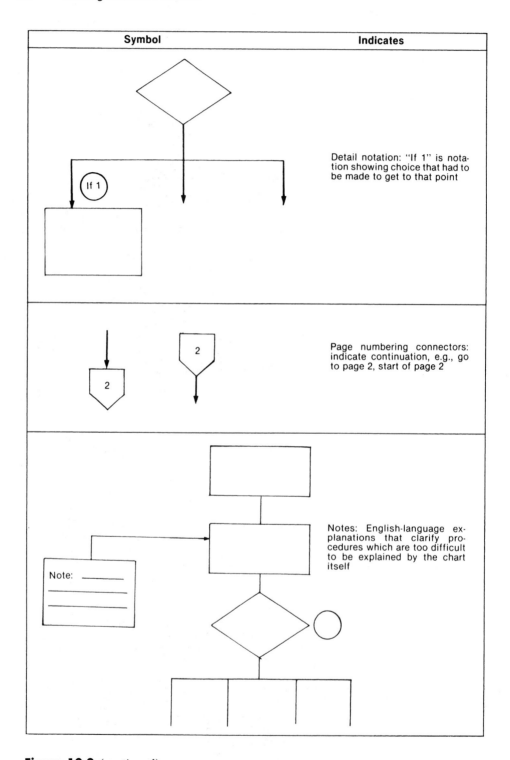

Symbol	Indicates
	Detail notation: "If 1" is notation showing choice that had to be made to get to that point
	Page numbering connectors: indicate continuation, e.g., go to page 2, start of page 2
	Notes: English-language explanations that clarify procedures which are too difficult to be explained by the chart itself

Figure 10.2 (continued)

large presentation boards. A good set of level 1 flowcharts should accompany the preliminary design documents.

Level 2 flowcharts add in all the details of the program, but leave out the mechanical instructions needed by computer programmers. Sometimes they are complete enough to serve as the basis for a prototype, since prototypes generally do not include the completed content of all parts of the program.

Level 3 flowcharts contain all the program details, mechanical instructions, counter instructions, frame numbers, etc. It takes intense concentration to develop level 3 charts. However, the effort is necessary because the program won't work if level 3 charts are incorrect.

Designing flowcharts requires three basic characteristics: a logical mind, tremendous patience, and strict attention to detail. The general process is to identify each content element to the smallest unit (the page, frame, cell, or screen), label each element, and connect the elements into a logical flow. Then, you should check and recheck to see that all necessary details, including loops and computer instructions, are present. Level 1 and level 2 flowcharts are often done before scripting begins. Level 3 charts are often completed during or after media production so that refinements in the script can be incorporated into the software program.

Figures 10.3 and 10.4 show level 1 and 2 flowcharts. Each chart combines the symbols into a unified sequence. All three charts present the same sequence with increasing levels of detail.

Figure 10.3 presents a level 1 flowchart for a "point-of-sale" CD-ROM, featuring a menu that will lead to one of several product stills. The still, in turn, leads the viewer to a choice of activities relating to the product.

In the level 2 chart shown in Figure 10.4, terms are used to identify key blocks of information. Words that are repeated are abbreviated: for example, "Product Still" is abbreviated PS. The flowchart makes all parts of the program clear and can be used by production personnel to begin work on the video and other sequences. However, level 2 charts, even though they are detailed enough for creating prototypes, cannot be used by software engineers to create the final code.

The level 3 flowchart shown in Figure 10.5 is so detailed that it must be done in code to get all the information on the page. The amount of detail makes any superficial assessment of the chart's accuracy impossible—it must be worked through step by step. Using this chart, the software developers can create an acceptable interactive product.

The Gantt Code

The level 3 flowchart shown in Figure 10.5 uses a variation of the code invented by Rodger Gantt, a Bank of America instructional designer. The Gantt code, as we call it, uses activity names or code numbers to represent all elements of

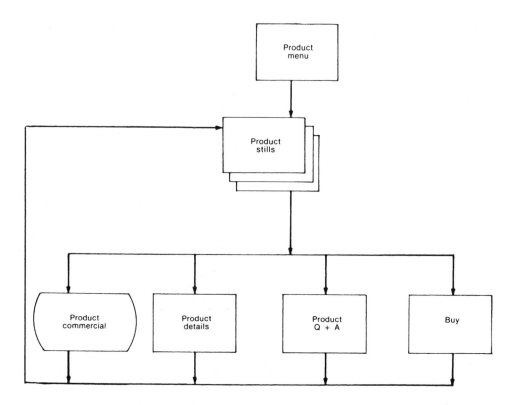

Figure 10.3 Level 1 flowchart.

an interactive video program. Although the Gantt code was constructed for instructional material, the principle could apply to other types of interactive programs as well. Of course, thanks to MS-DOS, we are all used to making up code names for items, and we are certainly free to use any code we want. The important thing about the Gantt code is that it is complete, intuitive, logical, and extensible.

As interactive media include more and more media elements such as stills, text documents, audio, video motion sequences, maps, and tables, the ability to organize and number these items becomes more and more important. Documents in software programs are usually identified by file names that are usually limited by the standard MS-DOS 8.3 formula (8 characters followed by a dot and 3 letters to indicate the kind of file it is). Being able to keep track of a list of hundreds of elements is difficult enough. Being able to keep track of a list that can be modified, updated, and maintained over time is a really complex task. Companies I have worked for have developed a fairly high position called the content manager. The job of the content manager is to identify, update, and list the ever-growing set of media in the program and to make sure that everyone has a current and clearly understandable list of that media.

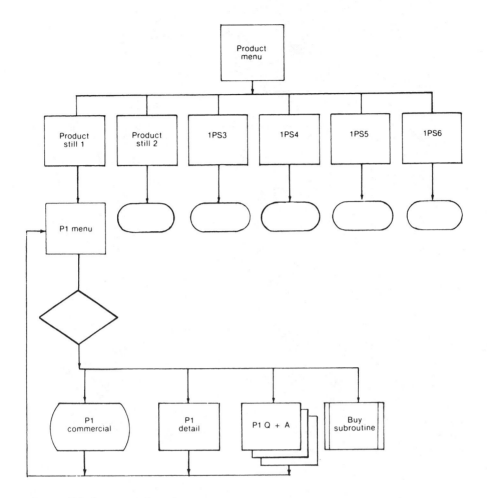

Figure 10.4 Level 2 flowchart.

If you imagine an interactive encyclopedia with its list of articles that are updated and modified every year you'll get an idea of what I mean. Large learning systems have the same problem as do Web sites that offer access to a growing and changing number of products.

When thinking of how to create and manage these kinds of content lists, systems such as Rodger Gantt's are clearly good models. That is why we will take the time now to review it here.

In Gantt's system, the activities are named, abbreviated, and numbered. The main purpose of the code is to create a clear-cut shorthand that designers and programmers can use to identify activities. It saves writing time and provides for greater consistency when program elements are being discussed. Each element of the code is explained in the following tables.

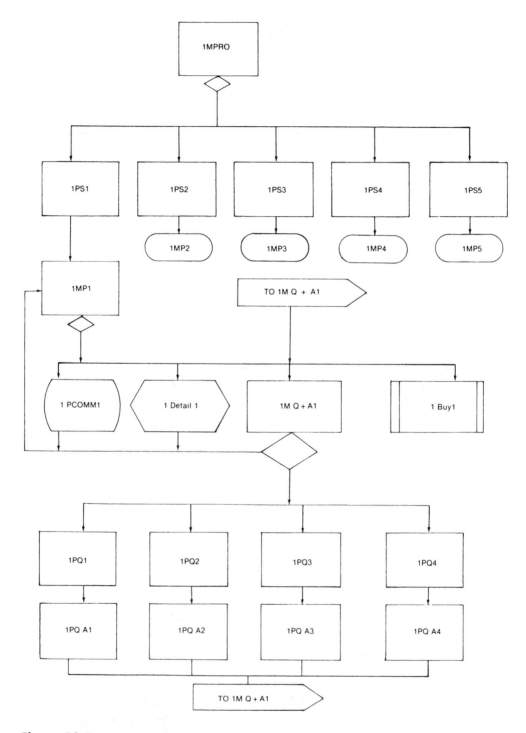

Figure 10.5 Level 3 flowchart.

The major building blocks of an instructional interactive program are demonstrations, exercise questions, and test questions. These are represented in the Gantt code as follows:

Demonstration DEMO
Exercise question XQ
Test question TQ

Other blocks include introductions, reviews, previews, and various types of menus:

Introduction INTRO
Review REV
Preview PRE
Test pass menu MTP
Test fail menu MTF
Review menu MREV
Preview menu MPRE

In addition to exercise questions (XQ), there are three different kinds of exercise feedback: correct, incorrect, and common feedback (a single response that works for all answers, right or wrong). There are also drills with questions and feedback:

Drill questions DQ
Drill feedback DF
Exercise questions XQ
Correct feedback XCF
Incorrect (false) feedback XFF
Common feedback XCOM

In programs that have more than one lesson, a number usually precedes the item to indicate the lesson:

Lesson 1, demonstration 1 DEMO
Lesson 1, review 1 REV
Lesson 1, exercise question 1 XQ

As there can be several activities of any kind in any lesson, the activities are given numbers, which are placed after the lesson number and item code:

Lesson 1, demonstration 1 1DEMO1
Lesson 1, demonstration 2 1DEMO2

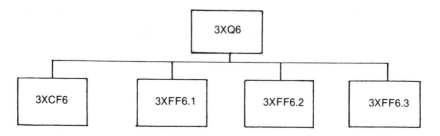

Figure 10.6 Feedback segment flowchart in Gantt code.

Lesson 1, demonstration 3	1DEMO3
Lesson 2, exercise question 4	2XQ4
Lesson 2, correct feedback for exercise question 5	2XCF5

Similarly, because there can be more than one incorrect (false) feedback to each question, the number of the feedback is indicated by a point after the activity number:

Lesson 2, exercise question 5, incorrect feedback 1	2XFF5.1
Lesson 2, exercise question 5, incorrect feedback 2	2XEF5.2

In flowcharts, those numbers would also be used to indicate different feedback corresponding to choices in a multiple-choice question. For example, Figure 10.6 shows the sixth exercise question in Lesson 3, which has three incorrect possibilities and one correct choice.

Thus far, we have discussed flowchart and site map design notation and the automated process for creating them with software such as Inspiration. We also reviewed the three levels of flowcharts used to communicate information about the organization of interactive multimedia to various clients, scriptwriters, production personnel, and programmers. In the upcoming chapters, we will discuss how all this documentation is turned into a real product, or at least the prototype of a real product.

Prototyping

Some developers feel that prototyping is the part of the creative development process that is the most fun. It requires that you actually make a working model that will let users experience the look and feel of the new product. In doing so, however, you don't have to build out the product in every detail. So you get to concentrate on all the features and the magic of the new product without having to add the detail of the more mundane, more repetitious sections. In that sense, the prototype is like the level 2 flowchart. It represents all the different kinds of interactions that are possible without actually following all of them to their necessary conclusions. Even prototypes of interactive stories need not show every possible outcome. They can show a few of the paths that can be taken and still give a sense of the kinds of interactions that are possible.

WHY PROTOTYPE?

The following list provides five good reasons to prototype:

1. A well-executed prototype is the best way to sell your project to a prospective client. Nothing sells a product better than a working model, and a prototype is at least a partially working model. Moreover, it is a milestone and a buyoff point that makes it easier for the client to say "Yes!" If there is resistance to starting the project, you simply point out that you will show the clients a prototype within a reasonably short time and they can revise it as much as they want. In addition, if they don't really like the way things are going at that point, they can stop the project right there. So why not at least sign on through the prototype phase?

2. A prototype of an interactive project can prove that the technology is the most effective way to present the material. A sales training exercise that uses student role-playing to simulate customer interviews can be effective; it can also be tedious. However, a simple prototype using digital media can demonstrate the power of the technology for the

application and help you and other decision makers determine whether or not it is worth doing.

3. By establishing design specifications and eliminating failures early, prototyping can make production faster and more effective. Design alternatives can be tested early by a small development team. Therefore, when production swings into high gear, all the hard decisions will already have been made.

4. In the process of creating a prototype, you can experiment with various strategies and tactics. Be as innovative as you dare—the risk is minimal and the rewards can be great. By exercising a little unbridled creativity, you might discover a way to present your material that is totally new and remarkably effective.

5. If you have never created multimedia, prototyping can be an excellent way to gain experience in the development process. By starting with a small project, you can discover the processes and the pitfalls on a small scale, with limited risk.

Demos versus Prototypes versus Pilots

A few years ago I worked in a multimedia R&D group where we made a clear distinction among demos, prototypes, and pilots. Each one had a special place in the product sales process, and each one cost significantly more than the previous. Demos were samples or illustrations of a work. Prototypes were working models that showed the feel of the whole thing and some of the parts in full detail. Pilots were complete products, programs, or productions that (like television pilots) were a single full-blown example of the work, but not of several episodes in an ongoing series.

So demos showed one path through an interactive program while presenting sample content. Even though the sample was supposed to be interactive and would show examples of menus and buttons, it was really linear. If six buttons were presented that led to six different choices, only one choice would work, and the demo would follow that one path. It was as realistic as possible in the pursuit of that path. The other five sections were not developed, so they could not really be shown at all. Very often the demos would be created on videotape. They were not meant to be *operated by* the user; they were meant to be *demonstrated to* the user. This usually required a salesperson to do the demonstration.

In an on-line Web site that our R&D group built, dedicated to sports scores and news, we would prepare a videotape with images of sporting action, presentation of scores, and sports headlines. Menus would feature buttons that went to various places. Viewers might actually see the buttons being clicked, but only one path would be taken. Salespeople might explain what

was happening and how the interactions were being completed. They might even pretend that the interactions were under their control. But they would not be. The video only showed one path through the material and as such only had to contain content relative to that path. Nevertheless, when presented correctly, the video demos gave the audience a good sense of what the experience would *look* like.

Prototypes, on the other hand, were meant to give the users a sense of what the experience would *feel* like, because the user would operate them. You could literally turn the prototype over to a group of people and let them bang on it, play with it, operate it, make it work. Because of this, the prototype often had to contain features that told where each path led. If paths were not complete or if interactions were not available, something would have to come up and say "not yet available" or "under construction" or words to that effect. Nevertheless, prototypes were never meant to be completed. They were a working model of part of a system, never the whole thing. So a prototype of the sports information system we were describing would have real clickable buttons and lots of articles and information that could be accessed. One or two of the simulation games at lower levels of the system would work, but they wouldn't all have to work. If there were on-line scores to be presented, some of them would appear during the presentation, although they definitely would not be up-to-date or changeable.

Pilots done by our R&D group, on the other hand, were completed programs or presentations. Every path went as far as it could go. All the information was complete. If general updating was available because the system was hooked into some information source that offered updatability, that was there, too.

What was not available was the creation of new content that would give the presentation the feeling of being an ongoing series. So, again, going back to our sports example, a pilot created during football season would have all the contents of a complete program. It would be tied into a wire service so that up-to-date football scores could be presented. It might even contain a fully functional model of a virtual reality football game. But no new content would be created for the pilot. The scores would update because they would be hooked into a system that automatically updated scores. The games could be played because they were self-contained units, but there would be no new fully developed articles on games that were played, no new feature stories, and certainly nothing about happenings in other sports whose seasons had not yet begun. That was another show, and the pilot only presented one complete program.

If you went to an outside developer and asked for the estimated costs of a demo, a prototype, and a pilot you would get relative costs such as these: $25,000 for the demo, $75,000 for the prototype, and $250,000 for the pilot. In such a structure you can see that far more prototypes than pilots were

done. But beyond that, if you could get behind the vendor's numbers you would find that the real costs of producing a video demo illustrating the use of an interactive product and the real costs of producing a working prototype of the product were really much closer. The cost difference could very well be nothing more than profit for the developer. You'd have to know the real functional specs of each kind of demo and prototype, of course, but knowing the kinds of elements that go into each, it is possible that the video demo and the software prototype require similar kinds of efforts and end up costing about the same.

So, in that case why not shortcut the process, save the cost of the demo, and go right to the prototype? Unless you have some big sales meeting in which you are forced to present a demo to a large group of decision makers, going right to the prototype is a very good idea.

Levels of Prototypes

There can be many levels of prototypes depending on the degree of functionality you want to show. But there are some fundamental things that have to be in *all* prototypes. Let's just list those and say that if you want to pay for more functionality, doing so is an interesting, but not necessarily a cost-effective, decision.

Prototypes have to show:

- The look and feel of the menus and navigation system
- The general metaphor for the system
- The graphic style of the system
- The branching structure of the system
- Samples of the media elements that will be in the system
- Samples of flow of the story through key branching points
- Samples of any game or VR functionality
- Samples of any other unique and special features of the system

You could sum up that checklist in a single sentence. Prototypes have to show the look, feel, functionality, and magic of an interactive system.

Tools for Creating Interactive Prototypes

New tools for creating prototypes are appearing all the time. Surprisingly enough, one piece of software has become the principal tool for creating interactive prototypes for CD-ROM games and interactive learning systems while the Internet itself has become its biggest rival. We'll spend some time reviewing that one tool and then consider Internet methodologies for creating prototypes.

Macromedia Director

Macromedia Director is the most evolved, the most stable, and the most versatile tool available today for creating interactive prototypes. Beginning in the mid-1980s as VideoWorks, Director evolved from the somewhat novel functionality of creating small animations with accompanying sound to being the engine that drives many of the great multimedia programs that exist today. Even now, while many of the elements that become part of a multimedia program are put together in Adobe PhotoShop and SoundEdit Pro, Director takes control of these elements and tells them how and when to perform.

Jason Robert's great "how to" book on Director, *Director Demystified*, gives a great set of lessons on using the program. If you want to learn Director, buy the latest version of the book and dedicate a few hours a day to reading through the lessons and doing the exercises that are called for. Use the materials provided on the CD-ROM, and then, as soon as possible, get a real project and start employing the software to your own ends. You'll be amazed at how easy it is to learn.

This book is not a "how to," but it does hope to offer some insight into the elements that make up interactive multimedia. To that end, here is a summary of Director's functionality from Jason Robert's chapter "A Guided Tour of Director," with a few added points from me:

- Director has four main windows, the Stage, the Cast, the Score, and the Control Panel (Figure 11.1).
- Director's files are called movies.
- All action takes place on the Stage window, a blank area that you can size and position anywhere on the computer screen. The action on the Stage is controlled by a control panel that advances, pauses, rewinds, or resets the action.
- The action is created, however, in the Score window (Figure 11.2). The process of experiencing the action is known as Playback. Hitting the play button on the control panel sends a cursor known as the Playback Head, through the score that effectively performs your movie by sequentially processing the score information.

Figure 11.1 Director's Control Panel.

Figure 11.2 Score window.

Figure 11.3 Director's Cast window.

- The elements of multimedia (graphics, sounds, digital video, even other Director movies) are stored and accessed in the Cast window (Figure 11.3). They are known as cast members. Some cast members are embedded, which means they reside entirely in the Director movie. Others are linked, which means that their actual data remain in an external file.

Figure 11.4 Director's Paint window.

- Each column or vertical row in the score represents a relative moment in time. Cast members placed in cells in a column will show up on the stage at the given moment during playback.
- Each Channel, or horizontal row, in the score represents a layer on the screen. There are specialized channels for sound transitions, tempo, and color palettes.
- Images and on-screen text can be created in different ways. They can be imported from outside programs such as PhotoShop or created internally in the Paint Window, Director's own graphics creation tool (Figure 11.4).
- Lingo is everywhere. The control language of Director can be attached to a cast member or be a cast member in its own right. It can also be placed in locations in the score.*

* J. Roberts. *Director 5 Demystified* ©1996 by Jason Roberts. Reprinted by permission of Addison-Wesley Longman Inc.

A final note on Director. It does feature its own tool for translating Director movies into Web content. It is called Shockwave. Run your movie through Shockwave, and it is available to anyone who has access to it and who has a Shockwave plug-in. Plug-ins for the Internet and related issues are discussed further in Chapter 12.

This is a very cursory review of the elements of Director, but I hope it at least shows you the complexity and the mechanical procedures required to create prototypes with the authoring system.

PROTOTYPING DIRECTLY TO THE INTERNET

Director movies can be imported to the Net by converting them to Shockwave files. So prototypes created in Director, for example, can be reviewed as movies and then posted to the Web for all to see. The problem with that process is that, although it is fairly easy to build a prototype of a Web site in Director, the final version will most certainly not be delivered entirely in Shockwave. The memory requirements of Shockwave are just too great. So, although there has been a tendency to create prototypes in one authoring environment and then to deliver the final program in another, many Web site developers are now building prototypes directly on the Internet. That process can't, of course, be employed for all CD-ROM or interactive television prototyping, but it does work for the Web.

There are a lot of good reasons for prototyping directly on to the Web. For one, if the final product is to be a Web site, the prototype programming can be a way of creating the actual structure of the site. Then no one will have to go back, take the prototype apart, and rebuild it as a Web document. In this case the prototype simply becomes more and more refined until it is a pilot of the final site and eventually the working site itself. A lot of steps are saved.

Another reason for creating prototypes directly on-line is the ubiquity of the Internet. If the Internet is everywhere, then anyone who has the password to your protected server can look at your prototype without file transfers, Zip discs, or other portable media.

Although not all designers are as proficient at Perl, CGI, Java, and the other programming languages required to create sophisticated Web sites, the basic language of the Internet, HTML (Hypertext Markup Language), is quite easy to learn. Moreover, many text development programs such as Microsoft Word can translate a page of text into HTML automatically. For more sophisticated Web design, Web building tools, such as Macromedia Dreamweaver, are making Web authoring available to more and more designers. So, let's take a look at both HTML development and the use of Web authoring tools.

HTML (Hypertext Markup Language)

HTML is not a programming language. It is a markup language. That is, it is a set of codes used to indicate how pages are to be laid out for display. In that sense it is very much like a set of editor's marks that say, the text goes here, the pictures go there, the type should be this big and this color, etc. The difference between HTML and the kinds of markups used in publishing, of course, is that HTML page layout indications are not interpreted by typesetters but by network browsers, such as Internet Explorer and Netscape, to determine how to present a page of information on the Internet.

Another big difference between HTML and classic page layout systems is that it uses hypertext. Embedded within hypertext are commands and controls that allow users to jump automatically to a preselected page. So HTML has the ability to display text and graphics and to link between pages on the Internet.

For more on the technical side of HTML, check out the extended write-up about it in the next chapter.

HTML can be read by any browser. Netscape, Internet Explorer—they all read and use HTML. If you know how to use raw HTML, you can put up a Web site anywhere, any time, on any computer without having to buy a special software development package. HTML uses ASCII code, the same text code that is the raw material of all text documents, so you can create HTML code in anything that will generate ASCII text, from Apple's SimpleText, to Microsoft's Notepad, to any word processor such as Microsoft Word.

Now, Microsoft Word will actually save its text as HTML if you ask it to, and there are very good reasons why that is a good way to develop HTML pages. But you're not going to get an understanding of the underlying principles of HTML if you just "save as HTML." So, let's go a little deeper.

Once you learn the basic HTML codes and what they are for, you can build a page or a set of pages and save them in ASCII. You need to use a Web browser such as Netscape to access the page you have created, and you must have saved it with the right title (such as Page.html). But then, WHAM, you have created a Web site. If you want to show it to the world, find a server to put it on and you have become a Web author. Just for the record, most service providers, such as America Online, offer server space to their members. So if you have a membership on AOL, for example, you can put your Web site on their servers and anyone can access it from there if they know the right name: its URL (Universal Resource Locator).

There are a lot of great things about authoring directly in HTML. For one thing, you can read a page of HTML and it makes sense. It isn't some unintelligible computer code. It is what it is: a page of headlines and text, including a set of markup codes that tell you how to lay out your pictures and text, and right in the middle of the codes are the text names of the pictures.

This means among other things that HTML is amazingly easy to edit. If there is a mistake on your Web page, go into the HTML, find the mistake (usually in the text), change it, save it, and voilà, your page is fixed. It doesn't take programming skill to edit HTML. HTML is about page layout. Moreover, once you have built your standard page formats, you can just copy, paste, and edit the page format and use it over and over again. You just substitute new text and new pictures but maintain the original page layout and the control strip, which serves as a common menu bar that offers consistent navigation throughout your entire Web site. The nav bar can be made up entirely of Hypertext links to the other pages or other features.

There are some great books that take you through the HTML process step by step. My favorites include *Using HTML*, from Que Publications, and *WEB Design in a Nutshell*, from O'Reilly Publications.

To get serious about programming in HTML, get and read either of those books or find one that suites your tastes. For a quick glimpse of how HTML works, check out the example in Figure 11.5.

It is a classic Web page for our hypothetical TV show *High Sierra Mission*. It's not a real show, but it is a real Web page. That is, it is written in HTML and was opened with Netscape. Below the page is the HTML code that created the page.

There are two good things about that code. First of all, it is an example of real code. Secondly, it is all the HTML you need to create a Web page of your own. I suggest you copy over the HTML into a different ASCII text document, insert your own headlines, JPEG picture, blocks of text, and links, and you will have made your own page.

But before you do that, let's look at the code and see what it means.

```
<TITLE>MOUNTAIN RESCUE</Title>
</HEAD>
<BODY><BGCOLOR= Tan>
<hr size=3 width=95% align=center>
<h1 align = center><FONT COLOR = BRIGHT RED>HIGH SIERRA
MISSION</FONT></h1>
<hr size=3 width=95% align=center>
<hr size=3 width=75% align=center>
<p align=center><A Href="LOG.html">THE LOG - - -</A>
<A Href="secrets.html"> MOUNTAIN SECRETS - - -</A>
<A Href="secrets.html">RESCUE HISTORY - - - </A>
<A Href="CREW.html">THE CREW - - - </A></A>
<A Href="CRITTERS.html">THE CRITTERS - - - </A>
<A Href="CAST.html">THE CAST - - - </A>
<A Href="ADVENT.html">THE ADVENTURE</A></P>
<p ><img src = "hs1.jpg" hspace=15></P>
<h3 align = center> <font color = bright red> Join The
Intrepid Mountain Rescue Team as They Save Lives In the
Wilderness</font></h3>
<hr size=3 width=80% align=center>
```

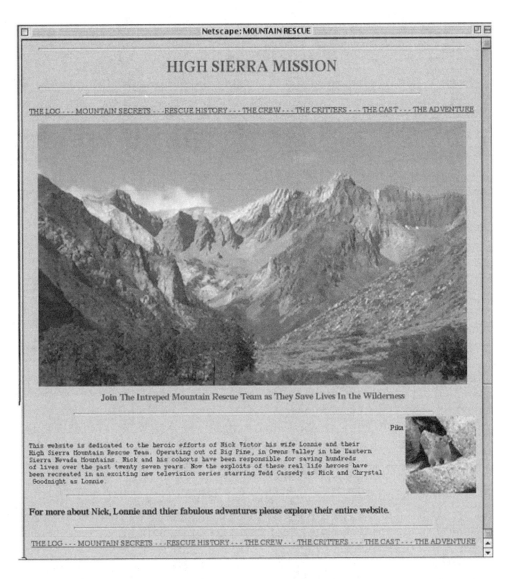

Figure 11.5 Web page for hypothetical site High Sierra Mission with HTML shown below. Photograph © Virginia Iuppa, 2001.

```
<P><img src = "pika.jpg" align=right></P>
<p align = right> Pika</p>
<pre>This Web site is dedicated to the heroic efforts of Nick
Victor, his wife Lonnie and their High Sierra Mountain Rescue
Team. Operating out of Big Pine, California and the Eastern
Sierra Nevada Mountains, Nick and his cohorts have been
responsible for saving hundreds of lives over the past twenty-
seven years. Now the exploits of these real life heroes have
been recreated in an exciting new television series starring
Tedd Cassedy as Nick and Crystal Goodnight as Lonnie.</pre>
```

```
<hr size=3 width=80% align=center>
<h3 align=center>For more about Nick, Lonnie and their
fabulous adventures please explore their entire Web
site. </h3>
<hr size=3 width=80% align=center>
<p align=center><A Href="LOG.html">THE LOG - - -</A>
<A Href="secrets.html"> MOUNTAIN SECRETS - - -</A>
<A Href="secrets.html">RESCUE HISTORY - - - </A>
<A Href="CREW.html">THE CREW - - - </A>
<A Href="CRITTERS.html">THE CRITTERS - - - </A>
<A Href="CAST.html">THE CAST - - - </A>
<A Href="ADVENT.html">THE ADVENTURE</A></P>
</BODY>
</HTML>
```

HTML code items are called tags, and they are contained within angle brackets.

The / sign indicates the end of something. So the entire page is contained within the HTML start and stop tags <HTML> and </HTML>. Together these two tags are called a container.

<HEAD> </HEAD> within this container is information that may be important to the site, but most of which is not seen on the site itself. Most of the information is not critical for prototyping except the title, which provides that name that appears on the browser bar. <TITLE> and </TITLE> tags contain the title within the <HEAD> container.

<BODY> </BODY> are tags that indicate the beginning and end of the body of the page. They are optional today on many browsers, but they serve as a good way to recognize the distinct content of a page.

<P> and </P> indicate the beginning and end of paragraphs. They also allow you to set rules for the display of the paragraph. For example <p=align center> means that the following paragraph is aligned to the center of the page and that paragraphs that come after this particular paragraph will be governed by their own parameters.

<BGColor> refers to the background color of the page and can be expressed a number of ways. The latest browsers support full names of colors. You can try and learn the color formats expressed as RGB values or hexadecimal numbers, which are more accurate. A simpler way is to choose a color name, then call up the page on your browser and see what the color looks like. For the record, tan is 211-180-140 in RGB values.

<H> refers to headline text. H1 indicates the largest size of that text. There are six different sizes that differentiate various headline strengths, 1 being the greatest. The rest of the instructions indicate that the headline is aligned to the center and that the font color is red. Or as it says in the code: <H1 ALIGN = CENTER>HIGH SIERRA MISSION</H1>.

<HR> is an indicator for a shadowed, horizontal rule (line) that runs across a percentage of the page. There is a paragraph break before and after the line. The tag <hr size=3 width=95% align=center> shows how tags are able to express dimensions and tells us about the line itself. Its width fills 95% of the page. It is aligned in the center and it is #3 depth.

THE CAST is a tag indicating the destination of a hyperlink. It is an anchored URL in quotes followed by its definition. The definition is the word that comes after the tag that, when clicked on, will take the user to the appropriate new page.

 indicates that the JPEG image of the Pika (which I was amazingly lucky to photograph) should appear at that point in the display and aligned to the right of the page.

<Pre> refers to preformatted text, which is the easiest but also the least creative way to get a block of text into the document. The tags <Pre> and </Pre> mean that everything that is contained between the tags will be displayed exactly as you type it. So you don't have to worry about where the line spaces will break. Hit return whenever you want and the sentence will break there.

The downside is that browsers often display preformatted text in very unimpressive fonts, such as Courier. Still, if you can live with the font, you will find this the easiest way to enter text. Otherwise, designate the font you want and use the tag to indicate a break in the line.

You can see that we repeated the nav bar at both the top and bottom of the page (not a bad idea on pages that require a lot of scrolling).

So, there you have an explanation of the basics of HTML, and even a template that will allow you to create simple Web pages. I suggest you go through the rigor of retyping this HTML doc in SimpleText or Notepad, only add the text you want, the colors you want, and the pictures you want. Remember to save them as JPEGs. Put them in the same folder as the HTML text and end the name of the HTML document with .HTML (or .HTM if you are using DOS).

Want more? As I said earlier, get a detailed book on HTML, or learn how to use an authoring tool such as those we will review right now.

WYSIWYG Authoring Tools

A "true programmer" will build Web pages with a simple text editor (such as TextPad or SimpleText) or a specialized editing program such as BBEdit. However, several companies offer Web-page development tools that provide "what you see is what you get" authoring and editing capabilities.

- *Macromedia Dreamweaver.* This software package allows you to visually lay out your page using a simple drag-and-drop method, and it creates the underlying HTML for you (Figure 11.6). As you learn, you can view

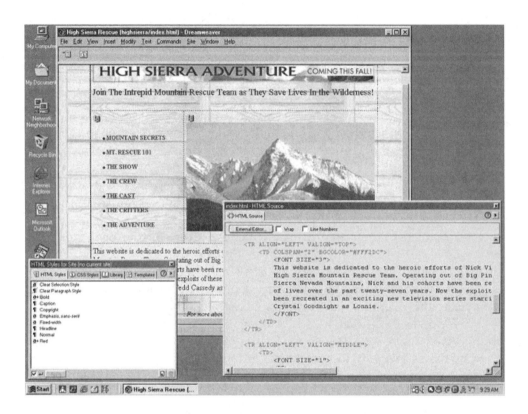

Figure 11.6 The development environment in Dreamweaver. Note: The large window shows the page as it will appear in a browser. You can create new content items like text and photos in this window and move items around. The small window at the left makes it easy to define text styles on the page: bold, caption, and headline, for example, allow you to create and apply style definitions, and give you access to libraries and templates. The window at right shows the HTML page being created or modified for this page.

the design in one frame and the actual code in another frame, allowing you to see how the code is created and edit it yourself if desired. Dreamweaver also helps you write and debug JavaScript code on your page, and will automatically create Flash elements for your text and buttons. Dreamweaver is generally considered to be the authoring tool that creates the cleanest code. Like other Macromedia authoring systems such as Macromedia Director, Dreamweaver does require an investment of time and money, but is a great choice for designers who intend to create finished Web sites.

- *Microsoft FrontPage.* This tool is easier to use than Dreamweaver. But it is full of Microsoft tags, so if you and your users are not "exclusively Microsoft" there will be conflicts.

Other products that provide similar functionality include HomeSite from Allaire, and HomePage from Filemaker.

So there you have an overview of the world of prototyping (ideally with enough information to actually build some basic prototypes). And now that we have taken these first steps into the technical world of authoring tools, let's dig more deeply and review more complex Web authoring materials before we go on and study some specific applications of this technology.

12

The Technology of the Web

Though some of the concepts behind the World Wide Web go back as far as 1945, the technology to implement it in a practical way began to appear in the late 1980s. Initial uses of the Web were for publishing information by major universities and high-technology organizations around the world.

It wasn't until the mid-1990s that the Web began to be used for commercial applications such as content publishing, entertainment, marketing, advertising, and commerce.

This chapter will highlight some of the technologies you should understand before you begin building your own Web pages.

HOW THE WEB WORKS

The basic idea behind the Web is that documents can reside on a computer—a powerful computer with specific capabilities, called a *server*—connected to the Internet. Another computer—your personal computer, called the *client*—can request a document from the server simply by knowing the "address" of that document. That address, called a Universal Resource Locator (URL), gives the name of the server, the name of the document, and the document file's location on that server. When the server receives a request, it delivers the document to the requesting client computer.

CLIENTS AND SERVERS: CLIENT-SIDE APPLICATIONS

When you run a Web browser on your personal computer and request a Web page, you are the "client" in this transaction. When you hear about a technology being "client-side," this means that it is running in conjunction with or as part of the Web browser.

Conversely, when a program or functionality is referred to as "server-side," that means that the software is running on a Web server or in conjunction with one.

We will first focus on "client-side" applications: Web browsers and various additional programs that run on a personal computer. Later in this chapter we will highlight some "server-side" applications.

Web Browsers

A *Web browser* is an application program that runs on your personal computer. It is a specialized type of program that performs a unique function: to request Web documents ("pages") from Web servers.

Two commercial Web browser programs account for the overwhelming majority of Web access today: Internet Explorer and Netscape Navigator. Both of these browsers are available for download free of charge from their developers, and for most Web-browsing uses they are functionally identical.

Netscape Navigator is a product of Netscape Communications Corporation in Mountain View, California. Incidentally, the initial team that built this browser included several of the programmers from the National Center for Supercomputing Applications at University of Illinois at Urbana-Champaign. This team, including their leader Marc Andreesen, created the first graphical-based Web browser, called Mosaic, back in the early 1990s.

Internet Explorer (nicknamed IE) is a Microsoft product and is currently the most popular Web browser on the market. Microsoft was just one of more than 100 companies that licensed the Mosaic browser technology from NCSA as the foundation for their own product.

Both browsers provide the basic functionality you need to look at Web pages. That includes display of text, graphics, and other media retrieved from pages, customizing the appearance of the browser according to your preferences, and the ability to keep track of "favorites" or "bookmarks" for sites you visit frequently.

Both browsers also support the addition of software tools that extend their functionality. These tools, called "plug-ins," can add the ability for the browser to play specialized types of multimedia including animation, audio, and video. Several popular plug-ins will be discussed later in this chapter.

HTML

As noted in Chapter 11, Hypertext Markup Language, or HTML, is the fundamental technology upon which most Web sites are developed. It is not a programming language, but rather a way to "mark up" documents to describe how they should appear in a Web browser. Since all the server does is deliver the document to the browser, we put HTML on the client side of the discussion.

Historically, HTML finds its origins in SGML, or Standard Graphic Markup Language, which was developed for use in the print publishing industry. HTML

was adapted from SGML for use on computing platforms. Today, the standard for HTML is managed by the World Wide Web Consortium (w3.org) based at the Massachusetts Institute of Technology (MIT).

An HTML page is a text file containing "tags" that describe how items on the page should look: titles, paragraphs, lists, text styles, and so on. A tag can also be used to make a word or picture on the page "link" to another page; hence the "hypertext" part of its name. By understanding just a few of the basic tags, you can develop simple pages very quickly.

When a Web browser receives an HTML page, it interprets the tags and displays the page to you in the format intended by the page's author. Since each user can customize some of the features of their browser (text font size, window dimensions, etc.), the display of a page is not guaranteed to exactly match the author's design. However, a good page design will take into account these variables and should present a pleasing appearance regardless of the browser's configuration.

Most of the early examples of Web sites were developed entirely in HTML, primarily by page creators using simple text-editing tools. Today, you can still build a very compelling and attractive site using just HTML for text and graphics, though now there are many tools that can help you in this process (some of which were described in Chapter 11). In the past few years, the HTML standard has grown to include background colors, font styles, colors, and sizes, embedded graphics, tables, and frames. A very attractive Web page that resembles a page from a high-quality magazine can be built using simple HTML and nothing else.

There are myriad books and on-line tutorials to show you the fundamentals of Web page construction using HTML. One of the best ways to learn HTML is to view the work done by others. Both IE and Navigator provide a "view source" capability that will allow you to see the underlying code behind a displayed page.

Incidentally, one notable difference between IE and Navigator is their tolerance for incorrect HTML. Historically, every version of Navigator has been very strict about the HTML it displays being in the correct form, with correct beginning and ending tags throughout; the equivalent version of IE has been much more forgiving, filling in those occasional missing end tags as needed. When you build a Web page, you should view it in both IE and Navigator to make sure that everyone who visits your site with either browser will be able to see the page as you intended it.

DHTML

Dynamic HTML is an extension of the HTML standard that provides additional functionality. It allows page developers to add life to their pages, both in text and graphics, by letting a Web page change itself even after it's been loaded into the browser. For example, a text item can change its color or size, a graphic can

move from one place to another, and information can be hidden or revealed on the page in response to the user's actions.

DHTML also provides the concept of layering, or Z-ordering. This allows items on the page to be on top of or underneath others and change their position within those layers dynamically.

DHTML is supported only in versions 4.0 and later of both IE and Navigator. Again, their implementations are slightly different, so be sure you view your DHTML code in both browsers before you release your dynamic page to the world.

JavaScript

JavaScript is a programming language developed for use on the Web and that is understood by the latest versions of Web browser applications. Most uses of JavaScript are designed to enhance the interactivity of a Web page that would otherwise be static without them. Buttons that highlight when you click them, text that changes color when you roll over it—these are common uses of JavaScript.

JavaScript code is typically embedded in an HTML page, providing new functionality that a simple Web page could not achieve. The Web browser interprets the code when the page is loaded and takes appropriate action when certain conditions are met: when you click on a button graphic, for example.

Writing JavaScript code is not for the faint of heart. An understanding of another programming language (Visual Basic, Pascal, or C) would be a good foundation for developing applications in JavaScript. Learning by example is another good method: find a Web page with an interesting functionality and "view" the source code for the page. Between the <SCRIPT> tags you'll find the JavaScript code. The on-line documentation provided by Microsoft and Netscape can be a good place to begin understanding uses of JavaScript with those companies' Web browsers.

Note: JavaScript should not be confused with Java, which is discussed later under "Server-Side Applications."

Flash

Macromedia Flash is a technology that allows you to create simple yet effective animations and play them on a Web page. Flash is often used for user interface elements like animated buttons and menus, and is frequently used to present content and advertising in interesting and compelling new ways. Animations are in the form of vector graphics, which feature a small file size (and therefore a short download time) when compared to GIF or JPEG format graphics.

The Macromedia Flash Player plug-in comes preinstalled in the Windows 98 and Macintosh operating systems and WebTV set-top boxes, and is included

with the installers for Netscape Navigator, America Online, and Prodigy software. That means that you can count on over 95% of your audience being able to play the Flash content on your Web page. For those few who don't already have it, the Flash Player plug-in is available as a free download from Macromedia.

Flash files can be authored using the Macromedia Flash application, Macromedia Freehand, and other tools that support the SWF file format, such as Adobe Illustrator.

Shockwave

Macromedia Shockwave is more sophisticated technology that can be used to create more advanced animated and interactive elements for your Web pages. Shockwave is often used to create interactive multimedia product demos and training, merchandising applications, and rich-media multiplayer games.

The Macromedia Shockwave Player plug-in is also pre-installed on Windows 95, 98, and 2000 and Macintosh operating systems, America Online 5.0, and the current versions of Netscape Navigator and Internet Explorer.

Shockwave files can be created using the Macromedia Director 8 Shockwave Studio application. Macromedia Director is the industry's leading multimedia authoring platform. At the heart of the Director authoring system is the LINGO programming language, providing serious computing power for your interactive applications.

Flash versus Shockwave?

Flash is primarily used for fast-loading animated elements on your Web page, such as user interface elements and interactive advertising. Shockwave is much more powerful and is usually used for much more sophisticated applications. Shockwave files tend to be larger and require more download time.

QuickTime

Apple Computer's QuickTime media platform allows you to play time-based media such as audio, video, and animations on your Web pages. The QuickTime plug-in installed in your Web browser will play QuickTime audio and video "movies" and supports the key standards for Web streaming plus MP3, AVI, WAV, and graphical file formats such as JPEG, GIF, TIFF, BMP, PICT, PNG, and Flash, among others. QuickTime VR adds the capability to view virtual environments with panoramic 360-degree views and 3D imagery. The majority of media available on the Web can be played with this single browser plug-in.

The QuickTime plug-in is included in the installation package for both Internet Explorer and Netscape Navigator and is preinstalled on all Macintosh computers. QuickTime is the premier technology for the presentation of digital

content on the Web and is installed on more than 100 million computers (both Macintosh and Windows) worldwide.

Windows Media Player

Microsoft's latest entry in the digital media realm is Windows Media Technology, featuring the Windows Media Player as the client application for media playback. It is intended for high-quality playback of audio and video streams for clients utilizing a broadband connection to the Internet. CD-quality audio and full-screen video at rates up to 60 frames per second are possible using the proprietary Windows Media Format. Using Windows Media Format can allow you to provide high-quality audio in a file half as large as a comparable MP3 file.

Version 7 of Windows Media Player incorporates seven media functions: CD player, audio and video player, media jukebox, media guide, Internet radio, portable device music file transfer, and an audio CD burner.

Windows Media Player is included on all Windows 98 and Windows 2000 operating system installations.

RealAudio and RealVideo

These pioneering applications from RealNetworks set the pace for streaming media on the Web, with more than 155 million registered installations since its inception in 1995. RealAudio was an early standard for presenting streaming audio, and it was followed by the RealVideo standard.

Millions of Web pages still feature Real-format audio and video, though the media does not live up to the quality standards now being set by QuickTime and Windows Media.

The RealPlayer application is available as a free download from RealNetworks and can be used either as a plug-in or a stand-alone application. There is also an enhanced version, RealPlayer Plus, available for purchase.

SERVER-SIDE APPLICATIONS

Now that you are familiar with the user's side of the equation—the "client side"—it is time to discuss the more complex world of "server-side" applications.

Servers

As mentioned earlier, a "server" is a computer that makes Web documents available to a client. A server can be a powerful specialized computer sitting in a secure facility with a high-speed connection to the Internet backbone; it can be

a moderately speedy desktop computer sitting in your server room, connected only to the intranet in your office; it can even be the laptop on your desk, serving Web pages only to the browser running there.

The software that delivers Web pages conforms to a standard called Hyper-Text Transfer Protocol, or HTTP. That's why you see Web addresses starting typically with "http://...." There are numerous software packages that support this protocol and can be used to serve up Web sites from almost every kind of computer made today. Most Web servers are running some flavor of the UNIX or Windows operating systems, though an excellent server can be built on top of Apple's Mac OS or Linux. Some equipment manufacturers have their own versions of UNIX, such as IBM's AIX, or Hewlett-Packard's HP-UX, or Sun Microsystems' Solaris.

Active Server Pages

Once you build an HTML page, it is static. It can be delivered millions of times to your page's viewers and never change. Updating an HTML page takes time and effort. If you have content that changes frequently, or a large number of pages to keep current, you might be interested in server-side applications that can help you automate that process.

Microsoft's Internet Information Server (IIS) is a program that not only serves Web pages (HTML) but also adds a powerful server-side programming capability. This functionality, called Active Server Pages (ASP), allows you to place software statements in your Web pages in addition to the standard HTML. When a client requests one of these pages, the server retrieves the page and looks for embedded software code within it. If code is found, the server executes that code before it delivers the page to the client.

This allows you to add lots of interesting functionality into your page. It could be something as simple as displaying the current date on the page, or as complex as fetching information from a database to display a list of news story headlines, with each headline a clickable link to the detailed news story. Using this functionality allows you to create Web pages that contain much more dynamic content.

The software within your page can be written in JavaScript or Microsoft's proprietary VBScript or JScript languages. When you're browsing Web sites, look at the address bar for the name of the page you've retrieved. If the filename ends in ".asp" you've encountered an Active Server Page. With the increasing popularity of IIS as a Web server, millions of ASP pages are being served every day on thousands of Web sites.

ColdFusion

The ColdFusion suite of products from Allaire provides functionality that is similar to Active Server Pages, but is available for Windows, Linux, Solaris, HP-

UX, and other server platforms. Like ASP, it allows you to embed code in your Web pages that is executed by the server prior to delivery to the client.

ColdFusion has the advantage of being highly scalable; that is, if your site is going to be quite extensive or viewed by a very large number of users, Cold-Fusion can scale up to meet the demand. This popular product is being used to serve many heavily visited sites with excellent results.

Another advantage is the large number of proven software components that have been developed using ColdFusion; if you have a requirement for a specific software application, you might be able to find it in their extensive library of components. There is also an extensive network of qualified ColdFusion developers available to assist you with your project.

When you encounter pages created by ColdFusion on the Web, you'll recognize them by their ".cfm" file extension.

CGI/Perl

The Common Gateway Interface (CGI) is a standard for creating programs that deliver dynamic Web pages. This was the original method for building pages "on the fly," predating proprietary developments such as Active Server Pages and ColdFusion that provide similar functionality.

CGI applications can be used to gather data from a database or perform complex calculations based on real-time information, tasks a basic HTML page could never handle. A CGI script can be used to process the data on an HTML form, validate it for correctness, report any data entry errors, and update a database when the information is properly entered. This is precisely the type of application for which CGI was originally developed.

You will recognize CGI-built pages when your browser encounters a Web address with "/cgi-bin/" in the middle of it. The file to which your browser links is not a simple HTML file, but rather a program or script designed to create the Web page and deliver it to you. A CGI program can be written in a programming language such as C/C++ or Fortran, or in a scripting language such as Perl or AppleScript.

Perl is a high-level programming language that was derived from several other languages, notably C. It is often interpreted (rather than compiled), which means that you can build a script, test it, tweak, test again, tweak again . . . very quickly and easily. Many CGI scripts are written in Perl for that very reason: quick testing and debugging. Learning to write Perl scripts is easy if you have some UNIX experience and are familiar with other programming languages.

You can find countless examples of CGI programs and Perl scripts archived on the Web, many available for you to use freely on your own server. If there's a simple functionality that you need CGI to do, there's a good chance that someone has already built it! A quick search on Yahoo!, for example, yields scores of sites offering free CGI code for a wide range of interesting applications.

Java

Java, created by Sun Microsystems, is an amazing technology that features two major components: a programming language and a platform. It is included here in the "server-side" section since it is a powerful tool for creating server applications (and even servers themselves). However, it is also applicable on the "client side" of the process since Java programs can run in a Java-capable browser or on most popular personal computers as well.

The Java programming language is sophisticated and powerful, yet can be easily learned by anyone familiar with the C++ programming language. As defined by computer scientists, Java is a general-purpose, high-level, object-oriented language. Java was designed to be simple to understand (relative to other programming languages, that is), yet capable of building robust, secure applications that feature excellent performance.

The Java Platform is the environment in which your Java programs run. You are already familiar with other platforms such as Windows, UNIX, and the Mac OS. These are usually thought of as the combination of the hardware and operating system software. The Java Platform is software only and runs "on top" of the other common platforms. It provides an environment that any Java program—written on any computer—can run in.

Java programs fall into two categories: applications and applets. A Java application might run on a server and perform a specific function, such as analyzing data from a database or managing a list of on-line contest entries. A Java applet is a program that runs inside a Web browser. In your travels surfing the Web, you have likely encountered applets that play animation, display a constantly updating clock, or even create an elegant interface to an on-line chat room.

Sun's success with Java comes from its portability: an application written in Java can run on any computer that supports the Java Platform. That is the thinking behind Sun's "write once, run anywhere" concept. The Java Platform has been developed for use on powerful server computers, desktop personal computers, handheld electronic devices, television set-top boxes, mobile phones, automobiles—the list goes on. It is on its way to being the ubiquitous programming environment for controlling and communicating information between devices.

Java's power and portability make it an excellent weapon to have in your arsenal for creating serious applications for the Web.

Databases

An excellent way to build a Web site that features dynamic data is by putting the content of the site in a database. Companies who built their expertise providing database software for traditional business applications are now finding new opportunities by expanding their offerings to include Web support. Oracle,

Informix, and Microsoft's SQL Server are among the popular database applications that support Web site development.

When you put your site content in a database, your data can be stored and formatted independently of the presentation of the site itself. You could use Active Server Pages or ColdFusion, for example, to extract the data from the database and create the pages that are delivered to your users. Then you can completely change the way your site looks—the way information is presented— by simply changing the .asp or .cfm files. Imagine, for example, that you have a catalog site with 10,000 products; each product is represented by a page on your Web site. If the site consists of 10,000 separate HTML pages, changing the look of your site (background color, navigation buttons) would be very time consuming and labor intensive. If that data is stored in a database instead, you might change just a handful of page "templates" to completely change the look of your site.

With your data stored in a database, you can take advantage of all the database architecture and functionality to maintain and manage your information. The tools and techniques developed over decades of database management can be at your disposal.

Keeping your data in a structured database, instead of "flat" HTML files, allows you to update the content of your site much more easily. In our previous example, anyone who was tasked with updating a product's page might have to know quite a bit about HTML to get the page right. Instead, you can put all the complex HTML coding (and DHTML and Flash and whatever other technologies you choose) into your template files; the data is stored in the database. Then you can build or implement data entry software to allow easy updating of the database itself. The data entry program can be extremely user friendly and guide your staff through the process of creating a proper catalog entry; no HTML experience required!

Maintaining and delivering your database content will require database software, including the server components that provide the data for your pages. That server software might reside on the same computer that delivers your Web pages. However, what if your Web server runs on Windows and you prefer a UNIX-based database application? No problem. You can have separate servers (running on separate computers) handling these two specialized tasks. You will want a high-speed connection between the two machines, and you'll need to implement the communication software to make the two applications "talk" to each other. Although this is not trivial, you won't be the first to implement it, and there are plenty of excellent applications out there to help you get it right.

Flash Generator

As we discussed in the "client-side" section, Macromedia Flash is an excellent tool for creating highly interactive navigational and information elements for

your Web pages. However, what if you want to use it to display content that changes frequently? Do you really want to hand-build new Flash elements every time your content changes?

Macromedia provides a product called Flash Generator that can be very useful for this type of situation. Using Macromedia Flash, you construct the dynamic interactive element for your page, indicating the places where database information belongs. When a client requests the page containing that Flash element, the server asks the Flash Generator application to build the element with the latest data.

Delivering the latest news headlines in a scrolling interactive display, charting stock price information in real time, or just animating the user's name in a unique personalized presentation: these are all possible using Flash Generator.

Used in combination with a database (as discussed earlier), this technology can allow nontechnical people to update very sophisticated elements of your site.

Streaming Media Servers

If you are going to provide your own streaming audio or video on your site, you will need a server dedicated to delivering the data streams. Depending on user demand, the server might need to be very powerful with lots of high-speed disc drives to contain and deliver the content. The server will also require a high-speed connection to the network (internal or Internet) over which the streams will be delivered.

As discussed previously, the client-side players for the popular streaming technologies are all available to your users free of charge via download, and all of them are available for the most popular client computer platforms. This is not always true of the server side of this equation.

An important factor when considering streaming server demand is the concept of "concurrent streams." This can vary dramatically depending on your content, its timeliness, and the audience. Let's say you are serving a 30-minute video stream for a training application. Your users might be geographically dispersed, perhaps even around the world, and they will belong to a particular class of individuals. In this case, you might have a demand for 10 to 15 concurrent streams (that many people viewing the stream at the same time), but that demand might be steady at all hours of the day and night. Now let's say you are streaming a 30-minute live fashion show featuring the latest offerings from the Victoria's Secret catalog. The demand for that stream might be enormous: hundreds of thousands of users all at the same time. You need to provide a very large number of concurrent streams. However, after that half hour the demand is gone; the show is over.

Windows Media Services software is available free from Microsoft for use on a Windows NT server; if you install Windows 2000 Server as your Web page delivery environment, the Windows Media Services software is included in that installation process. You can serve any number of concurrent streams at no additional charge. A single server might support 9,000 narrowband streams or 2,400 broadband streams. The only expense you will incur will be for additional server hardware to meet your demand.

Apple's QuickTime Streaming Server is available as a free download from Apple Computer and is included with the Mac OS X Server software. The Quick-Time Streaming Server (QSS) software has been written for servers running the Macintosh OS, Windows, Solaris, UNIX, and FreeBSD. The source code for the server software is also available free, should you be interested in converting the software to run on another type of server platform. QSS supports more than 2,000 concurrent data streams from a single server and is also excellent for delivering live broadcasts.

The RealServer software is available for purchase from RealNetworks, and the price you pay depends on how many streams you want to serve. RealServer Plus provides up to 60 streams, while the RealServer Pro package comes in configurations of 100, 200, or 400 concurrent streams and includes technical support. RealServer runs on Windows, Linux, Solaris, FreeBSD, HP-UX, IBM's AIX, and Silicon Graphics' IRIX operating systems.

We have taken a brief look at the technology of the Web from both the client and the server sides. But all that technology is useless without something to deliver, and what the Web delivers is (in a word) "content."

Of course, all that content has its own requirements and design principles. So, let's turn next to the various content areas delivered by the Web and by other forms of new media.

Interactive Instruction

III

Basic Structure

One way to think about the fundamental elements of instructional design is to divide them into lessons and tests. Included in the first element (lessons) are two activities called demonstrations and exercises. The demonstration explains how to do something; an exercise lets you practice doing it. They are taken together because their fundamental purpose is instruction, to teach something. Tests, on the other hand, are given to find out whether you have learned.

One way to tell the difference between an exercise and a test is to consider the kind of feedback they offer. Because tests are designed to find out whether a person has learned something, their feedback is more generalized. In some cases they don't offer any feedback at all other than a final grade. Their purpose is to evaluate whether or not you have learned and then to allow you to progress. Exercises, on the other hand, are all about feedback because their purpose is to help you learn.

The truth is that although demos, exercises, and tests are all important, the function we will spend most of the time considering is the exercise. In the next chapter and beyond we will consider how to construct exercises that match the goals of the lesson and to use interactive media to make exercises most effective.

But before we get into that level of detail, let's focus on overall interactive structures. Again, for that purpose, we will consider demonstrations and exercises together as parts of the lesson, and we will see different ways to combine lessons and tests to provide the most flexible structure for learners.

Figures 13.1 and 13.2 present two basic instructional design formulas. The basic lesson design flowchart in Figure 13.1 indicates that the very minimum you can do when teaching something is to demonstrate it and then ask one or more questions about it in a test. If users answer the questions correctly, they go on to the next lesson. If they fail the test, the lesson and test are repeated.

Figure 13.2 represents a modest expansion of the design shown in Figure 13.1. In Figure 13.2 there are several demonstrations and a multifaceted test. If viewers pass, they go on to the next lesson. If they miss several questions, they start over at the beginning of the first demonstration. If they miss one question, they go back to the part of the lesson that deals with whatever misconception

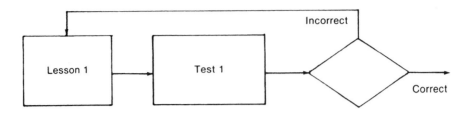

Figure 13.1 Basic lesson design flowchart.

Figure 13.2 Expanded lesson on design flowchart.

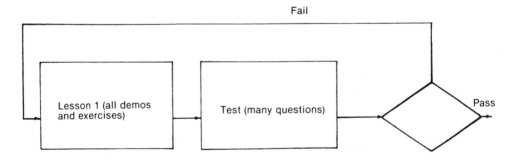

Figure 13.3 Universal lesson design flowchart.

led them to their error (in Figure 13.2, this would be the material presented in Demo 1C). Again, remember that lessons include both demonstrations and exercises and that tests can have many questions.

All major kinds of lessons, then, can be summarized with one flowchart, shown in Figure 13.3. However, an interactive training program usually consists of more than one lesson. In addition, there are other activities that must be carried out as part of a total training program. Let's move beyond lessons and tests to see how lessons fit together into whole training programs. We will also consider elements that can be added to the overall program design to make it more effective.

LESSON ORDER

Instructional interactive programs are usually made up of several lessons. Let's look at some examples of programs that consist of three lessons each. Lessons can be set up in unchangeable order (Figure 13.4). In that case, the viewer must proceed from one lesson to the next. However, lessons can also be designed so that the learner can pick the lesson order using a menu (Figure 13.5). Finally, lessons can be arranged so that the learner must complete a prerequisite lesson before choosing between other lessons (Figure 13.6).

INTRODUCTIONS AND EXAMS

In addition to lessons and tests, most instructional designs call for introductions, which include objectives, explanations, and overviews. There are also final exams, which integrate information from all lessons (unlike tests, which are tied to specific lessons).

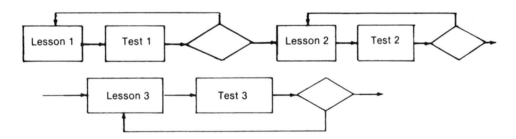

Figure 13.4 Predetermined lesson order.

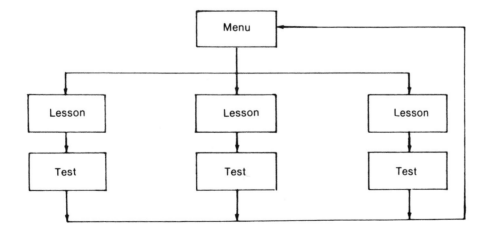

Figure 13.5 Learner-determined lesson order.

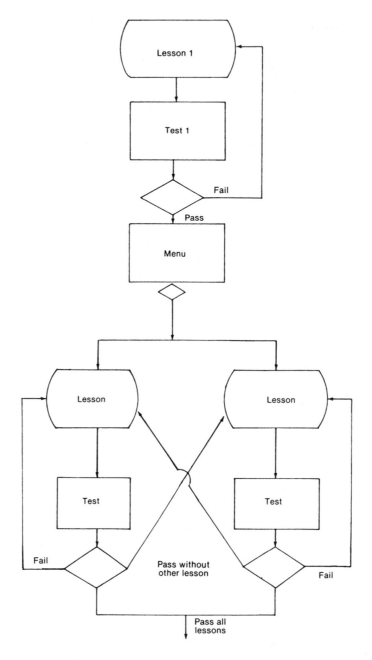

Figure 13.6 Learner-determined order with prerequisite.

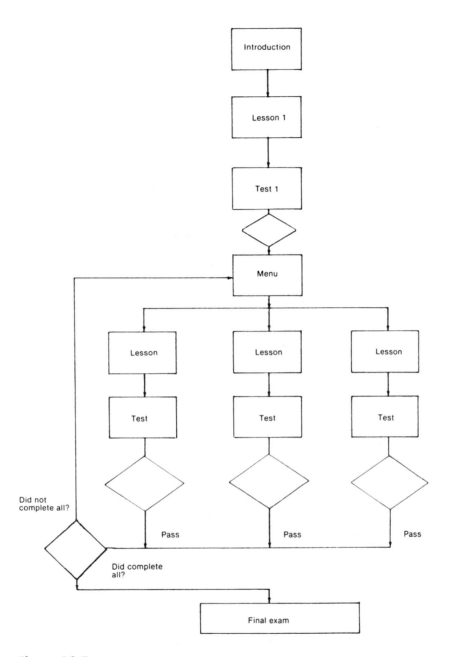

Figure 13.7 Master flowchart for a simple instructional program.

A master flowchart for a fairly simple instructional program, integrating all of these elements, would look like the one shown in Figure 13.7. Note that the "test fail" path is not shown. This omission is acceptable in a level 1 flowchart because it is obvious. However, level 2 and level 3 flowcharts would require it.

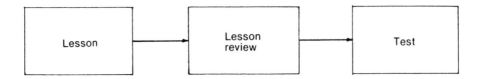

Figure 13.8 Lesson review technique.

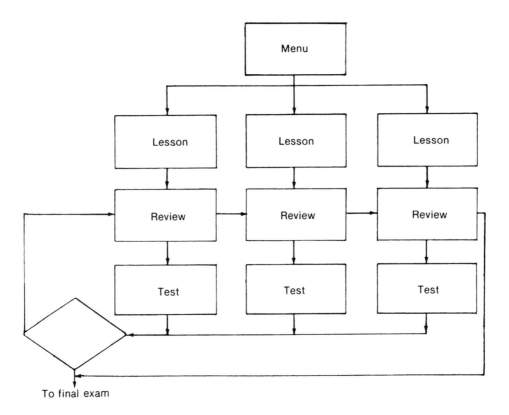

Figure 13.9 Program review technique.

ENHANCING BASIC INSTRUCTIONAL DESIGNS

Various techniques can be used to add some sophistication to lesson designs and make them more effective. These include lesson and program reviews, pretests, and even prologs and epilogs to help provide a context for the learning and to build learner interest.

The flowchart in Figure 13.8 shows how you can insert a review in each lesson before the test segment. The design in Figure 13.9 lets the learner review

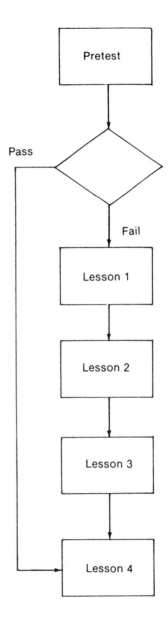

Figure 13.10 Pretest technique.

the whole program by skipping from one review segment to another. After completing the test, the learner jumps back to a review and then immediately branches to the other reviews before taking the final exam.

Figure 13.10 shows how the instructional design can allow for a pretest that permits the learner to skip certain lessons. Here, once the viewer passes the pretest, he or she skips lessons 1, 2, and 3 and proceeds directly to 4.

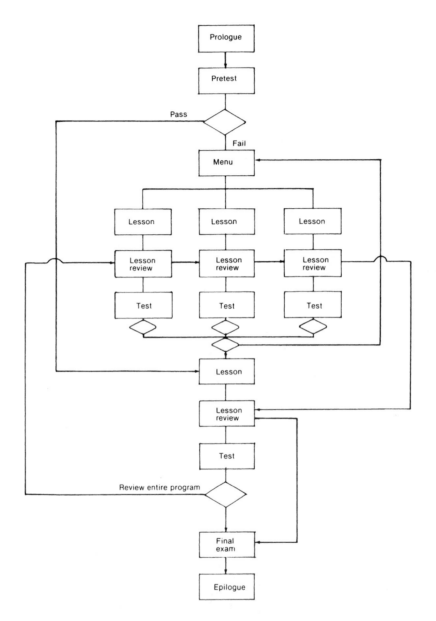

Figure 13.11 Fully developed master flowchart.

A fully developed program design flowchart incorporating all of these techniques is shown in Figure 13.11. What should be clear is that, depending on the design techniques you use, you can create one interactive instructional program that will serve a variety of learners who are at different entry levels.

The flowchart and instructional design techniques presented in this chapter will help you build the framework for your own interactive instructional media.

In the upcoming chapters, we will examine the design strategies that influence the effectiveness of your program in meeting its objectives. These strategies pertain to the design and construction of exercise and test questions, the heart of all interactive learning programs.

14

Exercise Design

Interactive exercises are most effective if they are simulations of the behavior to be learned. As simulation techniques depend on the kind of learning problem being addressed, there can be no universal exercise formula that will serve every kind of need. In this chapter we will look at several different kinds of instructional exercise designs and the learning problems they address. Moreover, even though a detailed discussion of interactive entertainment designs is coming, we will also present a few examples of interactive learning exercises that have been adapted to entertainment content and that work very well with that subject matter.

LEARNING PROBLEMS

Because exercises vary with the problems they solve, let's start with a systematic review of the four major types of learning problems.

Discrimination Learning Problems

Discrimination is the ability to differentiate between several items. For example, I once designed a bank training program to teach learner tellers how to tell the difference between three kinds of teller stamps. The tellers had to be able to recognize when to stamp a customer's check or deposit slip with a "batch" stamp, an "interbranch" stamp, or a "cash-paid" stamp. (Cash-paid was used only when cashing a check or paying on a withdrawal.)

The logical exercise format to choose in this case was a simple three-way multiple-choice exercise, since tellers who were actually performing the behavior were in fact picking one of three items. Figure 14.1 diagrams the part of the lesson dealing with the cash-paid stamp.

As Figure 14.1 shows, upon picking one of three choices, learners were given feedback tailored to the particular choice. If learners selected the correct answer (choice 3), they got positive reinforcement—a pat on the back. There was even some elaboration on why the answer was right before the lesson continued. If learners selected choices 1 or 2 (both incorrect), they got feedback

Figure 14.1 Simple multiple-choice.

Figure 14.2 Complex multiple-choice.

explaining why the particular answer was wrong. The program then looped back, not to the start of the lesson, but to the question so that learners could try again.

By using branching, you can design feedback tailored to the learners' responses. Using specially constructed feedback is far better than just repeating a section of the previous demonstration to provide feedback. Tailored feedback can go into detail about why the answer is wrong and can add new insight into the learning experience. Figure 14.2 shows how you can use branching to expand on the simple multiple-choice formula shown in Figure 14.1.

The branch occurs after the first question, where two diverse paths begin. If the learner is right, he or she gets correct feedback and goes on. If the wrong answer is given, the learner is asked a completely new question (XQ2). A correct

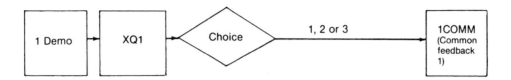

Figure 14.3 Common feedback.

answer to that question steers the learner back into the mainstream. A wrong answer receives incorrect feedback (XFF2), which really explores the misunderstanding behind the mistakes that were made.

An alternative to the branching just described is common feedback. Common feedback is written in such a way that it explains both correct and incorrect answers. There is no branching or looping back following common feedback. Learners proceed directly to the next demonstration or lesson (Figure 14.3).

Common feedback is a technique that should be reserved for questions that are part of a series, such as minor variations on the same idea. Common feedback is less specific and therefore less effective than branched multiple-choice, but in many situations it is quite adequate.

An Entertainment Application of Multiple-Choice

National Lampoon offered a great example of applying learning technology to entertainment products in its CD-ROM *National Lampoon's Blind Date* (Figure 14.4). In that entertainment CD, the user met an extremely attractive young woman and took her on a blind date. His goal in the date was to get invited back to her apartment. The ability to keep playing the game was predicated on being able to choose the right thing to say to her in a series of situations that occurred throughout the evening.

The "things to say" were presented as multiple-choice wisecracks. Discriminations were often hard to make and, of course, the feedback for the wrong choices was usually nothing more than a putdown or even the end of the game. But for those hardy souls who persevered, and that included going back and starting over whenever you made a really bad blunder, you could continue on the date.

One reviewer of the game noted that going out on a real blind date was such a frustrating experience that there was little joy in playing a game that pretty much offered the same kind of putdowns and frustration. A more positive male reviewer, however, pointed out that having a 25 to 50 percent chance that everything he said to a beautiful woman would elicit a positive response was better odds than he'd ever had in his life.

Regardless of the users' point of view, the game proved that the application of discrimination exercise to entertainment can be fun. And this was

Figure 14.4 *National Lampoon's Blind Date.* Used by permission of Trimark Interactive.

entertainment, not education. There was absolutely no proof that any players of the game learned the best things to say on a blind date.

Generalization Learning Problems

Generalization is the flip side of discrimination. Instead of learning to tell things apart, you learn to put them into groups. The most common type of exercise used to teach generalizations is an identification drill in which a variety of items are presented and must be grouped into several categories.

In *People Skills*, an interpersonal-relations, interactive video training program I designed for the Bank of America, learners were presented with a series of statements and were asked to identify them as statements that either

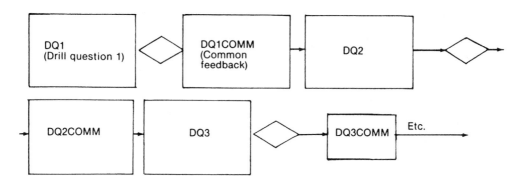

Figure 14.5 Identification drill.

clarified the conversation or got off the point. In general, learners first worked through exercises that helped establish the basic rules of commonality and identification for the different items and their respective categories. Then, a number of drill questions (DQ) were presented, followed by common feedback for either answer given, as shown in Figure 14.5.

The exercises that teach the basic generalization concepts are as important as the drill. Again, a multiple-choice design works especially well, particularly if you use an inductive multiple-choice format, in which learners draw on previous knowledge to find a new concept. When constructing an inductive multiple-choice exercise, you skip the explanation. Don't present the information needed to perform the task; instead, ask the question and allow the learner to make an educated guess. The positive feedback is the reward for being right, and its power can increase retention. Most learners find this technique quite enjoyable. The following is an inductive question on which stamp to use, from the Debits and Credits program. It is inductive because this point was never explained.

> There are three teller stamps: the batch stamp used in many transactions, the cash-paid stamp used only in cash-paid transactions, and the interbranch stamp used only in interbranch credits.
>
> Which stamp do you use on credits accepted for deposit at your branch?

Even if you are unfamiliar with banking, your sense of logic may lead you to pick the batch stamp. First of all, you have the odds going for you, since the batch stamp is used in many transactions. Second, you know that the interbranch stamp is only used for interbranch deposits. Finally, you could recognize that a deposit is, in principle, not a cash-paid transaction. Getting cash back is not part of the fundamental process of making a deposit. So the cash-paid stamp is inappropriate.

This type of inductive exercise helps clarify a principle and also helps learners remember what they have learned. I highly recommend inductive exercises, especially when you are dealing with sophisticated audiences.

Sequence Learning Problems

Sequencing lessons teach how to get things done in the right order. Many mechanical skills have a sequencing component. For example, changing a spark plug involves several steps that must be performed in the right order or the job won't be done correctly and the car won't work. The types of exercises used in sequencing lessons might include ordering exercises, in which the learner rearranges tasks in the correct order. There is also a variation on the fill-in-the-blanks format, in which the viewer numbers the tasks in the right order.

In *People Skills*, we had to teach the three steps in greeting a customer—recognize, identify, and stroke—steps that were supposed to be done in that order. We presented learners with steps in this incorrect order: (1) stroke, (2) recognize, (3) identify. We then asked them to reorder the activities. For the correct answer we allowed them to press numbers 2–3–1 in succession. The diagram in Figure 14.6 shows a simple way to construct this sequencing exercise.

An Entertainment Application of Sequencing Exercises

In the game we created for the Paramount Home Video Web site for *Mission: Impossible*, we asked users to put the events in a key part of the movie into chronological order. Users needed to take the numbers of the events and rearrange them into the right order. A unique feature of the game was that it had a "ClueBook" attached to each question. The clue was in fact a learning exercise that allowed players to figure out the right answers.

Figure 14.6 Sequencing exercise.

Figure 14.7 Exercise from *Mission: Impossible* game. TM and copyright ©
by Paramount Pictures. All rights reserved.

The clue was a click, drag, and bounce Java applet that allowed users to
select the icon to the left of the event, drag it to the name of the event, and then
see if it stuck or bounced off. Although there was a certain amount of trial
and error involved in the activity, the most successful users tried to think
through the chronology before they began clicking and dragging. It was the
thought process combined with the immediate feedback of the drag and bounce
that made it fun and effective. Figure 14.7 shows the graphic that was used.
Answers were entered in a second frame that used numbers to establish the
order.

Psychomotor Learning Problems

Using interactive media to teach psychomotor skills requires simulating of phys-
ical activities. Of course, when the activity is to use a computer or to press certain
buttons, the job is that much easier.

Psychomotor training is what is going on in all the typist-training
CD-ROMs that are on the market. These are the most natural and obvious of all

computer-based versions of psychomotor training. *Mavis Beacon Teaches Typing!*, the best-selling typist-training program, demonstrates the ultimate kind of exercise for psychomotor skill training. It's called drill and practice.

Here's what designers should picture themselves saying to learners in drill and practice exercises:

- Here's how you do it.
- Now you do it.
- Now do it again.
- Now do it with this slight variation.
- Now do it with that slight variation.
- Now do it with this slight variation.
- Now do it with that slight variation.
- Now do it again and again until you can do it in your sleep.

Figure 14.8 shows a typical screen from the program. Learners are asked to copy the text, which appears directly above the line on which they are typing.

Figure 14.8 Drill and practice screen from *Mavis Beacon Teaches Typing!* Used with permission of Mindscape Inc.

The folks who make *Mavis Beacon* have added some very nice touches to the drill-and-practice formula. There is constant feedback in the program on, for example, your words-per-minute performance that challenges you to increase your words-per-minute target if the system thinks you can. There are also challenges and games that ask you to keep trying to perform as fast as you can. It's an excellent program and an excellent example of this kind of instruction.

Meanwhile, psychomotor training on aiming and shooting weapons is the stock-in-trade of all action video games. It is also the key lesson in flight simulators or race car driving simulators. It even plays a role in on-line trivia games, where getting the answer in quickly is the key to success. Knowing just when to push the button is as important in *Jeopardy* and on-line trivia as it is in saving the universe. But we'll save that discussion for Chapter 19.

Learning Problems and Basic Exercises

Thus far we've focused on the four major types of learning problems: discrimination, generalization, sequencing, and psychomotor. We have said that the way to pick an exercise design is to look first at the problem to be solved and pick the exercise accordingly. Unfortunately, there is not an exclusive match of exercises to learning problems. The truth is that some exercises can work for almost all kinds of learning problems. Here is a simplified chart that tries to match up exercises and learning problems.

To Solve	Use
Discrimination problems	Simple multiple-choice
	Complex multiple-choice
	Common feedback
Generalization problems	Simple multiple-choice
	Inductive multiple-choice
	Matching exercises
Sequencing problems	Ordering exercises
	Simple multiple-choice
Psychomotor skills	Simulation games
	Target games
	Drill and practice

I hope we have clarified the importance of choosing exercises based on the problems they are trying to solve. Now let's look at more sophisticated exercise designs. Because these designs can solve a variety of learning problems, we will no longer organize our review by learning problem, but follow one that moves from one related exercise technique to another. Doing so will allow us to build on the information most recently presented. As always, we will continue

wherever possible to reference the learning problems that the exercises solve best.

INTERMEDIATE EXERCISE DESIGNS

Matching Exercises

To teach generalization skills, three to six items are presented that must then be matched to three or four other items or categories. The items matched can be individuals or groups to be identified by the appropriate name or category. For example, in medical training, types of symptoms can be matched to certain diseases; in sales and marketing, cars or trucks can be matched to model names. Matching is a realistic and valuable simulation technique.

Internal Matching and Rating

In this technique the computer compares several opinions presented by learners to determine their preference or attitude. For example, in *People Skills*, we showed an argument between a customer and a teller. Then we asked learners to rate the behavior of the teller and of the customer to determine which of the two they favored. The computer compared the two scores and branched to individual paths through the program based on the learner's bias as expressed in their preference.

Rating or matching exercises are excellent techniques for segregating your audience according to their preconceptions. These preconceptions can lead the learners to block out information or show bias toward a certain point of view and therefore need to be taken into consideration when presenting information. Rating or matching exercises are also good discussion starters for group activities, such as on-line chats or interactive classroom situations that are used with groups. Usually there is no right or wrong answer.

Visual Discriminations

Visual discrimination is a variation on a multiple-choice exercise used to teach discriminations. Essentially, several different objects are presented. The viewer is asked to identify certain parts of each object or to differentiate among the objects.

For example, if you want to teach people the difference between similar-looking items or parts of the same item, present the items or parts side by side and ask the viewer to make a choice. An example from banking is the debit/credit discrimination. A learner could be asked which of a dozen different rectangular bank forms viewed is a debit and which is a credit.

Motion should not be overlooked in visual discrimination. Although an interactive video probably can't teach you how to throw a forward pass or play the piano, it can demonstrate the correct procedures and teach people to recog-

nize the right way from the wrong way. The idea of interactive piano lessons is not totally inappropriate. There are plenty of complex fingering techniques that are not all that clear when written into the sheet music. A video demonstration that can be repeated until it is well understood is the best presentation device for this sort of thing. Discriminating between the right way and the wrong way will at least help performers know in their minds what is the correct way to do something.

Consequence Remediation

This may be one of the most effective types of advanced interactive multiple-choice exercises. Instead of branching from the question to a spokesperson who tells you why something is right or wrong, or looping back to see a repeat of a lecture or demonstration, consequence remediation shows you the results of your choice. It gets you to do things right by showing the negative or positive consequences of your actions. The following is an example of consequence redemption dialog from People Skills:

> CUSTOMER: What do you mean you have to place a hold on my checks? Listen, I've been a customer of this bank for 8 years. I've never bounced one check, and if you don't approve this check right now, I'm withdrawing every cent.
>
> TELLER: [This response is choice number 2 of three choices.] Don't talk to me that way, sir. If you really had been a customer for 8 years you'd know that holds are a standard part of bank operations and we have to follow procedures.
>
> CUSTOMER: [Consequence remediation to choice number 2.] Follow procedures? Well then, fine, start following the procedures to close my accounts!

[At this point the narrator can come back and offer a commentary on the transaction.]

> NARRATOR: By challenging the customer's authority, you made him feel as though he had to act his toughest. He may still back down, though. Remember, we're trying to clarify the customer's feelings. Try to resolve the situation.

Consequence Remediation in Entertainment

Consequence remediation is one of the staples of interactive entertainment, and we will be discussing it at length in Chapter 18. But just to mention it briefly here, the example previously presented, *National Lampoon's Blind Date*, actually uses consequence remediation. If you don't make the right choice and say the right thing to your date, she will present you with a consequence that will not

be at all to your liking. Imagine that you are a wisecracking guy and take a look at the banter from this award-winning game. We have made some right and some wrong selections for you.

SANDY:	I think I should warn you I'm a pretty good pool player.
YOU CHOOSE TO SAY:	Go easy on me. I'm just an amateur.
SANDY:	That's why there's a bar, it's a great equalizer.
YOU CHOOSE TO SAY:	So I guess I need to get you slightly impaired?
SANDY:	This game is a lot like relationships.
YOU CHOOSE TO SAY:	The strategy is to always think one step ahead.
SANDY:	Pool's a game, relationships are work.
YOU CHOOSE TO SAY:	I forbid my chicks to work.
SANDY [gets angry]:	Now part of you won't work either.

[She clubs you with a pool cue and you're back to square one. That's what this guy gets for FORBIDDING his girlfriend from doing anything.]

Consequence remediation is especially powerful when used in any kind of interactive video because the medium can depict the consequence so realistically. It is an outstanding technique for teaching personal interactions or any procedure where improper choices lead to very pronounced consequences. Consequence remediation is also the underlying principle in many of the advanced exercise designs, which we will discuss in the following section.

Non Sequiturs in Consequence Remediation

Notice that in *National Lampoon's Blind Date*, Sandy responds to the player's offer to buy her a drink by getting off the subject and saying, "This game is a lot like relationships." That is a non sequitur, and it is something that just doesn't feel quite right.

As a designer or a writer you may find yourself forced into building non sequiturs in your interactive conversations. Your users may be asking themselves, "Do they really want the character just blindly to change the subject right now?" The truth is that you may have no choice. So many different branch points may be coming together at that single response point that the answer may not make perfect sense with each path. But consider that people in real life do change the subject without bothering to respond to the previous statement, and, just as transcripts of real speech do not always read as cleanly as written dialog, so, too, non sequiturs are a real, although sometimes awkward-sounding, part of natural conversations.

Of course, occasionally non sequiturs are of such high quality that they seem almost brilliant. My favorite example of this kind of non sequitur comes not from the semi-grown-up world of blind dates, but from the childhood world of *Peanuts*.

Linus often confides in his sister Lucy, trusting her with some profound observation about our place in the universe and the meaning of life. For example, he may say something like, "When I gaze up at the sky at night it makes me realize how small we are in relation to the stars." Lucy always shows her superiority with a comment that is pure non sequitur and total putdown at the same time, such as "I prefer eggs for breakfast."

ADVANCED EXERCISE DESIGNS

In this section we will consider still more advanced types of interaction. As has probably become clear, usually, the more advanced the exercise, the more branching is employed.

Spiderwebs

Branching generally leads people to think of a decision tree, in which one decision leads to two more choices, each of which leads to two more choices, and so on. The problem with decision trees is that decision-making, or human discussion, seldom works that way. Actually, there is a great deal of redundancy in decision-making. In arguments or even friendly discussions, people keep returning to the same points. Usually they have a goal and they stick to it. So, in the end, real conversations find people limited to a few logical remarks and a few probable conclusions.

Producers of interactive digital media want to limit possible options, and rightly so. No one is really going to produce a dialog in which the conversation branches off into an infinite number of possibilities. It's impractical and impossible. More realistic and far less expensive is an exercise called the *spiderweb*. It operates on the same principle as the decision tree, but differs in that certain responses are repeated, as they would be in real life (people keep coming back to the same points).

In *People Skills* we wanted to show a loan rejection interview. We knew that the loan officer really had no choice but to stick to his guns and turn the applicant down no matter what she did. Figure 14.9 presents a graph and summary of the beginning of the rejection interview.

You can see that, despite the fact that there is a wide variety of choices, several responses keep reappearing, just as they would in real life. The loan officer (Joe) has figured out what to say to the customer in advance. That's only logical, as is the idea that he would respond with the same or similar words in situations in which he was confronted with extreme anger. Loan officers are

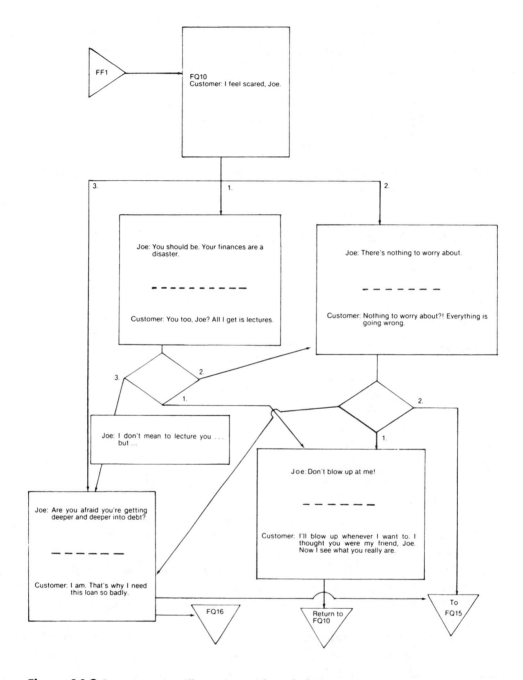

Figure 14.9 Loan interview illustrating spiderweb design.

trained on how to say "no" and how to deal with customer anger. It's part of the job.

Spiderwebs are an excellent technique for simulating a discussion. The viewer takes control of the responses of one party in the discussion and selects the best responses to statements by the other person. There are several options

for each response, and each response in turn generates a new statement. Because many choices lead to the same response, the exercise does not go on forever, but, instead, eventually resolves itself in one or two logical outcomes.

A spiderweb takes 3 to 15 minutes for a viewer to work through, but it takes a skilled designer and a talented writer dozens of hours to make it work. If you are going to try spinning spiderwebs, make sure that you check to see what happens when you follow every path. Do they all connect? Do the right answers sound reasonable? What happens when several paths come back together? How bad are the non sequiturs?

Invisible Spiderwebs

Unfortunately, in real life, conversations don't come to a screeching halt when you are faced with three or four well-defined choices. In real life, if you don't make a decision by a certain point, the conversation continues, probably along the same path.

To achieve this same effect in your interactive programs, design them so that they open "decision-making windows." Inform the learners at the outset that, if they indicate a choice anytime during a given period designated by some icon or some other identifier as a "window," the program will branch. If they don't do anything, the program will just continue as though they did nothing.

What kind of choices would learners be making in one of these invisible spiderwebs? In a program dealing with interpersonal relationships, you may just indicate positive, negative, or neutral feelings. Looking back to our discussion of the loan officer interview in *People Skills*, let's say you are in a discussion with a loan officer and are asked to push certain buttons whenever you feel a certain way. If you do nothing, the program proceeds in a neutral middle-of-the-road course. But if you indicate positive or negative feelings, the program branches, and the other person responds accordingly. In this case, your positive and negative feelings are probably reflections of what would be your body language or facial expressions. The system, not having a body to express language, relies on indicators of feelings.

What I am describing in the case of invisible spiderwebs is a program that does not come to a halt and wait for the learners to make decisions; it responds to opinions that are indicated while it is going on and continues whether those opinions are expressed or not. The flowchart for that program actually looks like a spiderweb, but because the questions (in this case the decision-making windows) are not visible to the viewer, it is indeed an invisible spiderweb.

Simulations Using Synthetic Characters

Spiderwebs (hidden or otherwise) assume pre-recorded messages that are accessed by mechanical input. Push the button and select A, B, or C.

But a great deal of research is already underway to allow learners to have a much more realistic exchange with characters in a simulation. The heart of that exchange is the creation of synthetic characters who can listen, talk, and reason and who look real.

How do you get a synthetic character to listen? Well, you have to get them to "wreck a nice beach" (as we used to say when we were testing speech recognition programs back at Apple Computer). That's "recognize speech." Work in that area is progressing . . . slowly.

And how about getting synthetic characters to reason and respond? To do that, you need the artificial intelligence to analyze the speech and formulate an appropriate response. That, too, is in the works. And then the synthetic characters have to "speak themselves; deliver the response."

Speech synthesis, the method by which graphic synthetic characters talk back to you, is another technology that is still evolving, as are the computer graphics that will make them *look* realistic. All these pieces are coming together in a way that will make the problems of creating branching dialog and spider-webs irrelevant. But they are not here yet.

High-Level Simulations

Earlier I said that all good learning exercises are simulation of the behavior that is being learned. However, it is important to remember that the behavior itself does not require all the trappings of the job to provide an adequate simulation. For example, a bank teller does not need a teller window, a live customer, and a long line of impatient people to practice recognizing the difference between a debit and a credit. There are levels of realism that can be present in simulations, and those levels actually have different effects on the simulation and the things people learn.

Low levels of simulation, that is, simulations that use paper and pencil or some other very rough approximation of a behavior, are often best for presenting the basic behavior and allowing the participant to practice the key elements in their purest form. Later, more and more realism can be added to the situation to help the learner practice dealing with the distractions or "noise" that occurs around the behavior in the real world.

In a cancer diagnosis exercise, you might first start with a diagram of the cancer that emphasizes the characteristics that identify it as a cancer without any other distracting elements present. Then over a period of time you could make the image more and more realistic by adding those physical elements that are not part of the cancer itself but are more reflective of the real physical condition. Those elements may make it harder for the novice to recognize the cancer, so they would not be present in the low-level simulations studied by novices. Adding detail would build the skills of the doctor until many cancers could be recognized in spite of the distractingly complex appearance of the cancerous area.

In driving a car, you might start with a paper and pencil explanation of the operation of a car, followed by a simulated drive in an automobile simulator. Even the simulator can make the experience more and more realistic as it adds more and more complete representations of the "on-the-street" driving experience. Next you might go out in a real car that allows the student to share control of the driving with the instructor. The instructor can override student decisions if they turn out to be dangerous. In the end, students are going to have to drive the car on their own with all the noise and distraction of the real world coming at them. But the closer they can get to that real experience before being totally on their own, the more prepared they will be.

Low levels of simulation help student drivers practice to get the basics, but they are far from real-world experiences. As students get closer and closer to simulating the actual solo drive, they are getting closer and closer to the point of transfer when they can move into the real world effectively.

High-level simulations are not the best kinds of learning exercises to start out with, but they are the best exercises to end with, because they do the most to allow the learner to transfer skills into the real world. For this reason highly effective and realistic simulations are sometimes called transfer exercises.

High-level simulations, which include as much realistic representation of the real world as possible, are great advanced exercises. Start with the basic skills to be learned, then add noise and distraction to challenge the learner. Figuring out how to add the required "noise" is a real challenge and one that takes advantage of the things that digital media does best. But it is important to understand that they are only part of an evolutionary exercise process. A great instructional design builds levels of simulation according to the needs of the learner. Eventually it ends up with very high-level transfer exercises to allow students to bring their skills effectively into the real world.

Evaluating Exercise Construction

In designing instructional programs, there is an underlying principle that tests the appropriateness of any learning activity you create. Does the exercise simulate the skill you are trying to teach? Ask yourself, "What does the learner do in this exercise?" Also ask yourself, "Is the learner doing what I am teaching?" For example, in *People Skills*, learners were asked to choose the response that paraphrased what a customer said. Here is the exercise we used:

CUSTOMER:	As I was saying, my wife and I just moved into town. Got a new job, new car; ain't got no house yet. Been looking around. Kind of found a place. Thought you folks might be able to help us out.
LOAN OFFICER:	Response #1: Sounds like you want a home loan. Response #2: How does your wife like it out here?

Let's examine carefully what is really happening in this example. Choice #1 does paraphrase the customer's response. However, choice #2 is so far removed from paraphrasing that, although it is a standard remark in opening a conversation with a customer, it is clearly not the correct answer. Choice #2, in fact, is an example of what not to do in creating an exercise. It is a nonclarifying activity called "getting off the point." The learner is choosing between a form of clarifying (paraphrasing) and a form of nonclarifying (getting off the point). To that end it is a good exercise. But on closer examination there is a problem. The essence of the problem with this question is that the answer is obvious.

Dealing with the Obvious

Sometimes the correct answer is too obvious, probably because the question itself focuses on too obvious a distinction. The skill being tested, then, is whether or not the student can recognize the obvious, rather than whether or not the student can recognize the clarifying response. A far better kind of exercise would have tested the difference between the two different kinds of clarifying responses (there are two, paraphrasing and amplifying). That kind of question would have been worded like this:

> Identify the response that best amplifies the customer's question:
>
> CUSTOMER: As I was saying, my wife and I just moved into town. Got a new job, new car; ain't got no house yet. Been looking around. Kind of found a place. Thought you folks might be able to help us out.
>
> LOAN OFFICER: Response #1: Sounds like you want a home loan.
> Response #2: Of course, we can help, and we have three different home loan packages we can discuss.

In that example the learner must distinguish between the two types of clarifying responses. Therefore, the exercise is not really about recognizing an obvious distinction. By the way, choice #2 is correct.

Writing an obviously wrong answer is an activity that really defeats the purpose of instruction, since all that is really being learned is how to distinguish the obvious. (Just for the record, the earlier version of the question wouldn't be much fun in a game either.) Being asked to recognize the obvious is never very rewarding.

Rules for Evaluating Exercises

Let's lay down some rules for evaluating exercise construction. After you create an exercise, ask yourself these questions:

1. Does it simulate the behavior I'm trying to teach (in whole or in part)?
2. If it simulates part of the behavior, is it the right part?
3. Are there other exercises that simulate all the other parts so that the learner learns the whole skill?
4. Does the exercise present enough choices so the exercise is meaningful?
5. Is the exercise difficult enough to make the learner consider the principles involved in making the decision, or is it just an exercise in recognizing the obvious?
6. If you use humorous wrong answers, are there enough other wrong choices to make the activity meaningful?

Keeping these principles in mind, we need to proceed to the next important segment of designing instructional interactive programs: creating and using tests. But before we do that, let's look at an entire compendium of interactive learning exercises that bring together all of the designs discussed in this chapter as well as many others.

Compendium of Distance Learning Exercises

This compendium will help illustrate the broad range of possibilities available for the designer of distance learning. In addition to the standard types of activities we have already talked about—identification, ordering, multiple-choice, and psychomotor simulations—I have added three other major kinds of exercises. These are Interruptive exercises that happen when you stop the action and do something; Pathfinding exercises; and Database Usage exercises. Pathfinding requires that learners find their way through a labyrinth of interactive branches or a series of events. Database Usage exercises teach research skills by asking learners to look up information in databases in order to determine their answers.

Each of the exercises in this compendium references the major kind of learning problem it solves (discrimination, generalization, sequencing, or psychomotor). The order of the exercises generally moves from the most simple to the most complex. Exercises are grouped by their general type so that, for example, all the multiple-choice kinds of exercises are grouped together even though the most complex multiple-choice is more complex than the simplest psychomotor simulation.

Type of Exercise	Interruptive
Exercise Name	Answer and Compare
Learning Problem Addressed	Discrimination

Procedure Students are taken to a point at which they must perform an activity. The interactive media poses a question, then stops and waits. Students answer the question on-line. When students have completed their answers, the system presents the correct answer. Students compare their answers to the answer on the screen. Extensive feedback may also be provided with the correct answer.

In a distance learning format, imagine streaming audio with pictures or streaming video providing the presentation of the material in a window surrounded by an interface that includes built-in worksheets. The video progresses,

the students do some work with the computer worksheets while the video waits, then the video resumes.

Type of Exercise	Interruptive
Exercise Name	Guided Discovery
Learning Problem Addressed	Generalization

Procedure Rather than just being taught straight out, students learn by finding things out for themselves. A goal is set, and students work toward achieving that goal using tools that are provided by the distance learning system. The steps in the process are structured so that, as they work through the problem, they learn a set of principles or procedures.

For example, in a multimedia lesson about finding your way through the woods, students are given a compass and a set of rules. As they work their way through the forest, they employ the compass and the rules and, in the process of finding their way home, they also learn direction, ecology, and personal safety.

Type of Exercise	Identification
Exercise Name	Stop When You See
Learning Problem Addressed	Discrimination

Procedure Again a "picture-in-picture" distance learning format with images playing within an interface that also includes controls of the images and worksheets on which students can enter observations. Viewers are then given a presentation in which certain activities need to be recognized. When the correct activity is spotted, viewers respond on the worksheet, and the system counts, sorts, and judges their responses.

The "spot the shoplifter" exercise developed by David Hon may be one of the best examples of the stop-when-you-see technique. David presents a store with four customers. One of the customers is a shoplifter. Using techniques that have been taught in the lesson, students are asked to identify the shoplifter. Whenever they think they see the shoplifter in action, they note the behavior by clicking the appropriate area of the interface and the computer records their response.

There are several ways to get feedback in an exercise such as this: audio cues giving positive or negative sounds per response, or video or text feedback sequences can be placed at the end of the entire exercise.

Type of Exercise	Identification
Exercise Name	Identify the Area
Learning Problem Addressed	Discrimination

Procedure This technique is a great tool for teaching medical diagnostic skills. Students move a cursor (or other marker) over a background until they see something they have been asked to identify (a tumor, a fracture, etc.). Students then click on the object to get appropriate feedback.

Type of Exercise	Identification
Exercise Name	Matching
Learning Problem Addressed	Discrimination or Generalization

Procedure The best application of matching we've seen is Wilson Learning Company's *Managing Interpersonal Relations (MIR)* interactive laser disc program. Learners are confronted with a list of personality types and images of four fictional characters they have gotten to know earlier in the lesson. Students choose one of the personality types and then the picture of the person who matches that type.

Of the available feedback techniques, the one the Wilson Group chose may be the best. The person identified appears on the screen and tells students why they were right or wrong.

Type of Exercise	Ordering
Exercise Name	Put in Order
Learning Problem Addressed	Sequencing

Procedure Students are presented with several steps that are listed as text or, better yet, portrayed as insert images on a composite picture. Students are required to indicate the order in which the steps must be performed. They can click and drag the images into the right order or enter numbers or letters identifying the scenes. Dramatic and very effective feedback can illustrate the resulting consequences of doing things in order or out of order.

This type of exercise is a must for procedural training that requires sequencing skills. Put the engine together, and then start it up. The most dramatic example of this exercise I ever saw was an Air Force simulation on packing a parachute. Once the exercise was completed, the student got to see what happened when the pilot deployed the parachute that they had packed.

Type of Exercise	Multiple-Choice
Exercise Name	Remedial Loops
Learning Problem Addressed	All

Procedure Remedial loops are the most basic form of multiple-choice, interactive exercises. In this technique, students are asked a question that has several possible answers. If a student selects the correct answer, the exercise moves

along. If the student selects the incorrect answer, the program loops back to the part of the lesson relating to that particular question.

Although it is tempting to use this technique because it is inexpensive and no additional production is required, it is weak because the feedback is not tailored to specific questions or responses. General feedback is usually not as effective as specific feedback.

Type of Exercise	Multiple-Choice
Exercise Name	Individualized Feedback
Learning Problem Addressed	All

Procedure Individualized feedback is the technique that improves on remedial loops. As with remedial loops, students are asked questions with several choices. In this case, however, when students answer, they move to a discrete sequence that explains exactly why they were right or wrong.

Type of Exercise	Multiple-Choice
Exercise Name	Consequence Remediation
Learning Problem Addressed	All

Procedure Consequence remediation is similar to individualized feedback. However, with this technique, when students answer, they are shown the results of their decisions. There may be a voice-over explanation of what happened or an elaborate video sequence, but the real power of this exercise comes from students' seeing the consequences of their very own decisions. The example of the parachute packing mentioned as part of the sequencing exercises really combines consequence remediation with sequencing.

Here is another example that relies on an entertainment-based story-line: Two old high school friends, Joan and Jean, meet years after graduating from high school. At a friendly lunch, Joan tells Jean that she is getting married and tells her all about Eric, the wonderful guy who will soon become her husband. Jean is horrified to learn that it is the same Eric who broke her heart on a Caribbean cruise last summer.

What should Jean do when Joan invites her to the wedding? Users of the system choose a possible response and see what actually happens when Jean goes to the wedding, or does not, or tells Joan all about Eric's past. You would want to see the outcome of your recommendation, wouldn't you?

Type of Exercise	Multiple-Choice
Exercise Name	Randomized Outcomes
Learning Problem Addressed	All

Procedure Randomized outcomes provide yet another twist to the multiple-choice format. In this exercise, a randomizer is put into the program so that the consequences of certain actions are not always the same.

For example, in our interactive story above, Eric could be nasty or nice to Jean when she shows up at the wedding. Eighty percent of the time he simply will not bring up their recent past. But 20 percent of the time he will be in a bad mood, stage a big scene, and come close to ruining the wedding. That's the chance Joan takes by showing up. Of course, the instructionally important outcome needs to be portrayed somehow, somewhere, if the randomizer does not show it. Otherwise real learning will not take place.

Type of Exercise	Database Usage
Exercise Name	Check Your Files
Learning Problem Addressed	Generalization

Procedure Database usage is an innovative technique that has been used effectively by Hewlett-Packard's Training Technology Group. This technique involves the creation of a large database of information relevant to the training topic. One example would be a database of fictional employee files created as part of a simulation in a Management Training Program. The database is stored on a central server accessible by all the participants in the program via their Internet or intranet connections. The information is organized in the appropriate logical order based on real databases in the company.

In our management training example, trainees would be presented with a problem employee who needs counseling. A low-level simulation would provide students with a menu that offers to show the employee's personnel file and any recent mail that specifically relates to the employee and her problem.

A higher level simulation would provide files for many different employees. There would also be general e-mail for all employees for several days. Information would be cross-referenced between the files. The intention is to get students to dig for the information they need.

Is this second version of the exercise more difficult to create? Yes! Is it more effective? An evaluation conducted by Hewlett-Packard suggests that it is.

Another management course, also designed at Hewlett-Packard, taught that long-term relationships between employers and employees are factors in management style choice. To demonstrate the length and depth of some of the relationships, Hewlett-Packard's course offered a memory bank through which the manager could search in order to reflect on the relationship with the employee before the counseling session actually began. A simple series of video flashback scenes did the job. With the help of this input, students were able to do a better job determining the appropriate style to use in the session.

Type of Exercise	Database Usage
Exercise Name	Market Research Simulations
Learning Problem Addressed	Generalization

Procedure Here is an especially effective technique for students in marketing courses. Offer learners files of demographic data that they can draw on when putting together marketing plans. Sources for this database might include statistics from company marketing research departments, recent articles from major magazines, and interviews with industry experts. Send the students out on to the Web to find even more information.

The easy and obvious exercise that would make use of these kinds of databases would be to supply a choice of several different creative advertising campaigns for a particular product, with resultant remediation showing the consequences of each choice. More imaginative or complex solutions could be carried out in virtual or real classrooms. There, students could be organized into teams whose goals were to design advertising campaigns based on input from the databases. They could see the prerecorded consequences of their campaigns in scenarios selected as appropriate by the course instructor.

Type of Exercise	Dramatic Database Usage
Exercise Name	Crisis Decision Exercises
Learning Problem Addressed	Generalization

Procedure This exercise builds on the database usage exercise just described, but in this case the database is created to support a scenario in which participants must work as a team in order to deal with a major crisis. Imagine, for example, that ecology students must come together to address an environmental crisis that has arisen in a nearby community. Rafts of media are created not only to help tell the story, but also to portray all the possible consequences of all the branching outcomes. Newspaper headlines, TV news reports, interviews, executive messages, and special scientific reports are all elements that the instructor can use to feed information to the students. The students in their turn must sift through the information and decide how to address the environmental issue before it spins out of control. If they don't, of course, there will be the appropriate dire consequence remediation. This kind of exercise is the perfect transfer exercise for university–level decision-making courses if there is faculty time and support enough to create the necessary database material. Enlisting members of related media courses, by the way, might make a valuable interdisciplinary activity.

Type of Exercise	Pathfinding
Exercise Name	Parallel Scenarios
Learning Problem Addressed	Primarily Discrimination but all others as well

Procedure Parallel scenarios are a little like spiderwebs in that they offer students a variety of decision points leading to different solutions to the same

problem. However, in parallel scenarios the story keeps going in each of four discrete paths all the way through to the end. At key decision points, students are given a set of choices. Each choice allows students to switch between paths and approaches. Each path uses similar data, but carries it out in a very different way to arrive at a unique outcome.

Example: a counseling session between employer and employee. Which of four styles should the employer use to communicate to the employee? If the employee acts with anger in response to one style, should the manager switch styles? Should the manager respond with anger, too, or try to calm the employee down by telling a joke or empathizing with the employee's situation? Any reaction on the part of the manager results in another reaction on the part of the employee. For each response, the manager is faced with yet another set of choices, each leading to a very different set of outcomes.

From the first decision point on, there are four parallel conversations going, each involving some of the same data, but each with its own special tone and style depending on the tactic chosen. Crossover points (points at which another counseling style can be accessed to continue the conversation using a different tack) are placed at logical breaks in the conversation where it would be natural to change direction. These points are dictated by the content of the conversation.

A parallel program must be created with very carefully written dialog so conversations can flow naturally from one scene to another. The emotional tone should also flow, even though there might be abrupt changes in mood. To accomplish this, transitional scenes have to be created so that a highly charged emotional scene in one scenario can flow into a more amiable scene that results when another tack has been taken.

Type of Exercise	Pathfinding
Exercise Name	Seamless Parallel Scenarios
Learning Problem Addressed	All

Procedure Scenarios that are not interrupted by menus or other decision-making devices are expensive and difficult to design and produce. Yet, many interactive game companies have worked wonders with this technique. The extremely high level of simulation offered by such scenarios makes them good prospects for both training and entertainment and games.

Because there are no menus, the interruptions cannot be seen and the transitions are said to be seamless. If the participants do nothing, the scenario continues as though there were no input at all.

Consider the difficulty of designing and creating a scenario in which the decision-maker can switch the tone and mode of the conversation at a dozen different points. You can imagine how much more difficult it would be to create a scenario in which the decision-maker can switch at any time.

The way to write such a scenario is to lay the scripts for each different tone or mode of conversation down side by side and write each scene so that it is in total harmony with the spirit and the informational content of the other scenes. Believe me, that is not an easy task.

Type of Exercise	Pathfinding
Exercise Name	Virtual Environments
Learning Problem Addressed	All

Procedure Beginning with MIT's pioneer project that offered a tour of Aspen, Colorado, these projects enable designers to offer viewers a sense that they are moving up and down the streets of a town (real or imagined). Or, with very little change to the design, up and down the halls of a building (real or imagined), or within a room or some other virtual space.

The technique allows the user to decide which way to turn at appropriate intersections and even whether or not to go into buildings or rooms that are found along the way.

Virtual environments offer training in recognizing landmarks and overall geographical navigation. They offer orientations to specific locations, buildings, and building complexes. They often provide the raw material for exciting adventure games, such as *Myst* and its imitators.

As a demonstration, Hewlett-Packard created a guide to the labyrinth of its offices by putting a 35-mm camera on a chair and rolling it up and down the corridors. The hundreds of still frames that were created could be arranged in many ways, including a "Type in the name and we'll show you the office" approach or "Here is the path that will take you there." These days, highly calculated matrices have been created to help plot out the number of images and angles needed to provide a realistic virtual reality representation of a place. Computerized cameras even perform those calculations and take the pictures at the same time.

Type of Exercise	Psychomotor Simulations
Exercise Name	Hunt and Shoot Simulations
Learning Problem Addressed	Psychomotor

Procedure The most basic video games are those that require players to seek a target and shoot it down. Generations of boys have become so skillful at hunt and shoot that it is hard for game designers to come up with games that are sophisticated enough for them. The return of some classic and simple hunt-and-shoot games gives the rest of us a chance to play.

When the designers apply training technology to the design of such activities, hand–eye coordination can be channeled in a very specific direction to meet very specific training goals.

Type of Exercise Psychomotor Simulations
Exercise Name Driving Simulations
Learning Problem Addressed Psychomotor

Procedure This hybrid of video games and virtual environments is perhaps one of the very best applications of interactive simulation. The player takes the controls of a futuristic car, and the multimedia images allow him or her to traverse the streets and highways of major cities of the present or the future. Simplified versions of this activity isolate parts of the task. For example, an interactive drag strip can let the user work on shifting skills without the designer having to worry about addressing the left-to-right control of the car. Dragsters only go in a straight line, and steering is not an issue.

Type of Exercise Psychomotor Simulations
Exercise Name Computer Software Simulations
Learning Problem Addressed Psychomotor

Procedure Some computer software applications require both psychomotor skill and a good deal of content knowledge. Multimedia programs have been created that demonstrate what to do with the software and what happens when you do it, and then present practice exercises with increasing degrees of difficulty.

Because a computer is best at simulating its own activities, this kind of training media is a natural. Moreover, since much of the built-in instructional software and tutorial material that comes with the program is rather weak, creating licensed instruction in how to use important software is becoming an increasingly lucrative business.

Test Construction and Evaluation

Unlike exercises, tests are designed not to teach, but to find out whether the learner has learned. For that reason there is no remediation following each question, as there would be in an exercise; instead, questions are presented one after the other, the right and wrong answers are tabulated, and a score is given. Remediation may be provided depending on the overall structure of the lesson. In this chapter, we will look at the various testing options that can be integrated into interactive instruction.

TEST FEATURES

Unit tests are the tests given at the end of each lesson. Final examinations, at least in our terminology, are tests on the course. The final exam is the last activity the learner will complete before leaving the program to perform the new skills in the real world. Therefore, the final exam should integrate all the steps being taught into the fullest possible simulation of the activity to be performed.

Another important aspect of a good final exam is that, like the lesson itself, it should be criterion-referenced. The key element in this technique is the criterion item, which considers not only what learners will do, but also how well they will do it. Ideally, all criteria for proper performance should be tested in the final exam. If learners are learning to perform a certain task and that task has to be performed within a given time frame, that time frame should be included in the test.

As noted, the final examination should offer a true simulation of the behavior being taught. Interactive simulation can never replace real-world performance, but it can often duplicate it very well. The challenge for a creative instructional designer is to construct tests that come as close as possible to actual performance. There are times, however, when the skills you are teaching may require live simulations in addition to those being presented through the interactive media.

For example, *People Skills*, the interactive instructional program I developed for Bank of America, taught principles of interpersonal relations and methods for applying them. In the final exam learners were asked to identify the best

responses to comments from a customer during a simulated banking transaction. In addition to the video simulation, learners were given a script that they could use to role-play the interaction with the customer. This added activity, in our opinion, greatly strengthened the learners' ability to transfer the concepts to their real-world jobs and offered a truer test of their ability to perform the skills we were teaching.

TEST STYLES

There are different types of tests that can be designed and integrated into interactive learning. These can be divided into testing for understanding (concept tests) and testing for performance (simulation tests).

Concept Tests

Concept tests are administered to determine whether learners understand the principles involved in performing a skill. They do not test the actual performance itself. For example, let's say that there are six steps involved in changing a spark plug. If you wanted to test for an understanding of this concept, you could have learners do any of the following:

1. List the steps.
2. Identify those steps that are part of the process.
3. Identify those steps that are not part of the process.
4. Arrange the steps in the correct order.
5. While a spark plug change is in progress, identify procedures being performed correctly or incorrectly.
6. After a spark plug change is shown, list the procedures done incorrectly.
7. Answer specific questions about critical parts of the process—for example, which wires to attach to which plugs to ensure proper firing order.

Note that at no time are you asking the learners to change plugs; rather, you are testing their grasp of the concepts and the activities involved. With an understanding of the concepts involved, learners will probably have an easier time performing the task in real life.

Simulation Tests

Simulation tests offer a reenactment of the skill being taught and allow you to come very close to testing learners' hands-on performance. For example, in the

lesson on spark plug changing, you might start with the act of connecting the spark plug wires from the plugs. Learners can be given two choices:

1. Disconnect all the wires, so that you can take out all the plugs, then replace all the plugs.
2. Disconnect the wires one at a time, so that you can replace each plug and reconnect the wires one at a time as the plugs are replaced.

Depending on the response given, the lesson would then proceed down one of three paths. But the first choice could lead to several branches depending on what the student did with the wires as he or she disconnected them. For example, if the wires were just disconnected and left hanging randomly, the student might have a hard time connecting the correct wire with the correct plug after they were replaced. On the other hand, if the wires were arranged in a neat order to indicate how they should be reconnected, the procedure could eventually link up with the same path that was taken if the plugs were replaced and the wires reconnected one at a time. That would be the foolproof way to do it.

Options coming out of the first choice, with wires left hanging randomly, could get pretty messy. For example, the student might have to go back and determine the firing order of the plugs. Or the student might just connect the wires as randomly as he or she disconnected them. The probable resulting misfiring of the plugs in the latter case could lead to an interesting consequence remediation in which the miswired engine would misfire and sputter inefficiently. Clicking and dragging wires on and off the plugs would be a very good simulation of the correct procedure for disconnecting the wires.

You could not, of course, simulate the actual snapping the wires onto the spark plug, although it is a critical activity in the process. Snapping the wires onto the plugs is a tactile skill: you have to feel the wire snap tightly. Things that require learning a certain "feel" are difficult to simulate in computer-based distance learning.

Multimedia simulation tests are excellent ways to determine whether learners have learned from the program. Because they can portray the consequences of correct and incorrect answers, simulations make excellent transfer exercises. As noted, transfer exercises are learning experiences designed to help learners bring the skills they have learned back to their real-world jobs. When designing simulation tests, it is important to include the entire job with all its details in a realistic setting. The goal is to let learners come as close as possible to real-world performance. So, in our spark plug wiring example, we talked about one step that may actually contain as many as 30 substeps.

TEST SCORING

In determining when a learner is ready to begin applying a skill in the real world, the number of right answers or allowable misses required for passing is

critical. Some skills require perfect or near-perfect performance on the part of learners. In other skill areas, however, perfection may not be as critical. Because setting a passing percentage begins with an arbitrary decision, test scoring should be adjusted after the program has been reviewed extensively and compared to competent performance in the real world. Setting criteria for adequate performance is a cycle. First criteria are established when performance is defined. Then they are refined as skills are transferred to the real world and behavior is observed.

TEST FAIL AND PASS MENUS

As you create tests that assess learners' comprehension and skill levels, you will want to determine where they will go if they have passed or what kind of remediation they will get if they have failed. Here, as elsewhere, you can allow learners to choose from a variety of options depending on their level of skill and rate of learning.

Test Fail Options

Usually, a lesson test failure requires a review or repeat of the whole lesson. However, you may want to give learners a choice of review options. Figure 16.1 presents a detailed schematic of a typical lesson.

The branching for the exercise feedback is not shown, but you can see three demonstrations (DEMOS) broken up with seven exercises (XQs) and a final review (REV). There are three logical ways to review this lesson:

1. Review the entire lesson (all demos and exercises).
2. Work through just the review and test.
3. Just take the test again.

I would bet that the last choice, the test-only option, would be the most popular with learners; however, it is probably the least effective. After all, there

Figure 16.1 Typical lesson.

Figure 16.2 Review option.

may have been no remediation at all, or perhaps learners may only have been told the number of answers they have gotten right. Not much feedback!

If learners want a quick way out, they can take the second choice, the review and then the final test. Reviewing the whole lesson is a very admirable option, though probably not a very popular one. Figure 16.2 represents a compromise: the program is playing the demonstrations, but skipping the exercises. It will play "1 DEMO 1," then automatically skip to "1 DEMO 2," to "1 DEMO 3," and then to "1 REV." What you have offered your learners is a chance to review the presentation part of the lesson and then take the test. This may be an excellent and popular remediation technique.

Another option is to offer a menu of the different subjects in the lesson. For example, "You can select an individual subject that seems to be giving you trouble."

Returning to the bank teller-training example, a good remediation menu would say:

- Press #1 to review the concept of debits.
- Press #2 to review all debit forms.
- Press #3 to review the concept of credits.
- Press #4 to review all credit forms.
- Press #5 to review the one exception to the debit/credit rule.

Finally, you can offer learners a break frame, in which the system offers to pause and give the learners a chance to take a break. All of these options can be presented in a test fail menu. Figure 16.3 presents the script for such a menu. It shows both the text that would appear on the screen and the narration that would accompany it.

Test Pass Options

Test pass options are much simpler to design. Learners can proceed to the next lesson, choose among several lessons, or go right to the final exam. There is one creative alternative: to offer learners a review of the key ideas (review sections) from all the lessons, before going on to the final exam. People who pass tests

Graphic	Narrator
You can review:	You should review the whole lesson; there are four ways to do that:
1. whole lesson	1. review the whole lesson
2. lesson without exercise	2. review the lesson without the practice exercises
3. key ideas	3. review the key ideas
4. individual concepts, or	4. review individual concepts which you think are giving you trouble, or
5. take a break	5. you may want to take a break
Indicate your choice.	Indicate your choice.

Figure 16.3 Test fail menu and narrative.

Graphic	Narrator
Choose:	You have some choices here:
	You can take the lesson on balancing or
1. the balancing lesson	the lesson on stamps, if you haven't
	already done so. If you have, you can pro-
2. the stamps lesson	ceed to a review of the key ideas for the
	entire program before going to the final
3. review of all key ideas	exam.
4. the final exam, or	If you don't feel you need a review, you can go directly to the final. We'll even let
5. a break	you take a break before you do any of that.
Indicate your choice.	Indicate your choice.

Figure 16.4 Test pass menu and narrative.

should also be given the option of taking a break. The narrative text for a test pass menu incorporating all these choices is given in Figure 16.4.

Pretest and Preview Options

Interactive learning modules will usually be viewed by learners of varying skill or knowledge levels. Therefore, it is often useful to provide a pretest to enable learners who are already familiar with the material in one lesson to go on to others.

One form of pretest is to start each lesson with the option of taking the lesson test first. If the learner knows the material, he or she will pass the test and can skip the lesson. Another option is to provide just the review and test for those

learners who want a slight brush-up. Finally, you can design the program to begin at the review, which serves as a preview of the lesson, followed by the entire lesson. As redundant as that seems, it does satisfy those who insist on the maxim, "Tell them what you're going to tell them, tell them, then tell them what you told them."

FINAL EXAMINATION SCORING

There should be a tabulation mechanism for scoring the final exam, as well as all the other tests in the program. Unlike the unit test, the final exam is a true measurement device and, if true to its real purpose, should exist only to determine whether the learner has passed or failed the program.

Of course, the ability of the computer to do innumerable calculations allows the system to tell the learners which questions they missed and what their percentage scores were. There is also the capability to do internal consistency checks and measures of answering patterns if needed. The best interactive simulations can even capture segments of simulation play action for later playback. In this way, learners can see exactly where and how they "did well" or "screwed up."

In any event, the primary use of test data relating to final exams is to move learners out of the learning experience. Those who fail are supposed to take the program all over again.

Creative designers may want to devise mechanisms to identify lessons or even particular concepts that are giving the learner trouble. The learners can then focus on the areas that have prevented them from mastering the material. Final examination data also help validate test items and testing techniques, and they should be studied carefully so that the program can be improved in the future.

PROGRAM EVALUATION

Evaluation of the instructional program itself is a way of answering all the questions that will be asked about it: "Did anyone like it? Did they dislike it? Did anyone learn anything? Did it improve things on the job? How did it affect the bottom line? And, oh, by the way, was it worth the money?"

There are several types of evaluations. Some are done as the program is being presented, others are done immediately after the program is over, and others are completed back on the job weeks or months later. Ideally, the result of any evaluation is an honest report that shows column after column of positive data on improved performance.

Few systems of evaluation are completely reliable, and many can be misleading. Still, it is possible to have some sense of the program's effectiveness working with the following levels of evaluation.

Levels of Evaluation

I have always identified five different levels of evaluation for interactive learning. All of them apply to instructional multimedia, and many are appropriate for point-of-sale and game programs as well. Ranging from simple to complex, they are:

1. Do learners like the program?
2. Can learners pass a pretest or posttest on the skills taught?
3. Can they perform the skill immediately after training?
4. Can learners perform the skill back on the job?
5. What is the effect of improved performance on the company's operation and profits?

Level 1 evaluations are very basic, but they do give you feedback on how learners liked or disliked the program. This type of evaluation, of course, doesn't tell you how well the program worked or how much anyone learned.

Level 2 and level 3 evaluations may seem similar, but there is a big difference between them. Think of them in terms of a written driving test versus an actual driving test or driving simulation.

Level 4 evaluation (whether people can perform the skill back on the job) is critical. Ideally, this should be measured through on-site observation by training analysts. That will require a commitment of personnel to do the observing, but it provides a much more concrete measurement.

Many people feel that level 5 evaluation is difficult, if not impossible, to compute. The problem lies in being able to make a clear link between learning and increased profits. For many years, a good training program's worth was said to be 10 times the cost of producing it. Thus, if a training program cost $100,000, the company would have to save or earn $1 million to justify the cost of the program. All worth ratios in these cases must be based on a decision by the company to attribute some percentage of new profit to the success of the training. Unfortunately, the profit percentage assigned to the training program is arbitrary.

An interesting argument can be made that *all* increased profits from a new product result from training. After all, untrained personnel may not be able to sell the product at all. Unfortunately, most companies will not accept that argument. They conclude, instead, that bottom-line profit is just too complex a figure to tie directly to the cost of training. They recognize level 5 evaluation as an ideal. More specifically, they feel that training value is an area so difficult to quantify that, in all likelihood, any number assigned to it will be quite misleading. If people need some yardstick or benchmark for value, simple metaphors seem to be very believable: for example, "If this training sells five new limousines, it will have paid for itself" is more believable than "There has been a 50 percent sales increase since the new model was introduced. We attribute 30 percent of that to

advertising, 50 percent to the design and features of the new model itself, and 20 percent to training."

Instruction and training have always been areas that have pioneered the use of multimedia. From programmed instruction in the early 1970s, to interactive laser discs in the 1980s, to distance learning in the new millennium, the design principles and activities that influence much of today's interactive entertainment and promotional multimedia were born in learning centers. The important thing to note, however, is that the new age of interactivity and connectivity brought on by the World Wide Web and other new media innovations offer even greater opportunity to help improve our performance, our careers, and even our lives. That is why we have begun our exploration of interactive applications with these disciplines. But now it is time to move on to an area that is just as challenging, quite a bit more glamorous, and far more financially dangerous. I'm talking about show biz: the entertainment industry.

IV

Interactive Entertainment

Basic Structure

There is a good deal of talk today about integrated media. The thought is that combining interactive on-line experiences with straight TV will be the first step toward interactive television. One way to do that is to surround the linear video show with the kinds of support content that usually appears in a movie promo Web site. So while the TV show plays in the upper right-hand corner of the screen, a column to the left of the video and a row below it offer areas where more traditional Web activities can take place (Figure 17.1).

Two things are going on here: first, there is an opportunity to just watch the TV show without interrupting it, and second, there is a chance to do some on-line things while the show is progressing, again without interrupting the show itself. So, there is room for chat, and there is room for polls about the stars of the show or the products that the stars are using that might interest the users. There are areas with the latest on the characters and the stars. There are informational areas on the history behind the show, the setting, and the technology that might affect the story (if there is any of that).

Sounds to me like a sitcom with a little interactivity on the side. It's a familiar formula, and one I don't especially like. Never mind that this design interrupts the users' attention to the TV show. Never mind that it's not very interactive, and never mind especially that it's not creative. It is an easy, logical, and therefore perhaps inevitable step on the way to interactive television.

As noted, it is really a blend of linear TV with what a good promotional Web site should include, except for one thing, the most important thing. To see what that one, important thing is, let's take a look at a really good, interactive, promotional Web site for a movie.

A PROMOTIONAL MOVIE WEB SITE

Promotional sites almost always feature something called an electronic press kit (EPK), press information about the movie—cast bios, pictures of the stars, the credits, running time, downloadable promotional trailers from TV commercials, anecdotal stories about the making of the movie. Movie sites always included EPK materials. So in the early days of Web sites, if you thought about a movie

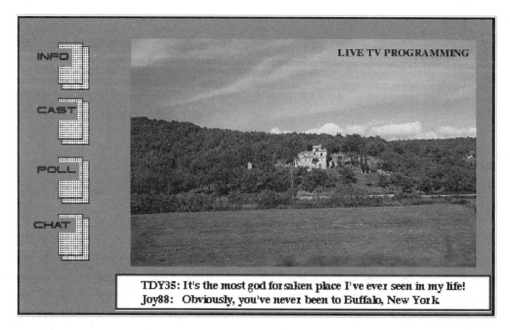

Figure 17.1 A hypothetical screen for a program that integrates Internet features and live TV programming. Photograph © Virginia Iuppa, 2001.

site, you either began with an EPK or you told the sponsors from Motion Picture Marketing, "We want this site to be different—we want to leave out the EPK entirely." They would never let you do it.

Electronic Press Kits

There is a logical progression from the EPK to the rest of the site. As soon as you have created a neat, little confined area called the *EPK area*, then the next piece that you need to think about is the flip side of the EPK. The EPK begins by answering the questions, "Who are the stars, what do they look like, and what was going on behind the scenes during the making of the movie?" The next area answers the questions, "Who are the characters, what do they look like, and what is the story all about?" This content usually fits neatly into a section that is called the *archives*.

The Archives

The archives house not bios and photos of the stars, but bios and photos of the characters in the story, downloadable pictures of the leading man and woman in character, movie clips of them doing things, downloadable audio of their most memorable lines. Having created archives of the characters (the good guys), you

Figure 17.2 *Congo* home page prototype. TM and Copyright © by Paramount Pictures.

need to tell your on-line users all about the bad guys, who they are and what they look like.

Now let's make a slight leap beyond this really standard stuff and ask about the locale, the setting, and the other things that go into the story. Really good movies create a whole world, and the archives give us everything there is to know about that world. What does the world look like? (Provide downloadable photos.) What is its history? (Provide photo and text essays and timelines.) Is there any unique terminology or colloquialisms or languages in that world? (Provide glossaries, etc.) Does the story feature any gadgets? (Show pictures and animations of them.) In addition to the hot and not-so-hot things in the archives, there is one very important area that can actually spill over into the next big set of areas.

An important area in the archives is related content. Many great movies are tied to important events, phenomena, or historic settings. In the site I created for the movie *Congo*, the archives included information about gorillas and volcanoes, but those areas were so big and important that they spilled over into their own sections.

Figure 17.2 shows an early prototype of the home screen for the *Congo* Web site. *Congo* Preview, Diary, and Production Notes are made up of content from the EPK. The Image Database contributed to the archives. Save the Mountain Gorillas was an area of related content.

Special Content and Links

We devoted an entire section of the *Congo* site to the Diane Fossey Gorilla Fund. We had downloadable pictures of gorillas and tons of data on the mountain gorilla—why it was endangered and what you could do about it. Then we added the first element that actually let the users do something other than look at pages of information. We allowed users to send messages to members of the Diane Fossey Gorilla Fund who were actually on expedition in Rwanda. Moreover, the members of the Fund agreed to send messages back.

We also created links to sites that were dedicated to gorilla preservation. Because another topic was volcanoes, we also linked to all the volcano sites we could find, and then we did the same with high-tech surveillance (another subtopic of the movie).

Communication

Now that we had people linking to people in the Congo, we had people branching out to other sites on related topics; we might as well let them talk to each other. So we created the communication area of the site so that people could share their feelings about the movie and the topics that were included in it: nature versus the machine, nature versus humanity, and the fate of endangered species. Bulletin boards and chat rooms were the communication features that helped people, months before the movie came out and months after its run, share their feelings and their opinions and form a sense of community around the subject matter.

There are two more sections that generally are often included in such sites.

Merchandising

Whether or not the mountains of merchandise that are created for each blockbuster movie need to be sold through the site itself is an interesting question. So far, few people have succeeded in making a lot of money through this sales method. Yet it is a logical thing to do, and, at least from a marketing standpoint, it can help leave no stone unturned in promoting a movie. Selling products inside a Web site involves product stills or video clips, promotional copy, ordering forms and processes, and order fulfillment. It is not a simple task, as discussed in detail in Chapter 22. Figure 17.3 shows our merchandising page.

The last, and in everyone's mind the most important, element of a typical promotional Web site (or any other kind of Web site) is the most interactive part—the fun part of the site: the game, the simulation, the activity. I have another name for it.

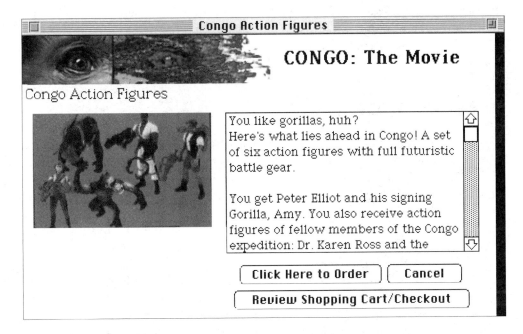

Figure 17.3 Prototype merchandising page. TM and Copyright © by Paramount Pictures. All rights reserved.

The Adventure

There doesn't have to be one adventure in a Web site; there can be lots of them. They can be games, they can be quizzes, they can be role-play simulations or branching story lines. To get away from Web sites for just a moment and consider CD-ROM titles, *The Adventure* is the stuff that those things are made of. It is also the thing that interactive TV should be made of. But at this point it is important to note that there is no place in the design of the supposed TV and Web site integration for The Adventure. It has been left out of the fusion designs for TV and the Internet—and that is too bad, because it is the one thing that would make interactive TV really interactive, not just a sitcom with a little interactivity on the side.

Because the adventure is so central to what the Internet is and what interactive TV is supposed to be, it gets its own chapter, coming up next. But before we go there, let's deal with a fairly recent exception to everything I have been saying in this chapter.

What if you wanted to create a movie promotional Web site that didn't look like a promotional Web site and that wasn't supposed to look like a promotional Web site?

What if you were to take just one part of the EPK and leave out all the others? I'm talking about a Web site based entirely on the section I call

the archives (the story of the movie). I'm referring to a Web site that treated story content as though it were real and made no reference to the movie itself. I'm talking about a true landmark in the still-brief annals of movie Web site history.

THE BLAIR WITCH PROJECT

Ignore the disaster that was the sequel. The original *Blair Witch Project* Web site was a masterpiece. It capitalized on the powerful and horrific back story of the movie to create an on-line experience that engendered the same kind of terror that the film eventually did . . . perhaps even more so. It used rich media sources to provide the background elements that occurred before the movie even began. It did this through detailed accounts of the Blair Witch herself, and the various characters who encountered her evil presence long before the movie's trio of ill-fated kids set off into the woods.

For a movie that benefited from its viewers' understanding of the terrible and troubling background material, and that demanded (at least at first) a very realistic representation of its terrifying details, the *Blair Witch Project* Web site was a perfect solution. Site users knew all about the Blair Witch and were already scared out of their minds before they ever bought a movie ticket. The site eventually created such a buzz for the movie that it, more than any other promotional element, has been credited with the success of the film.

The *Blair Witch* Web site is so on-target that there is a chance that the creators of the site even asked themselves the magic question, "Who are the users and what is their role?" Interestingly enough, in this case there are two sets of answers to those questions. The first set of answers is this: The users are people fascinated by sensational murders, especially those that have more than a touch of supernatural evil associated with them. The users' role is to explore the evidence and draw conclusions about the validity of the supernatural presence.

Of course the more down-to-earth set of answers to those questions goes more like this: the users are people who like to be scared, and their role is to sift through the evidence to find more and more terrifying story elements to scare themselves.

From our lexicon of interactive training techniques, the site is very much like the category called Database Usage. In the entertainment genre we have to classify it as an adventure even though it is made up of the elements of the archives. It is a movie promotional Web site whose only section is disguised as an interactive exploration—which in fact turns out to be a search . . . for horror!

The Adventure!

Many horror movies begin with people trying to prove or disprove the presence of evil. In the *Blair Witch Project* Web site, the designers decided that their users were like detectives on the trail of some supernatural presence. The users were not just observers, because they were *searching*, not just observing.

If, on the other hand, you take the approach that your users actually *are* nothing more than observers and their role is to look at things, you have what I call The Observation Adventure. If the goal is to deliver brief, entertaining Internet bytes that users can observe passively, you will be going the route of the now defunct super site, "The Den."

THE OBSERVATION ADVENTURE

The premise of such sites is that people need an entertainment break during the day. So, the sites' designers hope, users will log on and get a quick dose. Like eating a candy bar in the afternoon, the observation experience allows users to go back to work refreshed. But as noted, the major Adventure is in the process of choosing between several short pieces. The premise may be right and the idea may work, especially when broadband is everywhere and those pieces can load quickly and play smoothly as high-quality video. But for our purposes, interactive entertainment that plays to the passive observer provides a fairly low-level interactive experience.

To some extent the observation premise is not unlike that of an adult Web site. There has been a lot made out of the fact that adult Web sites are profitable. And that is true. You can look to their economic models and learn a lot. They have some interesting methods for charging their customers, including subscriptions that can run for months or years. There may also be charges for individual content along the way. But the income does not really come from the brilliant pricing structure or creative charging. The truth is that pornography is an addictive drug. Some adult sites even say, "Get your daily fix here." Others run a "Surgeon General's warning" about the addictive nature of their content. So, while the concept of a daily *entertainment* fix may be logical, the problem is

that entertainment may not be as addictive for the observation target audience as pornography is for its audience.

Unless you are able to deliver instant gratification to an audience that keeps coming back for more because they are addicted to your product, you won't strike it rich with the observer model. The other thing that has to happen to make the observer model work for you is that your product has to consist primarily of visual images or video streams that can easily be displayed on any computer. Pornography is unique because its product is nothing more than that: a bunch of pictures. You can surround the photo collection with all the finely drawn graphics you want, and even add some interesting interactive games (strip poker is always popular), but the economic model for pornography sites is nothing more than providing a gallery for a particular kind of image. It is because people can become incredibly addicted to that kind of image that pornography is profitable.

Because on-line pornography is unique as a product, you probably won't be able to transfer the profit models from pornography Web sites to other venues. The concept of addictive jokes, skits, or other forms of entertainment is a nice idea, and it has the advantage of appealing to a much larger audience. More people who are less addicted may mean just as much profit, but probably not.

There are, of course, other addictive items available on the Internet. If you remember the discussion of on-line games, you may remember that game designers identify one game feature above all others as being truly addictive. Amazingly and importantly enough, the most addictive feature of video games is *interactivity* itself.

INTEGRATED ADVENTURES

As of this writing there is a good deal of excitement about a project being launched by filmmakers Ben Affleck and Matt Damon, who are starting a company called LivePlanet. LivePlanet's first product is to be an integrated TV show and Internet site called *Runner*. The premise of *Runner* is an extension of currently popular reality-based programming. A real person is chosen as a runner and challenged to elude capture for 30 days while traveling throughout the United States and accomplishing 15 tasks. Let's say the runner is a crafty and athletic young woman. Her tasks might include the requirement of visiting a certain restaurant during a certain 48-hour period. If she does that, accomplishes all the other tasks, and evades capture, she wins a million dollars. Meanwhile, on-line audiences track the runner and her progress. If any of them can catch her, they win the million.

Hidden cameras follow the runner and her progress and, of course, all of this is featured on the Web site, together with live audio of the runner, maps of where she has been and where she is going, and her heart rate and other health

items. There should be some critical clues, too, that aren't available any other way.

If the proper amount of excitement can be generated by the TV show, and really valuable clues can be posted on the Internet, the project could be phenomenally successful, and the first great example of the convergence of TV and the Web.

Here the answer to the question, "Who are the users and what is their role?" has been very well thought out. The users are contestants, too, and their role is to try and catch this person called "the runner" and get her million bucks. The show's interactivity extends beyond the computer and into the day-to-day world.

Let's hope that Ben and Matt and their partners spend a little time thinking about what is going on between those users and their computer screens. How can the TV viewers share in the adventure through their computers? If they don't do that, the show might not appeal to people who don't want to spend all their time tracking down the runner and trying to catch her in the act.

STORY-BASED ACTIVITIES

In story-based adventures, the user's role is to share in the experience of the people in any story that the site is trying to tell. So, the next thing you have to figure out is, what are the people in the story doing that the users can share in? That should be pretty obvious. To go back to our example about the movie *Congo*, the people in that story were going on an expedition into the heart of Africa. So, then, there was only one more question to be asked: How do we let the on-line users share in that experience?

In the *Congo* Web site, the trick was to let people sign up for an adventure. Because the parent company of the *Congo* expedition, Travicom, Inc., was in the business of sending expeditions all over the world, one great idea was to create a database of upcoming expeditions that were heading to exotic places for unbelievable reasons, and then invite people to apply for those expeditions.

We could create a long and complex application form that users would have to fill out to apply for membership in one of the expeditions. Moreover, it could be written in the third person so users would have to write about themselves as though they were someone else, as though they were fictional characters in an adventure. In the end people could tell the story of their history as adventurers and about their strengths and weaknesses in the face of imminent danger. The response might be fantastic. We then could post the applications that were accepted on the site and even assign people to various fictional adventures.

That was one of the better concepts, but the idea we finally used involved the creation of a game as part of the *Congo* site. Figure 18.1 shows one sample frame. In the game, users received daily coded messages from the jungle. In the

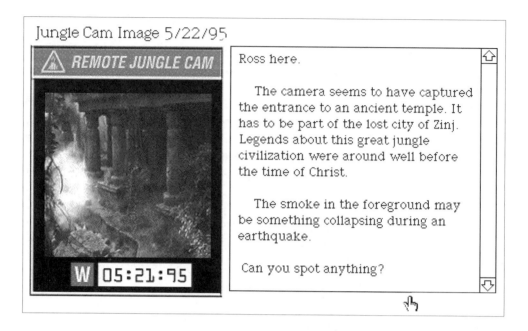

Jungle Cam Image 5/22/95

⚠ *REMOTE JUNGLE CAM*

W 05:21:95

Ross here.

 The camera seems to have captured the entrance to an ancient temple. It has to be part of the lost city of Zinj. Legends about this great jungle civilization were around well before the time of Christ.

 The smoke in the foreground may be something collapsing during an earthquake.

Can you spot anything?

Figure 18.1 Prototype frame from the remote jungle-cam contest. TM and copyright © by Paramount Pictures.

film *Congo* the Travicom company had first learned of the dangers to the Congo expedition when the signals at its remote jungle camera became garbled. With just a slight twist to the basic story, we said that the camera continued to function and was sending back random signals every two or three days. There was a message in the signals that could be translated, and when it was, those who figured it out and sent it in to Travicom headquarters would receive a set of prizes. We had lots of applicants and gave away lots of prizes.

SIMULATIONS BASED ON STORY

Another spin on this simple idea is to determine the activity in the story that lends itself best to simulation. In a Web site designed to promote a hypothetical TV show about the Highway Patrol, the story revolves around a super car of the future. The obvious activity is to give the users a way to simulate driving. Now, trying to create the feeling that people are actually driving a car through a Web site is extremely difficult to do, but creating the feeling that they are participating in a "training simulation" about driving a car can be more believable.

 So we might simply invent a training area within the Highway Patrol headquarters where users could go through a series of activities that would help them learn how to handle the car. People don't expect *learning* simulations to be perfect

replicas of the real world, and they accept a little "clunkiness." But the idea that you (the on-line user) can become part of a group who is going off on an important mission and participate in its training sessions, and even gain some rank for the level and quality of your participation—that is exciting.

Of course, for those who don't need to explain away the clunkiness, there are plenty of Web sites that offer driving, fighting, or chasing simulations. The technology to create these games is getting better and better, too. The clunkiness quotient is going down.

There may be an even better way to allow users to share in the experience of a story. In those stories where the common denominator is *inter*action rather than action, it might be possible to construct a game in which on-line users pick roles and play them in a simulation of the actual experiences of the characters themselves.

ROLE-PLAY SIMULATIONS

Web sites have started to take advantage of unique role-play technologies. In these applications, often called persona chats, the characters are listed, along with their interests, their personalities, and their goals. Players of the game then select a character they want to be (there can only be one per session), and then they are turned loose, in character, in a simulated environment where they can meet other role players and have the time of their lives.

The physical representation of the site on the Web looks and feels like an enormous chat room, but the location is defined. There is a map of the room that people are in at the time and indications on how to get to other rooms. The whole place has rules, monitors, and managers, and, of course, all those involved are pretending to be someone they are not. (Maybe it's not unlike a real chat room.)

There doesn't have to be a tremendous amount of structure to a persona chat, but there has to be some. The locations have to be identified. Props have to be listed and their uses have to be stated. There have to be one or two events that occur during the course of the role-play. These events are tied to the motivation of the characters in the game. That motivation spurs much of the interaction that takes place.

Avatars are physical representations of the characters in the persona chats. Several advanced Web site design companies are offering to build persona chats that feature avatars. So, when you pick the character you become in the persona chat, you also pick his or her physical appearance. This adds a higher level of reality to the game, even when the avatars are poorly rendered. Add movement through 3D virtual reality space (again being offered by some of the major Web site development houses) and the whole persona chat starts to move closer and closer to becoming one of those immersive experiences we will be talking about in Chapter 23.

ON-LINE STORYTELLING

I've talked about the story in on-line sites as though it were central to the existence of any site. The truth is that very few sites actually try to tell stories. Most of them present information. Many of them refer to stories that exist in some other medium. Even in entertainment sites, the existence of the story itself may be tangential to the goings-on within the site. Sometimes the story is presented in a very simple, direct, prose narrative that is tucked away at the far end of some long line of links.

There are, however, a few, very brave Web sites that actually try to tell stories. The most famous of these sites was *The Spot*, which finally had to close down in late 1996. If the pages of the site didn't tell the story of *The Spot*, then their lead line did: "Immerse yourself in the sun, sand, and secret journals of five twenty-somethings living under one roof."

The Spot can be thought of as MTV's *Real World* or the sitcom *Friends* on the Internet. Its story was told through the journals of five people living together in a house in Santa Monica, which they called "The Spot." The friends were called "Spotmates," and their dog, who was a character in his own right, was called "Spotnik." Most of the features noted in the preceding chapter were there, such as communication and archives.

The story exposition was in the daily journals (complete with easy-to-read large text and pictures); the archives, called "BackTrack," were made up of all the past journals. Just to make it easier to follow the long and winding story, the archives also included a variety of summaries, as well as a "Who's Who." The lead summary section was called "Spotgate." Communication also was a big feature of *The Spot*. The "Spotboard" bulletin boards had their own rules, ambiance, and personality.

You may be asking where the adventure in that site was. Maybe the storytelling part of the site was as close to an adventure as there could be. Of course, there was also the random access, which allowed users to jump between journals and skip back and forth between other parts of the site, and there was the communications feature.

In any event, in spite of its high usage figures, its wall-to-wall banner advertising, and its "Cool Site of the Year" designation, *The Spot* is no longer with us.

Amazingly enough, people haven't given up on the concept of interactive storytelling. At least as of early 2001 there are several sites that provide unique spins on the same kinds of features.

GET A LIFE, HARRY

This is a Web site that adds some unique elements to most of the features that were already on *The Spot*. As seen in Figure 18.2, *Harry* already offers background, bios, etc. And it goes farther than *The Spot* could ever go by adding a

Figure 18.2 A frame from *Get A Life*, *Harry*, with story summary on the left and QuickTime episode superimposed over graphic background. © Interactive Motion Picture Corporation. All Rights Reserved.

streaming video movie to tell the story. Right there many of the problems that people said occurred with *The Spot* are overcome in Harry's life, or his lack of one.

To go even further, *Harry* adds a major new item: polling. Users not only vote on the outcome of the story, they vote on each week's developments. The story is then written and produced to respond to the users' input. Periodic e-mail from the site to the users encourages people to follow the plot and get involved by voting. It's an interesting concept: one that does lack the instant gratification of moment-by-moment interaction, but still definitely involves the audience.

One problem faced by sites such as *Harry* and *The Spot* is creative excellence. *Harry* may have it. I have yet to see enough of the movie to decide. But the truth is that sitcom or drama Web sites that try to compete with weekly Hollywood TV product are competing with some of the most highly paid, most talented creative people on earth.

It is easy to knock the shows churned out by the Hollywood establishment. But people who have not fought their way into the rigorous Hollywood inner circle may not have the creative skills or the depth of experience to sustain an entertainment site that is revised weekly. If it is hard for *Friends* and *Frasier* to stay fresh and exciting every week, how can a bunch of people who do not have

the background of the creators of those shows pull it off? They may have flashes of creative brilliance and moments of great insight, but sustainability is another thing. As much as you may not want to hear this, going out and trying to sell investors on the idea that you can compete with James L. Brooks or David E. Kelly is quite a stretch. You may actually be able to do it. You may *be* the next David E. Kelly. The important thing is to admit to yourself and everyone else that that is what you are trying to do. On the other hand, if the centerpiece of your interactive Web site involves something other than a weekly sitcom or drama, you may have a better chance.

Interactive Storytelling

But let's play out the fantasy. Let's say you come up with, find, or are given a story line and are asked to produce a piece of interactive multimedia from it. You look at the content. You know that you don't want to produce a streaming video sitcom or a set of linear pages through which people can do nothing more than move back and forth. You want to create something really interactive. How do you do that? Well, begin by asking yourself these questions:

1. First and foremost, as we discussed in Chapter 8, you have to ask yourself, who are the users of the system, and what is their role in the story?
2. Is the story one that lends itself naturally to interactivity? Does it involve decision-making, the sorting out of information, or the processing of several complex and different paths, as in a mystery, a comedy of errors, or an adventure? Or is the story very straightforward and linear with few possible diversions to its path? If it is, then additional circumstances will have to be invented to make the story more interactive.
3. Having determined the role of the users and the nature of the story, the next question you have to ask yourself is, what are the devices needed to help users participate? Is there some unique form of interface? Are there a series of tools or techniques that allow the user some believable way to influence the direction of the story? Is there something in the nature of the story itself that could be simulated as an interface device? Are there characters who could serve as this device? Can they talk directly to the users? Do all of the characters do so, or do none of them?
4. Is there important supportive information that has to be reviewed, studied, and investigated to understand the story? Are there topics involved in that story that have the kind of interesting depth that would make users want to study them? Is there a way to make a review of the related topics an important element in the progress of the story? Are there points in the story that depend on it?

5. Are there opportunities for parallelisms? When one set of events is going on in one location, is it possible that another set of events could be going on in another, and could the users be at one place or the other and have that presence affect their knowledge of events and their capabilities for interaction as the story progresses?

6. Are there obvious simulations that fall out of the content or the action of the story? Does the story involve driving, shooting, finding a route somewhere, applying for anything, learning how to do anything (training), doing research, using a computer, using any one of a number of specialized electronic devices? Would it distract from the story to build those simulations into the story for the user?

7. Are there obvious and dramatic consequences of decisions that would be made during the course of the story? Is it possible for the users to make or to influence these decisions? Are there devices that would allow them to do this seamlessly?

8. Is subjective camera appropriate to present the user's point of view? (Subjective camera means that the camera represents the user and characters turn and talk to the camera as though it represented a character—who is, in fact, the user.) Can the story be written in such a way that the characters are always aware of and acknowledging the presence of the user as a character?

9. Are there areas in the Web site or CD-ROM that are attached to a Web site outside the actual storytelling area where users could meet with other users and discuss the events of the story?

10. Is it possible for the users themselves to take over the story and play several roles? If so, how does that influence the progress of the story?

11. How is the drama presented in multimedia? How are the users told about their characters and what is going on? Is there an obvious mechanism for exposition, and does it allow for an interactive user?

12. How does the story resolve itself? Can the users contribute along the way so that they are involved as the story progresses? Does the user have a critical role to play in the ending, or does the end occur regardless of what the user does?

13. Are there rewards for the user, prizes, awards, or at least recognition on a list somewhere?

Does it seem like that was a lot to read through and remember when considering the possibilities of an interactive story? Okay, then, here is a checklist that should make it all a little easier to handle. Copy it and use it if you ever have to consider the possibilities of making a story interactive.

Interactive Story Considerations:

1. What is the role of the users? Are they:
 ___Characters within the story
 ___Controlling/"making decisions for" characters
 ___Advisors to the characters
 ___Observers

2. Does the story lend itself to interactivity, involving
 ___Crisis decision-making
 ___Sorting information
 ___Following complex paths
 ___Solving a mystery
 ___Sorting out a comedy of errors
 ___Sharing an adventure
 ___A linear series of events (not a good choice)

3. How do users participate? Is there:
 ___Something in the story that could be turned into a communication device
 ___The possibility of a unique user interface
 ___Unusual procedures for communication
 ___A special character through whom the users must communicate

4. Is there background information to form a database? Are there any of the following:
 ___Deep, complex content areas that are critical to the story
 ___Details that could help participants understand or make decisions
 ___Database elements that must be reviewed to participate in the story

5. Could events be going on in parallel in different locations that could limit a participant's knowledge?

6. Does the story involve elements that lend themselves to simulation, such as:
 ___Driving
 ___Shooting
 ___Finding a path
 ___Applying for anything
 ___Using a computer
 ___Doing research
 ___Learning anything that can be simulated
 ___Making decisions
 ___Filling out forms

7. Are there obvious and dramatic consequences of the wrong decision that can be dramatized? What are they?_____

8. Is subjective camera appropriate to present the user's point of view? If not, how will the characters acknowledge the user's presence?

9. Can there be chat rooms or bulletin boards created outside the simulation where participants can meet and talk about it?

10. Can users take over the story and play all the characters? If so, what will that do to the story?

11. What media devices are used to tell the story?
 ___Streaming video
 ___Branching local video
 ___Audio
 ___Graphics
 ___Animation
 ___Text
 ___Collaborative tools
 ___All of the above

12. Does the user have a critical role to play in resolving the story?
 ___User's decisions decide the final outcome
 ___User guides the final action that resolves the story
 ___User advises the characters who must make the final decision
 ___User has no way of affecting the final outcome (not good)

13. How is the user rewarded or recognized?
 ___Is put on a list
 ___Receives a prize
 ___Is identified by the characters in the final episode of the story

These are some of the questions that you have to ask yourself when you are presented with a story line and have to make it interactive. What might you come up with? Well, the best examples of this kind of interactivity may eventually appear on digital video discs (DVDs), but right now you will find them on CD-ROM, as illustrated in Figure 18.3.

> Imagine that an enigmatic relative, your distant Uncle Thurston, has bequeathed you his entire estate, including the centerpiece of his holdings, the famed Last Resort.

Figure 18.3 Image from CD-ROM game *9*. Used by permission of GT Interactive Software Corp. © 1996 Tribeca Interactive Inc. All rights reserved.

A will, a postcard, a tourist's brochure . . . all indicative of the splendor that once graced this faded temple to the creative spirit . . . but those days, apparently, were long ago. . . .

Now you are entrusted with the care of the Last Resort . . . and soon you will realize you've inherited not just a deteriorating mansion, but also your family's twisted legacy. . . .

So reads the instruction to the classic CD-ROM adventure game, *9*, from Tribeca Interactive.

It turns out that it was your late Uncle Thurston's muse machine that provided art and inspiration for all the inhabitants of the Last Resort. So what you have to do to preserve your inheritance is to win a race against a pair of evil twins who are intent on destroying the Last Resort and all that it could become again. Aided by the Last Resort's nine muses, you must find and solve every puzzle in the Last Resort to restore the missing pieces of the muse machine before the twins complete their own machine and bring the place to its downfall.

INTERACTIVE WEB SITES FOR KIDS

Kids' Web sites also provide a level of interactivity similar to CD-ROM games. They have in fact always been in the forefront of interactive entertainment. Maybe it is because cartoons have been a way to interact with kids for nearly 100 years, and these days a good fast Internet connection can provide you with very good-looking animation and all the potential interactivity that that offers. Or maybe it is because adults, who have to deal with kids all day long, figured out long ago that the easiest way to keep kids happy is to give them something to do, keep them active . . . interactive.

There are a number of terrifically interactive sites designed for kids, from VeggieTales.com to Disney's *Blast*. One of my favorite kids' Web sites is *Noggin*. Figure 18.4 shows the Noggin home screen, which promotes key attractions from the larger selection shown under the heading called "THE WORX."

Noggin is a TV and Internet product of Nickelodeon. The fusion of TV and the Internet has been designed in from the ground up, and the Web site itself has a very high level of interactivity.

Figure 18.4 The *Noggin* Home Screen, which promotes key attractions from the larger selection shown under the heading "THE WORX." © 1999–2001 NOGGIN L.L.C. Used with permission.

Noggin is divided into four main areas: The Lab, Chronicles, Noggin TV, and Game On. Game On is the largest area, with more than a dozen complex and confounding interactive games that kids will enjoy. The games take advantage of Shockwave for a terrific set of sound effects and animation. My favorite game of the moment in called Wordmorphosis, which allows kids to move from a simple word like "shoe" to another word like "clap" by filling in blanks to change one letter at a time. At the end a very creative piece of animation ties it all together. It is much more interesting than my description of it, believe me. Check it out at http://www.noggin.com.

In the section called The Lab, the "Comic-Strip-Maker" asks you to provide interesting words, many of which you make up. Then it plugs them into a comic, and you have created your own strip with very original references and phrases.

Figure 18.5 *Argon Zark®.* ©1997 Charles R. Parker.

The Logo Lab lets you create your own version of the *Noggin* logo by pasting your images on top of the head of the *Noggin* Logo Guy.

For the fusion crowd, you can download and build your own casebook for the *Noggin* TV show, *The Ghostwriter Casebook*. The book and the site contain clues that might help you crack the case before the *Ghostwriter* team does it on TV.

Finally, The Chronicles section contains some very elaborate elements. Right now a section called "The Johnsons" follows a family with a whole lot of kids (eight) who have left their home in South Carolina and moved into a big bus. For the next year they will be taking a trip across the country. The trip is chronicled by their 16-year-old daughter, Heather, and the path of the trip is directed by decisions of the kids as informed by the e-mail advice of the users of the site.

POWERFUL PRESENTATION FORMATS

So kids' sites, with their affinity for graphics and animation and their ability to build in complex and entertaining activities, provide a good example of how adventures can be added to basic story lines in order to build rich Web sites. A more adult version of the same kind of thing can be found in comic strip Web sites.

Argon Zark (Figure 18.5) is one of the best original comic strip sites created for the Web. I've enjoyed reading it for several years, longer than most entertainment Web sites have been in existence. I think it has something to teach us all. We'll study audio, motion, and what we can learn from this amazing Internet format in the next chapter.

Comics on the Internet

Comic strips and comic superheroes have taken up permanent residence on the Internet in such great numbers that they seem to have formed a unique genre of interactive entertainment. Where sites were once simply static frame-by-frame comic presentations, more and more bells and whistles have been added until these sites have become some of the more interesting examples of the interactive form. Moreover, because animation is extremely well suited to comics, they offer a convenient set of content to study the various uses of animation and motion on the Web. So, here is a review of the variety of comic strip Web sites and some of the interesting games they have spawned.

BASIC COMIC STRIP SITES

There are a number of reasons why comics can and should be on the Internet. The first is simple convenience. You may not get your favorite comic strip in your local paper, or you may not have time to read it before you leave for work in the morning. No matter: you can probably find your favorite strip on-line. In fact, personalized home pages such as Excite allow you to pre-select your favorite comics and give you direct access to them from your home page. Once you link the comic site to your home page and begin reading it daily over the Internet, you'll have just one more reason to cancel your newspaper subscription. Just putting comic strips on the Web offers two very good examples of the basic value of the Internet: updatability and easy access from anywhere.

The simplest kinds of comic strip Web sites are designed to do little more than present the latest panels of your favorite comic strips on the Web in their current static form. Just being able to get to the latest pages of your favorite strip any time, no matter where you are, is pretty great. No more going to the out-of-town paper while you're traveling and finding that they just don't carry *Mr. Boffo*. Now just log onto the Internet, and the strip is one click away from your home page.

Still, the Internet always seems to offer something extra. Even in the case of static comic strip Web sites, you get the added benefit of comic archives from recent days and weeks along with today's strip.

THE DILBERT ZONE

The Dilbert Zone (Figure 19.1) goes way beyond the basic comic strip site. It adds a wide variety of clever and practical adventures. There are games and funny stuff, polls, shopping, and facsimile cover-ups (ways to hide *The Dilbert Zone* behind a piece of realistic-looking work in case your boss walks in while you are surfing *The Dilbert Zone*).

The "Funny Stuff" section of *Dilbert* has interesting puzzles and activities under "Dilbert's Daily Mental Workout." There are even additional "dumbed-down" games for the supposedly inferior minds of managers. This is in a section called "The Boss's Brain." The game area features a "Mission Statement Generator" and a "Performance Review Generator" to provide, as the site says, "the latest corporate gibberish" and "subtle but incriminating doubletalk," respectively.

The Dilbert Zone also features a much larger and more complex section that presents a series of brilliantly clever polls featuring items for site visitors to rank. A recent poll asked users to vote on the top 207 ways to get your company to pay for degrees unrelated to your business. Once the users vote on the list items, a sort list is created from the top choices. "The Short List of the Day" is published on the site, and that list is made available for e-mailing to friends.

Figure 19.1 *The Dilbert Zone* home page. (*Dilbert* © United Features syndicate, Inc.)

Just to take advantage of the presence of the kind of "engineering-type" folks who frequent *The Dilbert Zone*, there is an actual career center called the Career Zone sponsored by Dice.com. The zone offers a real on-line search for high-tech jobs.

Finally, *The Dilbert Zone* does offer animation—in fact, two kinds. There are short 2D and 3D cartoon movies if you have the appropriate plug-ins. These cartoons are excellent pieces, but they are set off in their own little area and their effect is not integrated into the other *Dilbert Zone* activities. Integration that was a little more complete might achieve an even more interesting effect.

MORE HIGHLY ANIMATED SITES

One of the most highly developed and highly irreverent comic sites of all time was one on which I was able to provide some design work with site project manager Brian Mansfield. The site was not based on a comic strip, but on a TV series. The *Duckman* site ran on the Microsoft Network for more than a year and featured the "Private Dick/Family Man" as the host of his own talk show. This elaborate site also promoted the irreverent TV series, which, at least as of this writing, still runs occasionally on Comedy Central.

Standard features of the site were: weekly monologues by the star; the celebrity Hot Seat, in which comic representations of celebrity guests invariably ended up getting fried in what turned out to be an electric chair; the patented "Rant Generator," which allowed users to access Duckman's preposterous point of view; and Hot Babes, which actually presented Duckman's Electronic Press Kit. Going to the Hot Babes section offered a sexy cartoon goddess as well as credits and background info for the site.

The *Duckman* site also featured a variety of interesting games as well as a spectacular use of streaming audio. Duckman's rants and his opening monologue were created in RealAudio, a streaming audio delivery system that allowed users to hear their hero's obnoxious droning streaming in real time.

ANIMATION SHOWCASE: AUDIO AND GAME APPLETS

If you want to check out the latest and greatest in Web animation, audio applications within animation, and game applets, you can do it all in one site. The Macromedia Shockwave site offers a complete collection of the very best of Web animation and uses of audio and game applets.

As discussed earlier, Shockwave is one of the most common applications used to present animated shows and games on the Internet. For this reason Macromedia, maker of Shockwave, has created a display site that features the very best of Internet animation. Go to http://www.shockwave.com to find the

latest and greatest online animation. Among the sites showcased are games, music videos, animated stories, and combinations of all of the above.

Among the best interactive features on the current site is the Madonna music video, which is interactive. During the playing of the music video the users can click on icons that identify segments of the show. Then during the final chorus they can go back to the icons they selected and, by clicking on the icon bar, show a combination of the segments they like best. The images continue to play against the streaming audio until the user changes them. It is like editing a sequence of your own music video.

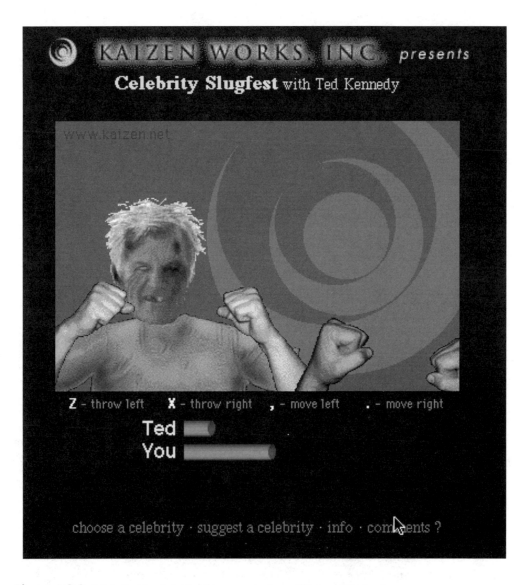

Figure 19.2 *Celebrity Slugfest.* Used by permission of Kaizen Works, Inc.

In addition to the music video, there are ongoing stories, such as the *Stain-boy* animated short films produced by the famed movie director Tim Burton. There are also a myriad of small interactive games, called game applets.

GAME APPLETS

Some of the most ambitious Web sites offer a full complement of games to support their central features. This is true not only of comics, but also of promotional and action sites. The invention of new forms of game applets has become big business for on-line development houses, and many of the applets appear in several sites. Occasionally game applets appear as greeting cards that you can e-mail to a friend or political soulmate to reinforce your shared feelings about candidates or current events. There was a rash of extremely clever applets during the 2000 presidential election.

My favorite political game applet was available during the presidential election on the Shockwave Web site. It came in two flavors: Dunk Gore or Dunk Bush. In either game the presidential candidate sat on a swing and taunted you as you tried to hit his party's mascot with flying tomatoes. If you were able to hit the mascot five times (out of 10) the candidate got dunked.

One of the most impressive games ever on the Web was *The Celebrity Slugfest* (Figure 19.2). In this interactive grudge match, viewers boxed with various celebrities. The Z and X keys controlled the punches the users threw. The period and comma keys moved the player left or right. Users threw punches at opponents as they bobbed and weaved and struck back. Opponents got bloodied as the match went on and ended up unrecognizable. Adversaries ranged from pathetic weaklings such as Barney to much tougher folks such as Bill Gates.

Now that we've considered comic strip Web sites, animation, and individual games applets for the Internet, let's take a look at more elaborate versions of games that exist on the Web, CD-ROM, and interactive TV. We will focus on the form that is extremely popular right now: game shows.

Game Shows

Television game shows go through cycles. A show will pop up and catch the fancy of the public, as did the spectacular ABC success *Who Wants to Be a Millionaire?* Typically, those shows go on for several years, slowly decline, and eventually go away. On the coattails of such a stellar show, game shows in general will follow the same course: peak, level off, and then decline and disappear. During these down years, the concept of a prime-time game show will begin to seem unthinkable. Then suddenly, a new hit game will be created and the whole genre will be back in business.

TV game shows are so involving that viewers automatically play along with them. Viewers answer questions out loud and try to beat the on-screen contestants. As a result, TV game shows have provided one of the earliest and clearest examples of the convergence of TV and Internet technologies.

This is definitely the case with *Who Wants to Be a Millionaire?*, where TV viewers are urged to log onto the abc.com Web site and play along. The enhanced TV version of the game is not revolutionary, but it does work. A few possible design problems are dealt with directly, and as a result the users are involved both with their computers and with the TV game.

The enhanced TV version of *Millionaire* begins with the premise that the TV and the computer are in the same room. This is a large assumption and one that has challenged interactive TV designers for years. The *Millionaire* designers seemed to have bitten the bullet and simply said, "This show is for people who somehow can get a TV and networked computer into the same room." The proof of this decision lies in the fact that the on-line user *has to* watch the TV in order to learn what the question is. The answer choices appear on the computer screen under a window that usually shows the logo of the show and nothing more. The site designers could have put the question there or shown stills from the TV broadcast . . . but they didn't.

A number of bonus points appear on the right of the screen along with the user's point total. The bonus points count down while the on-line users figure out the answer. If the users can answer the question before the TV contestant does, then they get the appropriate bonus points along with the points allotted for the question.

So the $300 question has 135 bonus points, which become 134, then 133, etc., while I am choosing the correct answer. If I beat the on-screen contestant, I

get the bonus. Of course I can hear his or her answer, so when the on-screen contestant answers there are no more points available at all.

So, I can just answer the questions and try and beat the contestant while ignoring the bonus points, or I can pay attention to them, try to accumulate them, and compete in a bigger "meta-game."

The *Who Wants to be a Millionaire* "Meta Game" allows on-line players to compete among themselves. Players can log on, use a screen name, and have their accumulating point total recorded as they play. In that way there is real competition between the on-line players. And it is independent of the TV show, so much so that the point totals that on-line players are accumulating bear no resemblance to the total that the on-screen players are winning. Beyond that, online players continue to accumulate points when one TV show player finishes and another begins, during the entire course of the show.

During commercials special bonus questions are added for the on-line players, and these questions appear in the window that normally holds the *Millionaire* logo. These bonus points are added in, too, so that the on-line player can accumulate quite a score during a complete show's play.

I'm sure it has not been lost on anyone that that same window that presents the *Millionaire* logo and the bonus questions could show the TV show itself if streaming video were allowed.

Imagine a window that would contain the streaming video of the on-screen contestant and host Regis Philbin. Then combine it with the graphics of the current Web site that surround it. Then we would have a much more complete vision of what interactive TV on the Internet can be like.

BUT THINK ABOUT THIS

What if the host recognized the at-home viewers as players in the game? What if there were branching responses that allowed the host to give individual feedback to the at-home viewers as though they were the principal players in the game? Then the host, the on-screen contestant, and the home viewers would be on a par with each other. The role of the viewer would be changed from that of an outside observer or secondary player to that of a principal player. As a result, a much higher level of interactivity could be achieved.

I have had some success designing games for interactive TV pilots that allow home viewers to play against on-screen contestants. In those games I allowed the home viewers to ring in first, answer the questions, and then, if wrong, see the answers go to the on-screen contestants. Because these games were prerecorded in true interactive video style, the responses of the on-screen contestants were always taped with both right and wrong answers. When the home viewer answered the question incorrectly, a randomizer determined whether or not the on-screen contestant gave a right or wrong answer. Scores

were tabulated, and users won or lost with all the hoopla of syndicated prime-time television.

Yes, this was a show in which all the game elements were created for the purpose of entertaining the home player. During production, the game was recorded straight through as in a real live game show, but then the on-screen contestants would have to provide an additional set of right and wrong answers. Finally, the host would have to record a series of responses that acknowledge the at-home player and his or her success at the game.

It is complex production, but when high-bandwidth streaming video allows the Internet to take on the features that were envisioned for interactive television, it's sure to be tried.

Until then, all we will have are the approximations of efforts such as enhanced TV, or the even simpler game shows that have been developed for the Web alone.

BASICS OF GAME SHOWS

Fundamentally, game shows are usually variations on multiple-choice questions. Take away the bells and whistles for a moment, and you have a core that includes a question with three or four response choices. The wrong choices are almost more important than the right ones, because it is these choices that determine the difficulty of the questions. (The writers of *Who Wants to Be a Millionaire?* are among the best I have ever seen at creating "seductive detractors," as the wrong answers are called.)

Building game shows then becomes a question of first creating a database of questions and answers on different topics. For on-line Web sites, the handful of questions that are used in a TV game show give way to thousands of questions that have to be stored and cross-referenced for use on a regular basis. Some Web sites go so far as to run their trivia games 24 hours a day, and the games are of extremely short duration, sometimes no more than 10 minutes a game. Even with 15-minute breaks in between the games, that amounts to a staggering number of questions and answers.

CLASSIC WEB SITE TRIVIA GAMES

If you are building a Web site and want to create a simple trivia game that is going to appear once a month, things should be pretty easy for you. You can create that sort of game and run it with simple HTML code. However, if you are charged with providing ongoing trivia games that run 24 hours a day and are never repeated, then you are into thousands of questions, and you had better ask yourself where you are going to get all that content.

If you are able somehow to find the content, you still have to go one step further and figure out how you are going to process all the scoring information that will be generated by game players on an ongoing basis.

Fortunately, several very clever companies will sell you the questions and the engine used to ask and store the questions. They will also build questions around any topic you want to consider. They will probably even administer the game on-line for you so that people can jump into a site for a few minutes, play a quick trivia game, receive their score, and jump out.

If you are charged with creating that type of game and you have a limited budget, you are faced with a rather formidable task. But there is hope. One way to cut the cost and difficulty of game development is simply to adjust your expectations about the game's frequency. In other words, don't keep it going 24 hours a day. If the game is good enough and enough fun to play, you may be able to run it for limited hours and spend the cost savings on production values. Of course, production values are a whole story in themselves. Let's tell it.

CLASSIC TV-STYLE GAME SHOWS

The opposite end of the spectrum from the on-line, text-only, fast-paced trivia games are the TV-style game show formats that cut down on rapid-fire questions. They replace those by adding a host, music, flashy graphics, long explanations of the rules, and variations on game play that include different kinds of questions from matching, to quick response drills, to fill-in-the-blanks.

Because of the extensive production values of this kind of game, the need for vast question databases is reduced. Questions can focus on very specific topics and really target their audiences. Moreover, the production of a game show, although it may require an expensive set, is not really all that costly, since the games can usually be produced in large numbers by shooting several in a day. This low-cost product is possible because of the real-time nature of game play.

The formats that were developed for the interactive TV pilots tested extremely well with pilot audiences. But then, because the interactive TV pilots were short-lived, there is no telling how well those games would have done with real audiences over time. However, the interactive TV game show designs adapted to CD-ROM, or even on-line gaming, can produce very entertaining and rewarding experiences for on-line users and for the people who develop them. Figure 20.1 shows the flow and organization of such a high-production-value TV-style interactive game show.

Now, because everything needed to produce a great interactive TV game show already exists in CD-ROM, it should come as no surprise that it was in that complex marketing arena that one of the true masterpieces of interactive design was created.

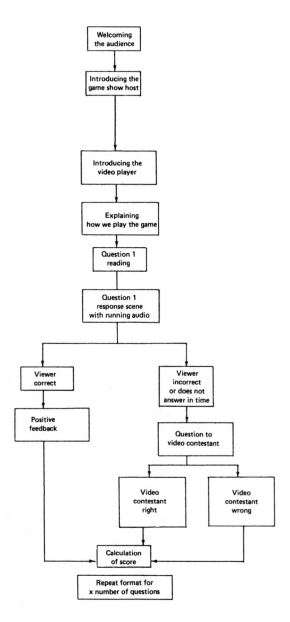

Figure 20.1 Flow of a TV-style game show.

YOU DON'T KNOW JACK

You Don't Know Jack, the highly successful CD-ROM-based interactive game series, is a perfect example of taking a basic design structure, stripping it down to its essentials, and then rebuilding it with a very fresh and very creative point of view. All the hoopla called for in our flowchart is there, but the expensive set

and the living, breathing faces of the TV cast and crew are replaced with voices and sounds. So we hear the director, the assistant director, the floor manager, and all the various participants in the production of a live TV show talking to each other and to us as they prep for the production. They are kibitzing as only media production people can.

This cacophony of voices provides the background for the opening of the game. But mingled in among the noise are real questions being asked: "Give us your name." "Do you want to play a 7-question game or a 21-question game?" "How many players are there?"

The graphics that accompany these disembodied voices are bright, colorful, animated text and numbers. They dance, they sparkle, and they pretty much entertain without the need for what would actually be the more mundane presence of a physical being. We are getting plenty of personality from the voices on the screen; why see faces? There is music, too, and singing. It introduces each question category and moves the game along. Figure 20.2 shows one question screen from *You Don't Know Jack*.

The questions are the standard stuff of game shows, largely multiple-choice, but there are also very clever matching exercises and very difficult and very

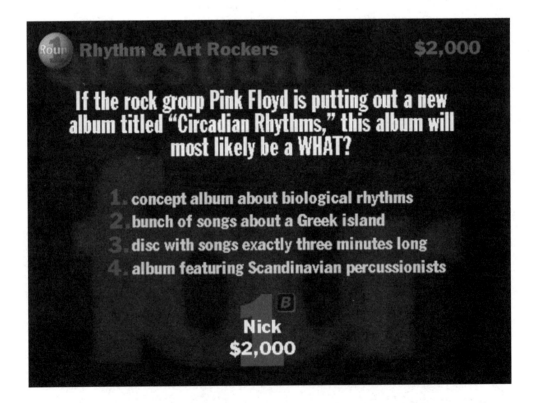

Figure 20.2 Sample screen from *You Don't Know Jack*. © Berkley Systems Inc.

clever rhyming fill-in-the-blanks sets of questions. It is the writing of the questions, more than anything else, that makes this game so brilliant. Typical topics to choose from include "That's Pretty Big, Mac," "Charlie's Angels in Hell," and "Projectile Cometh." Yes, they are irreverent and brilliant!

Players pick their topic, and then they choose the right answer using one or two keys on their computer keyboard. As noted, this is a multiplayer game, so you and your partner sit side by side and "duke it out" using single keystrokes to identify yourself and select your answers.

The system evaluates your answer and sets your score. You get a witty and not very polite critique from the game-show host when you are done. Then you get a chance to play again . . . and again . . . and again. Like all great interactive games, it is addictive.

Whenever we talk about interactive media, the concept of game shows invariably comes up. That, quite simply, is because game shows are so intrinsically interactive. People tend to interact with the games even if the game-show format that they are watching doesn't allow interactivity.

As noted, game shows are also a form of popular entertainment, and they rise and fall in popularity. Game shows are extremely popular these days. They were far less popular a few years ago and (except for *Jeopardy*) were almost unheard-of a decade ago. To some degree, they, as much as anything else in this uncertainty-principled world . . . are fads.

Information, e-Commerce Systems, and Beyond

V

21

Corporate and Informational Web Sites

Corporate and informational applications have really become the cornerstone of the World Wide Web. So, although many different kinds of digital media offer this kind of information, it seems like a good idea to focus on the Internet and generalize from that point.

Let's start by making one critical distinction. Corporate and informational sites are not the same as point-of-sale or e-commerce sites, in that they are intended to disseminate information, not sell products directly. Even when there is a sales area within an information site, the basic design of the site remains fundamentally different from that of sales sites.

The structure of an interactive sales situation can be thought of as an inverted pyramid in which all interactions funnel the viewer to a single action—a purchase. By contrast, the interactive information dissemination structure can be considered as a series of opening doorways that lead to more doorways. In such a structure, viewers' options expand and movement through the material becomes more and more flexible. Figure 21.1 illustrates the difference between information and point-of-sale structures.

Even though the structures of informational and point-of-sale programs are exact opposites, the two applications share similar requirements. In both cases, for example, the architecture should not get in the way of the user's ability to find information or complete transactions as quickly and as easily as possible.

CONTENT SELECTION

In previous chapters we noted that the content makeup of many Web sites is similar. We moved from promotional movie sites to entertainment sites and found that we were identifying a set of content areas that can or should appear in almost all of these sites. The areas we identified were:

- Promotional materials
- Archives

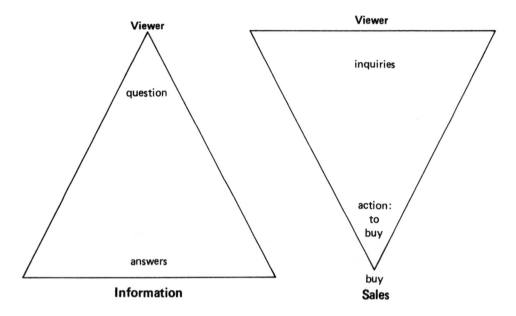

Figure 21.1 Informational and point-of-sale structures.

- Related content
- Communication
- The Adventure
- Merchandising

How could that structure possibly relate to business? Well, here is that list again with an expansion of the categories based on the needs of e-business sites. Let's see how well they hold up.

- *Promo materials* (your basic package of product and corporate content)
 All about your company
 Your corporate philosophy and point of view
 All about your products (what they are)
 Tools that help customers select the specific model of product that is right for them
 How to use your products
 Ads for your products
 Anything else you can think of to help your customers understand the value of your products
 A complete product catalog

- *Archives* (putting all your past customer publications on-line)
 Any series of useful booklets you have sponsored relating to your products or their functions

Training materials
Decision tables and matrices
CD-ROM content modified for the Internet
A collection of past features from the site

- *Related content and links* (information appropriate to your target audience, even though it does not directly include your product line)
 Anything that ties your world to your customer's
 Information about the general category of content that your product relates to
 Anything interesting or entertaining to your users as a unique demographic group
 Tools that will help them do their job
 Articles or presentations about the contribution of members of their demographic group to the arts
 Travel and leisure topics of interest to that group
 Links to related sites

- *Communication* (ways to build a direct link between you and your customers)
 Mechanisms for customers to send you messages
 Answers from the experts on your staff
 Bulletin boards where customers can post their opinions and gain a sense of community
 Opinion surveys about your products
 Questionnaires to help you gather demographic data on your customers and generate mailing lists

- *The Adventure*
 Active user involvement with your content
 An on-line version of your service
 Attention-grabbing games and activities designed to bring traffic to your site
 Other activities to promote your products
 Contests

- *Merchandising*
 Selling your product
 Offering coupons

A few years ago, I helped create a corporate Web site for Bristol-Myers Squibb. The site was designed to offer information to women as a group and to feature those areas at which Bristol-Myers Squibb excelled at providing care for women. In the depths of the site, the various brands of products

(Excedrin, Clairol) gave details about dealing with headache pain or choosing a hair color. Let me just map part of that site against our newly redefined set of categories.

Promo material	Product Directory, *About Bristol-Myers Squibb*
Archives	*Momness* and all the great publications that Bristol-Myers Squibb had created on mother-hood, headache management, skin care, hair care
Related content and links	Articles on fashion, style, glamour in general; articles for women on how to use technology; homemaking tips; a stain removal guide
Communication	Ask the headache specialist, *Ask Clairol*, exit polls upon leaving the site
The Adventure	Highly interactive product guides, games built into the site to draw traffic
Merchandising	Gift certificates, giveaways

An important point about my use of the term "the adventure" in a corporate site is that I have used the term to designate the most interactive features of the site. So, for those sites that actually provide a service on-line, *that* is the adventure. Consider on-line banking, which gives you instant access to account activity. It can't get much more interactive than that. Negotiating a deal on a car or learning how to negotiate a deal on a car is an adventure as well. Sure, it has all the downside of an adventure (danger, risk, loss of fortune, and self-respect), but at its heart there still lies an adventure.

SERVICE SITES

Creating a banking site or an investment site or a product tracking site is a demanding task, one that goes far beyond the goals of this book. The best sites I have seen in this arena simplify the graphics and the distractions and get right down to business. Generally speaking, that means a minimum of fancy backgrounds and snazzy lead-in animation. Those are used to get and keep people at your site. Users of business sites are fully motivated by the work they will do on your site. They don't need pizzazz. On the other hand, the structure of the interface continues to be critical. Once you or a vendor you have chosen have created the basic functionality of your site, you had better test the interface until it runs as smoothly as a high-performance sports car. Poorly identified pull-down menus can hide critical choices. Cryptic button names can end a transaction before it even starts. Lack of sufficient instruction is often a real barrier to usage.

You have to test and retest to make the process foolproof. A good rule of thumb is to start with the minimum of instruction and see how things go. Then, through developmental testing, you can refine the menus, the names, and the instructions until the site is one transparent, smooth operation. Remember, too, to test your site on a variety of platforms and with all the browsers your clients might use. It is amazing how font changes and reformatting dictated by one browser can distort or destroy a site that works perfectly well on another. Only when all this testing and revision is complete should you allow the world access to your product in cyberspace.

DATABASE-DRIVEN CONTENT AREAS

One interesting set of corporate or informational sites include those that offer so great an assortment of information that they require databases to archive and deliver the content. Any time you have to deal with hundreds or thousands of products, you are talking about databases. Consider, for example, *Paramount Home Video*, another of the sites with which I have been involved. It is a Web site designed to present all the titles offered by the Paramount home video service. To create such a system, we had to digitize and store descriptions of all the titles, digital images of the boxes, clips of scenes from the movies, and quotes from the best dialog. We also had to provide summary data about each video (genre, awards, cast, director, running time, rating, color, closed captioning). We had to build templates to structure the data and offer a consistent way to present it. The images, too, had to be accessed and displayed in a consistent way.

Databases are the best way to put a site such as this one together. When the need for constant updating and multiple ways to access the data are added to the equation, databases become the *only* way to do it.

So, we ended up with more than a thousand pages representing the videos in the home video collection. On top of that, we added a search engine that could find any title alphabetically based on input from the user. Next we provided ways to look up movies by genre, actors, and awards. We also created a little engine that allowed people to access similar movies from the screen of the film they were considering at the moment (movies with the same star, the same director, or the same genre). Then, on top of all that, we created a welcome screen that promoted the most recent releases. The first thing you saw when you went to the site was "What's New?" The same screen also allowed for special promotions and giveaways.

In the earliest versions of the site there were also adventures. We had a game area that provided monthly games based on the content of the new movies we added to the site. Beyond that, we added a meta-game designed to encourage free exploration of the database.

Figure 21.2 Artist's sketch of the Adventure Room for the *Paramount Home Video* Web site. Note the chair, done in stitched Naugahyde, and the skull on the table. ©1997 Paramount Pictures. All rights reserved.

The meta-game grew out of the metaphor for the site. We said the site was a giant library where all the films in the catalog were stored in rooms that were appropriate to each movie genre. So there was a Western room, a sci-fi room, a drama room, etc. The graphic for each room showed the view from an appropriately styled recliner that looked at a large-screen TV where the home video box represented the film. These images were surrounded by furniture appropriate to the genre (Figure 21.2). So the Western room had Western-style furniture and wall hangings, etc.

The premise for our meta-game was that two college kids wandered into the library and were taken captive by the mad curator of the place (sort of "the Phantom of the Web site"). The kids escaped their captor but couldn't get out of the Web site. They called on the site users to rescue them, and they kept leaving clues about where they were and how to get them out. The clues were hidden in the various drawers of the pieces of furniture throughout the rooms in the site. Put enough clues together, find the kids, and you got a prize. It was an interesting way to get people to explore the database and learn the extent of our home video library.

"The Great Video Rescue," as the game was called, drew lots of users, gave away lots of prizes, and even won awards for its creativity. All in all it served its purpose (to get people to explore the site and Paramount's extensive video library) at the same time.

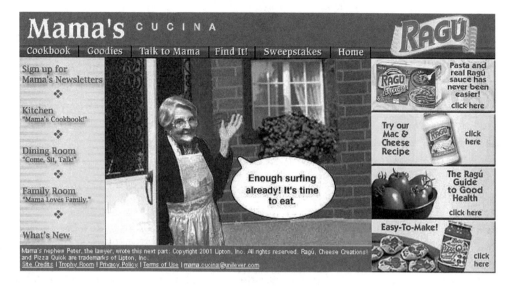

Figure 21.3 The home page for the Ragú Web site. Copyright © 2001 Lipton, Inc. All rights reserved. Ragú, Chicken Tonight, Cheese Creations! and Pizza Quick are trademarks of Lipton, Inc. Used with permission.

Having considered ways of selecting, organizing, and exploring a great variety of content for corporate and informational Web sites, let's spend a moment considering how to get people to come into the site to begin with. We've already talked about building an adventure into the site. That is exactly the approach of the wildly successful site for Ragú Spaghetti sauce, *Mama's Cucina* (Figure 21.3).

At the Ragú site, metaphor is again the key to the presence. Mama is seen dispensing some of her usual wisdom. Within the site, adventures encourage you to read her soap opera, tour Italy, or learn Italian. Of course there is no shying away from the purpose of the site: to sell spaghetti sauce.

THE HOME SCREEN AS AN ATTRACT MODE

In a free-standing interactive information or game kiosk, the attract mode is a video segment designed to get the attention of passersby. It invites them to come up to the information center or game and explains a little about how the system works. If you think about it, that is exactly the purpose of the home page of a Web site: to attract users into the site and invite them to explore further, while giving them enough information to see that they navigate the site correctly.

When you think of the home page of a corporate information site as an attract mode, the idea of a static page that consists largely of a solid block of text with little more than a text headline across the top seems quite out of place. The purpose of a Web site home page is to get people into the spirit of the site immediately and then to get people to dig deeper.

In Figure 21.3, the home page of the Ragú site, of course all those purposes are addressed. Get people into the spirit of the site, which is of course the spirit of eating Italian food. To get them to stick around and dig deeper, the rooms of the site (the living room, and the family room) draw people in with more recipes, more adventures, and more spaghetti sauce.

Going back to our home video site, as noted, we started off with the newest products available on the site because that is why nine out of ten visitors came there. What's new and what's coming? Allowing the home video site to answer that question directly is just a good solid design strategy. Building a framework around the product information would also enhance attendance at the site.

Placing a game about the hottest title right at the very top of the site was also a great strategy for getting people to enter the site, stick around, and explore. When people see the ads for the game, they go to the site, they play the game, and then they go on and visit the other areas of the site exploring and, one hopes, deciding to rent other home videos. The game becomes a traffic builder for the whole Web site experience. Again, as noted, we created "The Great Video Rescue" to get people into the site and encourage further exploration.

MENUS

When designing menus for interactive information systems, special attention should be paid to selecting the categories that the information is divided into. It is important that the category name match the feeling that the site is trying to convey and yet be complete enough to tell people what the contents of that category are.

In travel information sites, the problem gets more complicated. If the first menu a user encounters features six categories of information and there is a good deal of overlap in those categories, the user may get confused and just give up in frustration. For example, if a user wants information about the local production of the musical *Cats* and encounters a menu that lists "Nightlife," "Things to do," "Places to go," "Entertainment," and "Events," what category should he or she choose to find out about *Cats*? Is that feline opera "Nightlife," "Entertainment," "Events," "Things to do," "Places to go"? If the user looked for the play under "Nightlife" and didn't find it there, he or she might just give up and go somewhere else for information, feeling that this site was incomplete. The problem in travel sites (and those like them) is that there is a temptation to create menus with overlapping categories to facilitate the sale of ad space within more

than one category. In the end, the net effect is that the site seems incomplete and loses customers because of it. Defining categories carefully and correctly and getting the right products into the right categories is paramount to the creation of a successful site.

Let's say I created a site called *The San Francisco City Tourist Information Center*, funded by ad revenue from restaurants and theaters. If I have six nebulous categories, I can sell ad space to advertisers in all six different categories. So I get revenues from the Fog City Diner as one of the "Places to Go" and as a "Restaurant." Of course, when "Joe's Seafood Fiesta" wants to buy space only in the "Events" category to promote a special discount day in May, Joe is misleading his customers who won't realize that Joe's is a fine restaurant that is open (without discounts) 365 days a year.

Get the point? Make your menu categories sexy and appropriate to the mood of your site, but also make their content and purpose clear and distinct.

A way around the overlap issue is to expand on the categories once you have created them. That is just what the highly successful *CitySearch* Web sites do. *CitySearch* lists the usual mix of subcategories, but then highlights them in the details of its home page.

SEARCH CAPABILITIES

Of course, the site provides another answer to the problems of overlapping categories. It uses a search engine at the very top of the site. Want something? Look it up right away. Search functions are second nature to most Web surfers, so they can't miss.

SUBCATEGORY MENUS

Once users get past what is ideally the transparent main menu section of the home screen with its crystal-clear categories, the users' options can easily expand. The restaurant category can lead to a subcategory menu. But here, the plot thickens. While the rule about main menus is to make them as clear and simple as possible, rules about subcategory menus are far more difficult to pin down. You can give the obvious subdivision of the category (restaurant subcategories could be French, Italian, Chinese, California cuisine). If there are many different ways to subdivide the category, you can offer the user a choice, such as, "Do you want restaurants classified primarily according to price, location, or type of food?"

Designers must decide whether they want to give users lots of choices at the subcategory level or to simplify things and avoid the confusion that occurs

Figure 21.4 Path of an information system about restaurants.

when users are offered too many choices before they get to the information they seek. In designing information programs, our rule of thumb is: Don't require the users to take more than three steps before they get to the information they want.

Figure 21.4 shows one path of a flowchart. It represents an information dissemination system about restaurants that begins with a main menu and then leads to a specific "high-priced" restaurant. Notice the number of decision levels that the user has to go through before he or she gets to the actual information module. This may be too many, and it might be better for information organizers to "bite the bullet" and pick one way to organize their information, at least for those users coming at the information from the start of the program. People who have been in the system for a while might be offered more complex menus with more discrete choices through a separate set of branches.

At the *CitySearch San Francisco* site, where the text style may be best described as "San Francisco Hip," the approach is absolutely "more is more." So restaurants are categorized by kind of cuisine, but price range is also an option, as are other quite original ways to designate restaurants ("kid friendly," etc). The detailed restaurant description sits on the right-hand side of the page across from a more detailed restaurant guide that offers fewer but more detailed choices. The balance of the information is clear and good and makes it easy for users to make the most possible choices from a single page. The fact that part of the *CitySearch* service to restaurants is to create the restaurant's pages for them ensures a high standard of quality content on the site.

Figure 21.5 shows the home screen from CitySearch.com. *CitySearch* is a highly developed series of sites created for specific cities by TMSC (Ticketmaster Online–CitySearch). To quote the "about" information on their Web site, *CitySearch* . . .

> . . . is the number one online local network enabling people to get the most out of their city.
>
> Operating in cities worldwide, the sites help people find and plan what they want to do, and then take action, with local transactions functionality such as buying event tickets, making reservations, or meeting the right people to do things with—anytime, anywhere, on multiple devices. This integrated family of sites includes ticketmaster.com, the world's number one online ticketing company; citysearch.com, the leading local network; and match.com, the premier online matchmaking service. Located in Pasadena, California, TMCS is majority owned by USA Networks, Inc.

NAVIGATION

For an in-depth discussion of navigation and navigation controls, see Chapter 9 on interface design. The important point to be made in this section is that it is especially critical that interface designs reflect the character and functionality of the site.

Take a closer look at the *CitySearch* home page. Note the nav bar across the top of the page. It's simple, it's direct, and it's always there. On the submenu pages more global controls such as *Return to Home Page* are positioned at the end of the article on the restaurant or location.

LINKS TO OTHER SITES

Informational sites are designed to help people get all the information they want any way they want to get it. So, providing lots of links to other sites is an ideal way to support that mission. However, in corporate sites, offering links out of the site takes people away from your area—and, once they leave, it may be hard

Figure 21.5 The home screen of San Francisco Bay Area citysearch.com. © 2001 Ticketmaster. All rights reserved. Used with permission.

to get them back. There are a variety of solutions for the corporate Web developer. You can design navigator frames that go with your users when they visit other sites, so that they have an easy way to get back to your site. Or you can open other sites on top of your site so that your site stays on the screen when the other locations are opened. Another solution is to create "link pages." These are points within your sites where all the links out of the site are brought together into one spot so that users must get to that launch point to leave the site rather than being able to jump away from the site from a variety of points. This reduces

the chance of people leaving the corporate site before seeing all there is to see and finding out all there is to know about your corporation.

PRINTOUTS

Being able to print out pages of content is a natural and easy function for Web sites to offer. People want to be able to take away some of the information that you have for them. There are a variety of ways to offer printouts. You can allow a printout of the page just as it appears on the computer screen. Of course this adds graphic elements that may make the printing process slow and wasteful. An alternative is to create a printout version of the screen. In that case you will want the printout screen to include all the pertinent information that is on your screen. The more the better, but minimize the graphics and the backgrounds. It is not uncommon for sites to create printouts that shortchange the user by giving them far less than is on the screen they are viewing. "What you see is what you get" is what people have come to expect, and even when you are offering a scaled-down version of the screen, be sure not to scale down the pertinent information.

You may want to offer other printable items for your users as well as the data on a particular screen. Printing out fact sheets about your company, or price lists, or whatever is a great benefit. Coupon printouts, on the other hand, present special problems. Any coupon that can be printed can be duplicated en masse. So, if you are considering printable coupons as a promotion on your Web site, ask yourself whether the loss of revenue through piracy is worth the promotion. With some kinds of products it may be, but in others it could result in a great loss. Coupons will be duplicated if for no other reason than that it is extremely easy to do.

Printing out maps is a valuable service that travel sites can offer. The user can be offered a variety of local maps in greater or lesser detail. Remember to check the detail of the printout of your maps. Too many sites offer map printouts that become immediately illegible once they hit the piece of paper. Design your maps for readability on the screen *and* on the printed page. Taking advantage of proprietary software, sophisticated travel information sites can build unique maps that trace the paths to and from specific destinations. What is the best way to get from your hotel to the restaurant of your choice? Print out the map and you'll know.

Corporate sites are clearly one of the most successful parts of the Web. For some time they were being created as experiments to see whether people would come and what they would do when they got there. Today, a more and more global vision is growing, and in that vision the Web itself seems to be turning into an enormous, ever-growing encyclopedia, one that is explored by people whose need for information is often critical. The quality of that entire encyclopedia

depends on the quality of the sites that go into it. Many of them are simple, home-grown efforts, which is good. But to the extent that major corporations choose to tell their story on the Web, they should do it with all the style and skill that their company deserves. Great corporations can't be represented by halfhearted efforts in an arena that is expanding with such ferocity.

Now, having discussed the possible architecture and content organization for corporate and informational sites on the Web, let's move on to those interactive applications dedicated to selling products.

22

e-Commerce Systems

In Chapter 21 we briefly discussed the distinction between interactive information systems and interactive commerce or sales sites. In that chapter we defined the structure of the information system as a series of ever-opening doors leading the user to more choices and more information. By contrast, the e-commerce system was described as a series of fewer and fewer choices leading the viewer to a single action: a purchase.

Interactive shopping systems can be divided into two major categories: "promo" systems that show off products and offer information but don't take the order, and "buy" systems that actually allow the shoppers to place their orders through the computer. However, because "promo" systems also are eventually designed to get users to buy by referring them to a store or a phone line, we will consider all e-commerce systems here to be "buy" systems.

SALES FLOW

A major concern of professional salespeople is sales flow. To complete a sale successfully, events must move smoothly from one stage to the next. The smoother the flow, the easier the sale. The worst thing that can happen to a sale is to interrupt the flow. Unfortunately, this occurs quite often with interactive commerce systems because mechanical or technical problems or software difficulties created by faulty logic can easily interrupt the order-taking procedure. This results in user frustration.

User Frustration

Assume that a shopper knows just what he or she wants to purchase on an interactive commerce system. If that shopper is unable to determine the breadth of products being offered by the system or how to enter order information, there will be an interruption in the sales flow. This can occur at any point during the sale. If the user finds the system too cumbersome or frustrating to use, he or she will most likely just give up. To avoid user frustration, designers of e-commerce systems must make sure that they take into account the goals of the shopper.

They must also be sure that the controls of the system are obvious and easy to understand and that product information is crystal-clear.

KINDS OF INTERACTIVE SHOPPERS

To determine how information should be organized to make it as clear as possible, designers must first take into consideration the different types of on-line shoppers. I like to divide interactive shoppers into four different types: the first-time user, the browser, the person ready to buy, and the inquirer. The needs of each group must be served.

The First-Time User

The first-time user of an e-commerce system does not usually want to get from the "start" to the "buy decision" as fast as possible. The first-time user wants to begin by learning something about the site or system. This might include a general discussion of the different products available on the system as well as a brief explanation of how the system is run, where goods come from, and how orders are fulfilled. The additional information required by the first-time user distinguishes him or her from the person ready to buy and the browser. Once the first-time user understands how the system works, however, he or she may then become interested in browsing through the products available on the system.

The Browser

The needs of the browser are different from those of the first-time user and the person ready to buy. The browser wants to explore the products by looking at several of them, comparing them, and seeing them in action. The browser is the person to whom most of the space of the e-commerce systems is devoted.

Because the browser does a great deal of bouncing around among products, it is important to remember that the goal of the shopping system is to close the sale. With all the bouncing around, if the sales flow gets interrupted, a potential sale may be lost. This is one good reason why, on Web sites dedicated to sales of products, links to other sites are very big problems. Even if they are bringing in substantial revenue, links to other sites definitely interrupt the sales flow and are therefore to be avoided. In any event, even though the organization required for the browser is different from that needed by the first-time shopper or the person ready to buy, it, too, must be crystal-clear.

Another important thing to remember about browsers is that they are not buyers when they enter the site. Therefore, it is a good idea to insert some "close-

the-sale" activities into the presentation to turn browsers into people who are ready to buy. Having a "Buy" button or an "Add to Shopping Cart" button on every page is a necessity.

The Person Ready to Buy

The person ready to buy is prepared to make a purchase the moment he or she arrives at the site. For this person, the process of browsing is superfluous and may even get in the way of closing the final sale. What this person needs is a structure that gives immediate access to product information followed by quick order entry. In other words, he or she needs a "main line" from the start of the shopping process to the very end. The key ingredient for this shopper is a system-wide product search engine on the home page or main menu.

The Inquirer

The inquirer is someone who needs guidance to decide on a particular product. He or she does not really want to browse around, but does not know what is available, either. What is needed here is help. The mechanism for that guidance (the way the system helps the user to determine what he or she wants) is present in the very best interactive e-commerce systems. It may be nothing more than a series of questions about specific products or even questions about demographic data that zero in on a specific category of items. This technique may seem obvious, but it will increase sales sharply if the information is easy to access and the system easy to use.

RULES FOR CREATING INTERACTIVE e-COMMERCE SYSTEMS

Now that we have looked at the requirements of a continuous sales flow and the various kinds of shoppers, it may be possible to summarize what we have discussed in a few rules:

1. Make sure that the controls of the interactive commerce system are obvious and easy to understand.
2. Make sure that the organization of the system is crystal-clear.
3. Provide a path by which first-time users can get the background information they need to feel comfortable making a purchase.
4. Allow the browser an easy method to explore, learn about, and look at products in action.
5. Build in a method for closing a sale for browsers who want to do nothing more than "look around."

6. Provide the person ready to buy with a method to get right to the buy decision in the shortest possible number of steps.
7. Offer a method by which the inquirer can be guided to a product by asking a series of questions.
8. Devise an order entry mechanism that will not get in the way of the sales flow.

Home Page

The most successful e-commerce sites are starting to look alike. The pages feature a lot of white space with small images and clearly defined menu bars. Text is small, with a few highlighted text items that make the page interesting. Menu bars, too, are kept small. Although "white space" has always been considered a good thing in advertising because of its clean, simple, uncluttered appearance, it has an even more important purpose in e-commerce. Pages with small images and a lot of white space download quickly. There is not a lot of time wasted getting the image onto the screen. User frustration can be minimized.

Controls

Methods for creating navigation bars (menu bars, control strips) have been reviewed in several previous chapters. In many ways the nav bar needed for a interactive shopping system would be similar to that needed for an information system. One or two additional keys might provide all the added control required. Figure 22.1 shows the main controls needed for a shopping system. A "Products" button allows the user to access pages of information about the product. "Home Page" accesses the previous menu, "Order" goes directly to a purchase, and "New Comers" provides background information.

Organization

The best way to make sure that the organization of the e-commerce site is crystal clear is to pay special attention to the structure of the decision points in the site (think of them as a series of menus) and the clarity of the welcome statement that gets everything started.

Order | Products | Home Page | New Comers | Contact Us

Figure 22.1 Nav controls needed for a shopping system.

The Welcome Statement

The welcome statement is a short presentation (in graphics, text, or video) that appears on the home page or (in interactive sales systems based on CD-ROMs) when a user begins to use the program. Its purpose is to explain as clearly and directly as possible the goals of the site, how to move through it, who is running the site, and customer benefits. Figure 22.2 shows the home page from Amazon.com. Amazon considers the home page its Welcome.

Menu Construction

In a Web site, each page of a sales area is in fact a menu. In interactive CD-ROM or interactive video sales efforts, the menus stand alone as individual screens that must be dealt with. In both cases menu construction is a difficult business. Each menu must contain a clear presentation of all choices plus instruction about any action that must be taken to make the menu work. It is also important that menus be looked at in series so that there is a logical flow from one menu to the next. Sometimes people go from menu to menu to menu.

There should be little or no redundancy in the names of the categories used in the menu, because this can lead to confusion. We covered this point in Chapter 21, but the same principle applies to shopping systems. It is critical that in a large

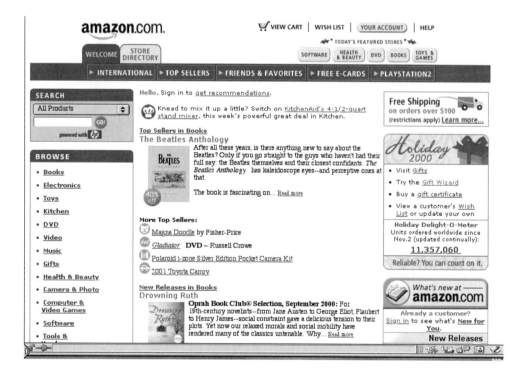

Figure 22.2 The home page from Amazon.com. © 2001 Amazon.com, Inc. All rights reserved.

shopping system, people know what they are getting within each shopping category.

Moreover, enough instruction should be included in the menu area so that the user will know what the menu is for, and how to use it. In interactive video presentations, and even on Web sites where streaming audio is possible, it is sometimes a good idea to have a narrator describe the use of each menu the first time it is used. After the first set of instructions, the system can just eliminate the narration.

PROVIDING A PATH TO THE SALE

The Direct Route

Rules 3 through 7 in our list of rules for creating commerce systems relate to the separate paths that should be created for the four different kinds of shoppers. Because the most important customer is the customer ready to buy, the best place to start is by creating a path by which that customer can get to the buy decision as quickly as possible. Figure 22.3 shows such a path.

In spite of our best intentions, the sales path described in Figure 22.3 requires the customer to complete a sale by clicking on buttons at least four times and advancing through three menus. A faster way to accomplish this may be to place a "buy key" in the attract mode screen so that the customer can go directly to an order-entry frame. A search engine can be used to name a product, then clarify the item information as the customer is entering the order.

Figure 22.3 Direct path buy decision.

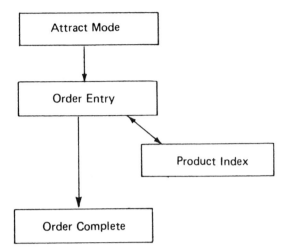

Figure 22.4 Short path for the person ready to buy.

Figure 22.4 shows the location of such a product list or index. This technique, which is similar to that used by computerized directory services, saves the user time.

In systems such as Amazon.com, the buyer enters the site, types in the name of the product in the search function, goes to that screen, and then places the order.

The "Additional Information" Block

Now that we have created the main trunk of the organization in our e-commerce site and satisfied the needs of the customer ready to buy, it is necessary to deal with the requirements of the other customers—the first-time user, the browser, and the inquirer.

The first-time user should have access to a special block of information that has been placed out of the main informational flow. A button on the navigation bar can access this special information. It is designated as "Background information" or, in the case of our example from Amazon.com, "About Amazon," which is both a communication tool and an additional information block.

Such a button should access a first-time user's screen or menu. Figure 22.5 shows the "About" screen from Amazon.

This page should offer detailed information about the operation of the system, an introduction to the sponsors of the system, an overview of the product selection, and an explanation of how orders are processed and products delivered, as well as information concerning special offers and guarantees.

Figure 22.6 illustrates the flowchart for this module of the sales system if the page were broken down into a series of screens supported by a menu.

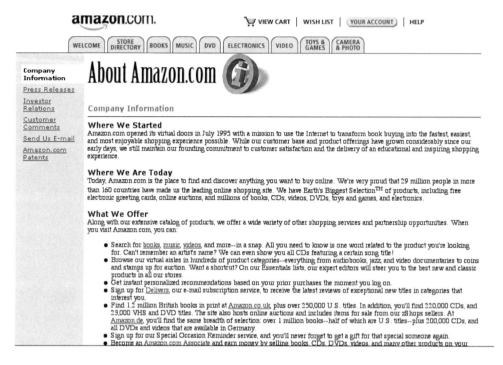

Figure 22.5 About Amazon.com. © 2001 Amazon.com, Inc. All rights reserved.

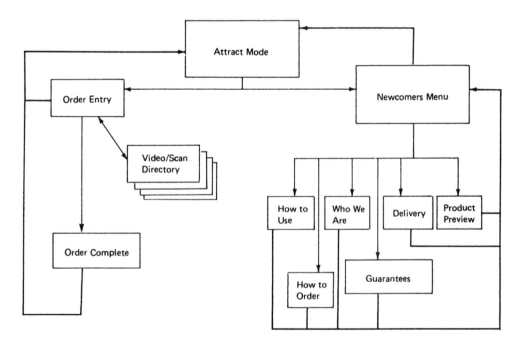

Figure 22.6 Information module for the first-time user.

The Product Information Module

Our next step is to add the module on product information. This is the material with which the browser spends the most time. Let's consider how the information is organized.

Products should be divided into categories for easiest access. Amazon has a lot of special features in its category menus. To stay with the home video topic we covered in the last chapter, Amazon offers users the ability to browse its lists by alphabet or by genre, and to seek out top sellers or new releases.

Products can be accessed from the category screen or from the home screen via the search function. With the huge size of the Amazon site, search becomes the best way to go for the person ready to buy, and even for browsers who have a general sense of what they want to look at.

The search accesses product screens. Each product includes a picture, a product description, and pricing information. Figure 22.7 shows a product screen. Amazon.com also includes reviews of the product both by established sources and by users of the site. You can also access a larger picture of the product.

In more advanced versions of this kind of site the product close-up could be replaced by a brief motion sequence. This is not the case in most current

Figure 22.7 A product page from Amazon.com. © 2001 Amazon.com, Inc. All rights reserved.

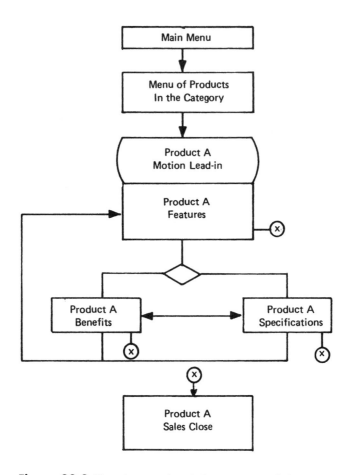

Figure 22.8 Flow in a product information module.

e-commerce Web sites. But, as the technology improves and download times become shorter, there will be more motion and animation in these sites. At the present time the user frustration that might be kicked off by a long download is not worth the risk of losing the customer. Figure 22.8 shows how such a future, media-rich product information module could be organized.

Recommendations

One of the most amazing things about a site like Amazon.com is its Recommendation feature. If Amazon is able to cookie your site (put a piece of software into your system so that it knows who you are when you come to it), Amazon can make recommendations on its site that are tailored just to you. It looks at the last things you bought and begins building a profile that describes the kind of things you like. Amazon knows that I like to buy books and DVDs and that my

favorite subjects are the great outdoors, technology, and comedy. As a result, when I go to its home page, Amazon shows me the latest books that are available in the subject areas I like. If I am there to browse, I start with those selections. If I am buying, I may take a side journey from my original purchase and look at the latest publications in my areas of special interest.

This is a very powerful function and one that is designed to appeal to the Inquirer in us all. Another feature that Amazon added for the 2000 holiday season is a "Wish List" feature. Members of my family who use Amazon a lot can build a list of the things that they want and then put it into Amazon. When I enter the site, I can review their lists and buy a lot of my Christmas gifts right there on the spot. What a great idea! In fact, when I finish writing this chapter, I'm going into the site to create my own wish list.

The Shopping Cart Function

Note the indication of the shopping cart in Figure 22.7. Shopping carts have become a very workable metaphor in e-commerce. They provide a virtual space in which users can accumulate items as they move through the Web site. The advantage of accumulating items in a shopping cart is that they can be purchased in a single act. Users don't have to enter separate order information for each item they are buying. Figure 22.9 shows the position of the shopping-cart function as well as the position of the product information module (which is encapsulated into a single box) within the entire sales flow, from the welcome frame to the purchase.

Figure 22.9 Placement of the product information module.

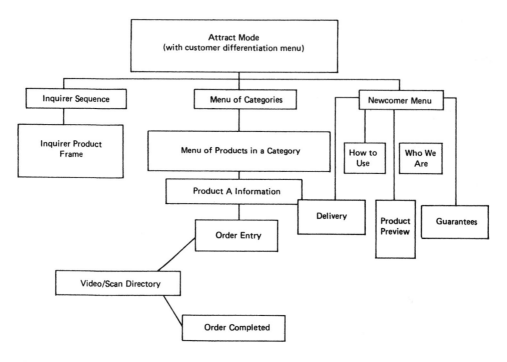

Figure 22.10 Flow including the inquirer sequence.

The Inquirer Sequence

The material for the inquirer can be treated as a separate block of information. As noted, this block is made up of questions that would allow the user to be directed to the product just right for him or her. The questions could lead into the product information sequence or (less efficiently) to a frame or frames created just for the "inquirer sequence." In any case they would fit into the overall flowchart, as shown in Figure 22.10. Note that the variety of approaches to the material necessitates the creation of a navigation bar that identifies the customer type from the very start.

Needless to say, keeping clear menus and directions in the face of an organization so complex seems like a difficult task. But the fact is, if the designers trace every path through every possible twist and turn, they can eliminate loops and dead-ends and come up with an organization that does not get in the way of the sales flow.

THE USE OF MOTION AND ANIMATION

We have said that downloading motion sequences in an e-commerce site bears the risk of customer frustration because of the possible download time. Never-

theless, we do need to think about the best places to put these elements, so that, as bandwidth improves, so will the quality of our sites. The interactive television trials where we did construct full-motion commerce sites indicate a few obvious places to put video, as well as a few that are not so obvious.

The obvious places include the "welcome" sequence and several elements within the "newcomers" or first-time-user sequence (i.e., who we are, how to use, and product overview). There is also good reason to use motion in brief sequences that show individual products at work. These sequences can range from simple GIF animations to full-blown streaming video segments or downloadable 10-second commercials.

The not so obvious places for video motion or animated sequences in interactive e-commerce sites are as part of each menu for a group of products. These menus have been called "category menus" because they represent a category of items. The motion sequence that might kick off the home video menu for Amazon, for example, might feature a montage of scenes from the month's newest releases edited together to help promote and draw attention to those films.

ORDER ENTRY SYSTEMS

Order entry systems finalize a sale by getting the customer's name, address, and credit card information into the point-of-sale system. This enables the ordered product to be paid for and delivered to the right place. Currently there is still some resistance to entering personal information and credit card numbers into the computer because of concerns about security on the Internet. We can hope that resistance will decrease with the growing, universal acceptance of the Internet.

At the same time, this continues to be one of the most common places to lose the order because of user frustration. All that form completion that has to be just right still makes the user want to drop out and run down to the local store.

Since most order entry systems are now turn-key, the best thing that you can do is search for the most highly worked-out, most complete, and even the most forgiving order entry system. You should probably look for one that does not lose customers because it demands and will not go on without pages of demographic data. Look for the short-form order entry systems.

Membership is a good thing. In membership systems the computer knows who you are when you enter the site and even has your address and credit card number when you are ready to check out. All they ask for is a password. Here is another point of customer frustration. Users are encouraged more and more to use different passwords with different Web sites. The net result is that they can't keep their passwords straight—and they may hit that user frustration level when they have $500 worth of merchandise in their shopping cart and

are ready to check out. The solution: do everything in your power to keep that customer from bailing. That is a $500 order that is about to log off, and no living, breathing salesperson on earth would lose that sale over something like a password.

The solutions, unfortunately, are better on-the-spot password workarounds. Five retries to enter a password, followed by a password hint, followed by "we'll have to send you a new password in a few days," is not a solution.

What is the solution? Hey, it's a performance problem. Sounds like the original signup system should have a better password preparation and password hint section (one that will go farther in helping the user keep and remember his or her password).

Even asking users to create a "password log" in their desktop directory or address book is a pretty good idea.

In this chapter we showed that the ideal interactive e-commerce system serves four very different kinds of shoppers and provides a flexible design that can accommodate any one of them. The ideal system is also dynamic enough to adapt to the shopper as he or she changes from one kind of shopping pattern to another. We pointed out fundamental rules: the need for crystal-clear organization, the importance of welcome sequences to get the customer started on the right foot, and menus that are complete, clear, and easy to use. We also presented program designs that offer background information, security, and reassurance to the first-time user, an interesting product database for the browser, and an "expert-system-type" question format for the inquirer who needs product recommendations. We also suggested the need for a direct path to the order entry segment for those who are ready to buy.

Currently e-commerce is one of the most promising of all applications, but one that has seen some of the most dramatic failures in the whole world of new technology. It probably won't reach its full potential until enough customers feel that systems are more secure and experience shows them that they can be as comfortable with on-line shopping as they are with catalog shopping. Unfortunately, that may require tapping into a whole population segment that is not now computer literate and who require a far greater level of media support than today's systems can easily deliver.

Where Is It All Going?

What may be most amazing about the vision of Ray Bradbury's PlayRoom, which we described at the very beginning of this book, is how well it dramatizes the entertainment medium of the future. I feel that Bradbury described it as clearly as Jules Verne described the submarine in his book *20,000 Leagues Under the Sea*. Yet, as gripping as it was, Bradbury's PlayRoom was never as fully realized as the same concept has become in the films and television programs of recent years.

Virtuosity, the 1996 action film, told of a massive, virtual reality police training simulator whose main feature was a virtual adversary with a personality that was a mix of the greatest villains in history. Virtuosity's forte was to create the perfect character to live within its virtual space. Of course, all hell broke loose when the multipersonalitied villain got out of the simulator.

An even darker note is at the heart of *The Matrix*, where the virtual world is going on in the heads of all humans who, at that point in future history, are test tube creatures whose body heat is used to power the mainframe computers who rule the world. The Matrix is a virtual environment seen from the point of view of human batteries who dream of getting a real life.

Earlier in this book we also mentioned the Holodeck. As noted, the Holodeck is the virtual playground and learning simulator that exists on most of the starships in the later *Star Trek* series. It is programmable and creates virtual people and places as specified by the demands of its users, the crew of the ship.

The Holodeck allows the crew members to live out their fantasies of any time and place they choose to experience.

Through story devices such as the PlayRoom, the Matrix, and the Holodeck, it is becoming clear that virtual immersive experiences are the full realization of interactive entertainment. So many of our greatest entertainment visionaries and storytellers are calling for and expecting this kind of experience that sooner or later it is going to happen.

If that is the case, why aren't the underpinnings of the virtual experience being put in place today? Why aren't our media conglomerates "laying pipe" for the emergence of this newest and most mesmerizing of all entertainment forms? The answer is simple . . . they are.

CD-ROM AND DVD

As noted, on the Internet, QuickTime VR offers the ability to take a 360° view of any item or place you want to get to know. So, now when you visit the Montreal site, for example, each of its streets has been laid out and developed for your virtual visit.

The still-evolving Virtual Reality Modeling Language (VRML) promises to go even further in turning the Internet into a three-dimensional space in which people can explore whole new places on-line. Even without virtual reality built into the Internet, the medium grows more and more ready to deliver streams of updated, ever-changing media that are infinitely deep and easily accessible.

At the same time, following the principles we have talked about in previous chapters, sophisticated CD-ROM games continue to refine the possibilities of branched storytelling with multiple outcomes and consequence remediation. DVD, the next, latest, and best incarnation of CD data delivery, now offers the high resolution of Hollywood's master tapes, super hi-fi sound, and a storage capacity of 4.7 gigabytes (seven times that of a CD-ROM). The delivery of CD-ROM content devices and story formulas through the added power of DVD technology will offer richer storytelling environments on our computer and television screens.

At the same time, automated characters whose physical features and actions are becoming alarmingly like those of real people are suddenly populating the most advanced gaming platforms. Electronic Arts, in its PlayStation 2 game *Madden Pro Football 2001*, allows you to play the game with players who look almost exactly like real athletes on real teams (Figure 23.1). Their faces have been mapped for computer imaging and their movements have all been studied and incorporated into the game as well. The race of physical characters who will populate the PlayRooms of the future have begun their evolution. If you can't get or can't afford a PlayStation 2, just check out *Monday Night Football*. The same automated characters appear in the promos and lead-ins of the show.

So, the underpinnings of immersive experiences are already being worked out. And the principles that have been evolving for on-line learning and entertainment are beginning to be documented in this book and elsewhere.

Figure 23.1 Images from the PlayStation 2 game *Madden Pro Football 2001*. © 2000 Electronic Arts Inc. All rights reserved.

At the same time, interactive stories are getting stronger, and the balance between game play and story development is being refined. The critical issue, "Who are the users and what is their role?" is working itself out through the plot lines of the hundreds of interactive stories that are being created each year. So, too, the question "How much branching?" is finally being understood and answered.

As we have tried to point out, the right answer is not branching into infinity, but rather, more realistically, branching into limited paths that cross, dovetail, and re-cross. So, the ongoing evolution of entertainment Web sites and CD-ROM/DVD action and adventure games and stories is well on its way to providing much of the content design answers that will lead to truly immersive media.

What's next?

SITECAMS, VIDEO WALLS, AND HIGH-DEFINITION TV

Imagine that the wall of your den or media room is a giant-screen TV that, when it is not showing ordinary TV programming, is featuring some animated graphics: ongoing scrolls of news images, weather, sports, and other info, or moving images live from your favorite place in the world (sitecams). Figure 23.2 shows a mythical sitecam image from one of my favorite mountain locations.

The wall-size TV screen is emerging through efforts that range from industrial media walls and jumbotrons to projection TV and the newly arrived high-definition television (HDTV). Feed in realistic images. Mix together live data and image feeds via the broadband Internet with finely crafted, locally stored imagery downloaded from DVD. Add the interactive story designs and principles that have been evolving since the dawn of time, and you have the groundwork for totally immersive interactive experiences.

As usual, the technology is way ahead of the art form. But at last the art is starting to catch up. By the time the combination of DVD, broadband Internet connections, and HDTV is in enough homes to make it economically viable to do so, there will be enough *Myst*s, *Doom*s, *9*s, and other media models to show us what to do.

AND DON'T FORGET THE MILITARY

For decades, the U.S. military has been using simulators to train their troops. As the quality of simulation technology has strengthened, the demands of the military have risen with them. Where are they now? To quote an article in *Wired* magazine:

> By 1990 [Bolt, Beranek, and Newman—winners of the 1983 contract to build a new generation of simulators for the Army] had turned over 238 network simulators

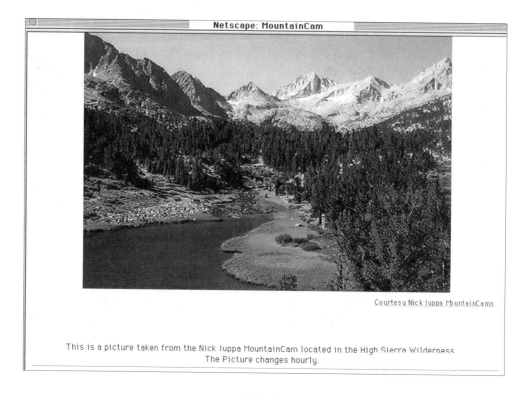

This is a picture taken from the Nick Iuppa MountainCam located in the High Sierra Wilderness. The Picture changes hourly.

Courtesy Nick Iuppa MountainCams

Figure 23.2 A hypothetical image from a sitecam in the Sierra.

to the U.S. Army. Meanwhile the scalability of the architecture allowed combat training exercises to grow from dozens to hundreds of players and incorporated a growing number of vehicle types. Today a large distributed interactive simulation or DIS exercise might have 1,000 humans (the system could support 10,000 human players just as easily) and 9,000 software robots, representing the interactions of jets, tanks, ships, satellites, armored personnel carriers, and helicopters. By the end of the decade [the Army] hopes to be running exercises with 100,000 participants that will include smoke, weather, and a variety of microterrains (forest, swamp, desert, etc.).

As they have in the creation of so much digital media technology, the Army, Navy, Air Force, and Marines, with their massive training needs, are paving the way for the creation of media types that will have a profound impact on consumer products.

BUT DO CONSUMERS REALLY WANT THEM?

A funny thing has happened to new media in the last couple of years. People have suddenly begun demanding it. They demanded CD audio and were willing

to accept it so completely that within two years the LP record was obsolete. People convinced themselves that they wanted the information superhighway. And when interactive television (which they thought would be the information superhighway) didn't happen, they found the Internet, and they demanded it so forcefully that Internet service providers, and Net browsers, and Web development companies, and even phone companies sprang to attention to answer their demand.

Immersive experiences are the ultimate interactive technology. Do people really want them? Can they be as addictive as the PlayStation 2 or network television?

Two-thousand-pound gorilla, late night talk-show personality, political pundit, and *Monday Night Football* commentator Dennis Miller, although generally negative on the whole idea of new technology, answered the question very well in his bestselling book *The Rants*.* I paraphrase for obvious reasons:

> Listen, the day when an unemployed iron worker can lock himself in his TV room with a Fosters, his channel flicker, and a virtual Claudia Schiffer it will make crack look like Sanka.

Maybe not the most wholesome image, especially not for Ms. Schiffer, but I hope you get the idea.

I don't always have the energy to fight off aliens, solve the "Murders in the Rue Morgue," save the world, or rescue the damsel in distress (even if she is Claudia Schiffer). I sometimes don't even have the energy to have the damsel rescue me when I am in distress (even if she is Claudia Schiffer).

But I have a feeling that I will gladly come home any night of the week and step out into a meadow beside a lake in the High Sierra and watch the sunset reflected off the mountain peaks. I'd gladly sit around a campfire any night of the week and talk to virtual and real friends about things friends talk about. I'd rather hike virtual mountain passes, and if I get my daily exercise doing it that's all the better.

Let's give the current crop of TV couch potatoes some real choices. Let's give them a way to be interactive that is more to their liking than simply surfing an all-too-imitative selection of daily TV fare. Let's build them a PlayRoom; even in its most rudimentary form . . . one that lets them create their own worlds in which to play. That is where all this effort is going anyway, you know. It's just that most people in the media biz don't really realize that yet. Let's build a kinder, gentler version of Ray Bradbury's PlayRoom. And eventually, I'll bet it will become so compelling that it will, in fact, make today's television look like Sanka.

* *The Rants*, Dennis Miller, Doubleday, 1996.

Index